ZOLTAN SZABO
PAINTS LANDSCAPES

ZOLTAN SZABO PAINTS LANDSCAPES

ADVANCED TECHNIQUES IN WATERCOLOR

WATSON-GUPTILL PUBLICATIONS/NEW YORK
PITMAN PUBLISHING/LONDON
GENERAL PUBLISHING CO. LTD./DON MILLS, ONTARIO

First published 1977 in the United States and Canada by Watson-Guptill Publications
a division of Billboard Publications, Inc.
1515 Broadway,New York, N.Y. 10036

Library of Congress Cataloging in Publication Data
Szabo, Zoltan, 1928 –
 Zoltan Szabo paints landscapes.
 Bibliography: p.
 Includes index.
 1. Water-color painting—Technique. 2. Land-
scape painting—Technique. I. Title.
ND2240.S95 751.4'22 77-622
ISBN 0-8230-5980-4

Published simultaneously in Great.Britain by Pitman Publishing
39 Parker Street, London WC2B 5PB
ISBN 0-273-01046-8

Published simultaneously in Canada 1977 by General Publishing Company Ltd.
30 Lesmill Road, Dons Mills, Ontario
ISBN 0-7736-0057-4

Manufactured in Japan

First Printing, 1977
Second Printing, 1977

DEDICATION

An artist's soul is the womb of ideas. This fragile substance is extremely sensitive to external influences and needs the moral support of fellow human beings. However powerful this moral support may be, it is strongest when it's combined with love.

Watercolor painting is my way of communicating my ideas, emotions, and dreams. The enthusiastic moral support of my fellow human beings — but particularly that of my wife, with her devoted love and practical help — has greatly enriched my creative life and contributed to the birth of this work.

To her, the warmest representative of all of you, my fellow dreamers — to my little spiritual snowflake Linda — I dedicate this book.

ACKNOWLEDGMENTS

As a long overdue gesture of gratitude, I would like to take this opportunity to express my sincere thanks to Don Holden, Margit Malmstrom, Diane Casella Hines, and Bonnie Silverstein for their untiring help with my three books. Their polished professional skill, combined with warm human qualities of gentle understanding, patience, and a genuine interest in art, not only made my job as an author easier, but turned the time-consuming years of creating those books into a joyful period of my career as an artist.

CONTENTS

FOREWORD

After two books on transparent watercolor and related techniques, you could rightfully ask, "Why a third?" My answer, of course, is that watercolor is such a complex medium that I could never hope to exhaust its potential, no matter how many books I wrote!

My first book, *Landscape Painting in Watercolor,* was written for the beginner and for the reader with modest experience in watercolor. *Creative Watercolor Techniques,* my second book, was meant to introduce you, the reader, to various offbeat approaches to transparent watercolor and related media. This latter book was designed to loosen your attitude about creativity and offer some interesting solutions to painting problems.

This new book will speak to all fellow artists who are profoundly committed to the values (and aware of the traps) of honest-to-goodness transparent watercolor, and whose art is in the process of constant evolution. This book is for the "advanced" watercolor artist who has reached the point where he's convinced that transparent watercolor is his chosen medium of creative expression—who has begun to sense the transforming process of watercolor in his life. In my opinion, watercolor is more than technique; it's a philosophy, a way of life that's treasured by those who sincerely practice the art — and recognized by those who are sensitive receivers of watercolor's unique power to communicate.

To grow old in the company of such a noble friend as watercolor is something I look forward to, knowing full well that I cannot live long enough to stop learning.

When I'm alone with my thoughts as I paint, I sincerely wish to represent my ideas, my emotions, and my visual experiences in my paintings as well as my technique permits at that moment. When I'm finished with a painting, I hope that it will communicate those same qualities to the viewer who wishes to read them. The visual means of this spiritual communication is the technique of transparent watercolor. By the time you finish reading this book, I hope we'll be spiritual friends.

Whatever you'll read in these lines—or in between these lines—will be offered to you only as suggestions. You're free to accept or reject them. My intention is to enrich your technical skill, not to dominate your thinking. Your way of painting will come from your mind, formed by *your own* experiences. The decisions that you'll make while painting — even after you've absorbed the suggestions of this or any other book—must be your own and cannot come from anyone else. I invite you to read these pages with an open mind, knowing that I have the deepest respect for your intelligence and integrity.

NOTES ON LANDSCAPE PAINTING

COLOR AND WATERCOLOR PIGMENTS

Once you're familiar with the basic tools of watercolor and have made your choice of paper, brushes, paint, and other tools, you'll begin to feel the need for discipline.

PALETTE

I don't feel comfortable committing myself to a fixed palette. However, if at some point in the future I feel the need for a change of colors or a reduction in the number of pigments, I won't hesitate to do so.

Except for Davies gray, my colors are all Winsor & Newton artist-quality pigments. I know the way they behave, I'm convinced of their high quality, and I don't substitute for them in my paintings. Therefore, the behavior of the colors on my chart will hold true only for this brand. Other brands *don't* necessarily react similarly. However, I frequently experiment with new colors and/or new brands, though so far I haven't found an equal substitute.

LANDSCAPE PALETTE

My present landscape palette is simple and based on sure knowledge of each color's intrinsic nature and mixing qualities. My outdoor palette consists of:

New gamboge
Raw sienna
Burnt sienna
Brown madder
French ultramarine
Cerulean blue
Winsor blue
Sepia
Sap green

For studio use, I add the following colors to those mentioned above:

Aureolin yellow
Cadmium yellow deep
Vermillion red
Alizarin crimson
Yellow ochre
Raw umber
Prussian blue
Antwerp blue
Manganese blue

Colors I use occasionally are:

Charcoal gray
Davies gray (Grumbacher)
Paynes gray
Hookers green
Warm sepia
Van Dyke brown

COLOR CHART

I suggest preparing a color chart such as the one shown on page 57 in order to familiarize yourself with and test the qualities of your own pigments. Along the edge of the left-hand side of the chart, over a black India ink line, paint each one of your colors in both a heavy and a light wash. Now, in the first column, paint a 50-percent mixture of your first color (here new gamboge) with a 50-percent mixture of every other color in the column. Each color swatch should be the size of a silver dollar. In the second column, paint your next color (here raw sienna) with every other color in the column. Continue doing this until you end up with a chart looking similar to mine, but containing your own colors. By means of this chart, you can now see what your color looks like alone and mixed with each of the other colors.

When your chart is completely dry, tightly cover half of each of the swatches with a paper strip; and wet, then blot off the exposed half, as I have done. Now you can see which colors wipe clean and which ones will stain your paper.

COLOR EXERCISES

If you find yourself using too many colors in your work, I highly recommend the following exercise in discipline: Divide your palette into cool and warm colors. Cool colors are icy and lean toward the blues; warm colors are fiery and lean toward the reds. Now try painting with only three colors: two from one half and one from the other half of your temperature-divided palette. Try to have at least one of a dark value and two of a lighter value—any two. For example, select Winsor blue from the cool side, and burnt sienna and raw sienna from the warm side. When you finish your first painting, choose another combination of three colors for a new painting. Continue this until you exhaust your choices. You will be pleasantly surprised at what a great range of hues are available to you when you select your three colors wisely.

After this, try the same exercise, adding one or two more colors to your original three. Beside being fun to do, this exercise should cure you psychologically of overusing color in the future.

COLOR UNITY

By "color unity" I mean a harmonious color composition that unites the painting, makes it psychologically comfortable to look at, and prevents unnecessary isolation of forms from the rest of the surface. The impact of color on the eye is so strong that it can tear apart a composition and dominate all other qualities. On the other hand, a well-controlled color unity adds balance to your composition and enhances your work. For a harmonious palette, I suggest that you use as few colors as possible for each painting.

HAPPY ACCIDENTS

I encourage accidental effects to happen as freely and naturally as possible. First, I use a watery consistency in my paint and on the wet paper, which means a greater chance for unexpected runs. I also blend my colors on the paper as often as on the palette, a brushful at a time. I often use a flexible painting knife instead of a brush; it prevents a predictable result since it often seems to have a mind of its own. Occasionally I add salt, sand, wax, turpentine, soap, and other special ingredients to my washes to encourage the spontaneous, accidental qualities of watercolor (see Chapter 2).

Because I'm never exactly sure where these accidents will occur, and since I design my composition around them, I find placing preliminary pencil lines on the paper before painting too restrictive. However, I often think out my composition in advance in a quick thumbnail drawing or painting in my sketchbook. These small preliminary drawings clarify my thinking and solidify my plans and ideas. They serve as excellent sources of information and as invaluable supplements to my photographic references, though they reflect the excitement and mood of the moment far better than a photograph ever could. When I combine both photographs and quick sketches for reference material, I seldom fail.

VERY TRANSPARENT COLORS

While most watercolors are transparent to some degree, certain very transparent colors are made of exceptionally fine pigment. You can apply them freely in a single heavy wash, as well as glaze them in several layers on top of dry washes, without the risk of getting muddy results. They spread further on wet paper than the heavier, grainy pigments. You need just a small amount in your mix to get a strong intensity. An example of an exceptionally transparent color is Winsor blue.

FLUCTUATING COLORS

Antwerp blue and Prussian blue are fluctuating colors. They have the unique ability to fade in bright light and come back to full strength when returned to a more normal light. Therefore, if you use these pigments in bright sunlight and they fade too much, don't add more color until you go indoors. Chances are, their value will be correct when the light is dimmer.

GRAINY COLORS

Certain pigments are coarser by nature, and they settle in a granular pattern when applied in a rich wash mixed with plenty of water. These colors also tend to be more opaque than the others when applied in a thick consistency — and they are potential mudmakers. This muddy color may occur not only with just one application of a thick wash, but also when a new wash is applied on top of another dry wash, even in a thin layer. Yellow ochre, manganese blue, and cerulean blue are some examples of grainy colors. (See chart on page 57 for others.)

SEPARATING PIGMENTS

Separating pigments have a tendency to settle independently when mixed, applied together in a single wet wash, and allowed to dry *undisturbed*. The separation is caused by the different physical qualities of each pigment, such as weight. When applied on dry paper, the pigment floats in water, and then the granules settle in collective pools, clinging to each other in clumps. When the water dries, these pigments show a natural texture that varies with the different paper surfaces (smooth, medium, or rough). When applied on shiny, wet paper, some of these colors spread further than others and create a halo of color around the heavier pigment, as, for instance, burnt sienna does around a clump of cerulean blue. Other pigments such as yellow ochre, burnt umber, and sepia, separate when mixed with French ultramarine, cobalt blue, and manganese blue. (See chart on page 57 for others.)

STAINING COLORS

Staining colors are made with synthetic chemical dyes. They're usually the most transparent colors and have the ability to stain the paper, whether applied alone or mixed with other non-staining colors. This means that once they've had time to stain the paper—it takes only a few seconds—they can't be removed. Winsor & Newton sap green and Hookers green; alizarin crimson; Winsor blue, Prussian blue, and phthalo blue; aureolin yellow and new gamboge are all examples of strong staining colors.

I especially like sap green because of its rich green color and its ability to stain even when mixed with another color. A spectacular result follows when you want a contrast of light and dark greens and you use sap green as one of the colors in your wash, let's say, with French ultramarine and burnt sienna. Apply the wash, then allow it to sit at least five to ten seconds, long enough for the green to stain the paper. Then lift or knife off the dark value. The remaining color is a lighter, brilliant green because the stained paper is now green. The beauty of this technique is that it may be done at a later date too, long after the wash has dried. You simply wet the dry paint and proceed to lift it off; the green stain comes through as strong as the day you applied it.

Staining colors, because of their transparent qualities, can be used to recover the appearance of translucency on dry paint, where color unity or muddy colors require correction. If you glaze a diluted staining color over other pigments, it also stains the granules of dry paint as it soaks into the paper. The result is a single glaze of strong color, influencing everything your brush touches. (Don't let sharp edges create distractions; soften them.)

WHITE SPACE

One of the quickest ways to spot a good watercolorist is by the way he uses white space and by the transparency of his darks. Once the extremes are mastered, handling the values in between is easy.

By *white space* or, as it's often called, *negative space,* I mean an essential, strongly related, carefully composed part of a watercolor. I don't like the word *negative* because it implies a lack of something. White space, intelligently used, is anything but that. I always think in terms of white space as I paint. Actually, every time I touch the paper with transparent watercolor, I'm using white space. My brushstrokes are always defining the shape of the neighboring white space at the same time as they define their own. The pure white shapes I leave whenever I paint must be as well balanced as all my other forms.

The surface of a good quality rag paper has an expressive texture and color. When it shows through the paint as a tiny sparkle or emerges around a softly blended vignette, it is itself enriched by the contrast. In other painting media, this white glow must be painted in. In watercolor, it's freely available. All you have to do is use it wisely.

The white paper is also a factor in color harmony. Because white is the most reflective color of all, it's your lightest, brightest value. Therefore, when you paint with transparent watercolors, remember that it's the reflective quality of the white paper that makes your colors bright and clean. Transparent watercolors, when diluted with enough water, permit the light to penetrate them and reflect the white paper below. If transparent watercolor is applied too thickly, its very thickness prevents the light from going through. It ends up looking dull and weak because, unlike opaque watercolor, it can't itself truly reflect light.

WHITE PAINT

White paint is not a good substitute for white paper. It lacks the warm intimacy of the paper. Compared to the other colors, it sticks out and screams for attention. It's opaque when used as a pure white color and does not reflect well enough to be practical as a color. The only possible use of opaque white I find acceptable is when a light, semi-transparent white mixture is designed into the scheme of a particular painting. But, never use opaque white to correct errors. Mistakes can be corrected only in one way — by doing them over.

SPECIAL TECHNIQUES

Watercolor techniques present endless options for the imaginative artist. I'd like to explain in detail some of the most expressive technical approaches that I often use and refer to in these chapters. You'll then have an opportunity to apply them in your paintings for technical variety.

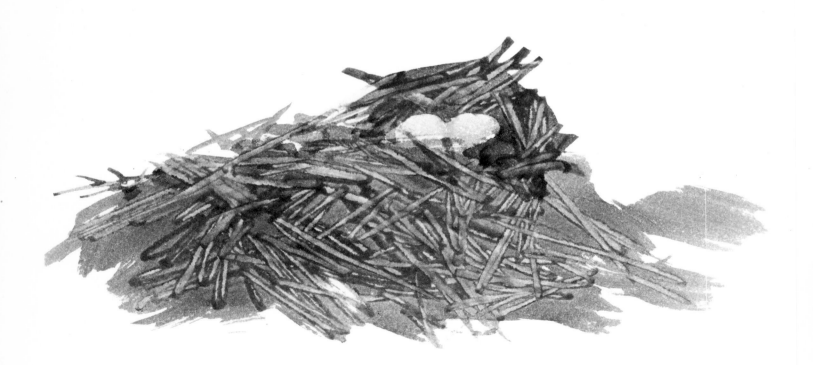

MOISTURE CONTROL

The first word in watercolor is water. Technical excellence in watercolor boils down to one crucial question: How well can you control the combined moisture in your brush and on your paper while you paint? Watercolor behaves differently on wet paper than it does on a dry surface. The amount of water in your brush and on your paper combines to give you results that range anywhere from very soft runs to drybrush.

THE PAPER

On dry paper, you can allow brushstrokes to flow together freely for an effect similar to the wet-in-wet technique (that is, working one wash into another one while the first is still wet), except for the outside edge, which keeps the wash confined to the area where your brush has touched the paper. Because the freshly blending washes present an exciting variety of value and color with soft blends, I suggest that you become familiar with the procedure.

To perfect it, you must overload your soft brush slightly with rich, well-diluted paint to allow the strokes to blend as they touch. To avoid sharp overlaps, don't let edges of individual brushstrokes dry before the next stroke is applied.

The same heavy load of pigment behaves differently on wet paper. As you apply your color on the shiny wet paper, the pigment particles spread further than the exact area that your brush touches. Because of the spreading, your paint thins out and loses strength. The outer edges soften and vanish.

JUDGING PAPER MOISTURE

Occasionally when your painting has passed the drying point when you can no longer softly model it with controlled, even lifting, it's best not to touch it again until it dries completely. When the paint is dry to the touch, you can recover some of the soft, light brushstrokes.

To test your paper, touch it with the back of the second portion of your finger where it's most sensitive to cool temperature and has the least oil on the skin surface. Don't use your fingertip. This is where your hand has the most oil and may create a resist spot. When the paper feels cool to the touch, it still has moisture in it, in spite of how dry the surface may look. When the paper feels the same as your body temperature, it's dry enough to apply new wet washes.

SOFT-HAIR BRUSHES

Each brush holds varying amounts of water, and each releases it to the paper with just a slightly different feel from the others. If you have a favorite brush that is well broken in, does everything right, and performs to your exact command, there's a chance that your habits and the natural qualities of the brush match perfectly. The result is a good, predictable technical control.

Using a soft brush — like sable, camel, and squirrel hair — is common practice in watercolor, but the amount of water and paint in it is a crucial decision you must make each time you touch the painting. These soft-hair brushes hold a lot of water because their flexible hair spreads to retain moisture when you want it to. But always be careful not to overload your brush with too much water when you lift it from the palette.

LIFTING OUT WITH SOFT BRUSHES

Dry paint can be lifted by applying water with a soft brush, loosening the pigment with the back and forth movement of the wet brush. As soon as the pigment is loose enough to float visibly in the freshly added water, blot it off with paper tissue. The result will be a soft, light value where you've lifted the loose paint. The removed paint will be on your tissue. Repeat this until you've removed the right amount of paint.

A more forceful way is, after you've brush-loosened the paint, instead of blotting it, wipe it off with the clean surface of a crumpled-up tissue. Be careful not to use the same spot on the tissue twice, but turn it to a clean surface after each lifting. Otherwise the second stroke on the wet surface will re-transfer some of the lifted paint to the paper, dirtying your painting.

THIRSTY BRUSH

An additional control is possible with these soft brushes on wet paper. If you mix very little water with your paint, your brushstroke won't spread as far on the wet paper. The combined amount of moisture in your brush and on your paper is less than before, and the result is more concentrated color and somewhat better defined form.

If you further reduce the water in your brush to the minimum amount by squeezing the wet ferrule between your thumb and forefinger hard enough to get all the water out of it, you end up with a thirsty, damp brush. It's thirsty because as soon as it touches a wet wash it soaks up some of the surplus water from the surface usually with floating pigment in it. This touch permits you to model softly blended light values out of darker washes before they dry—for example, wisps of clouds or the soft diamond-shaped highlights of rolling waves.

BRISTLE BRUSHES

I often use a firm bristle brush to apply *rich* pigment quickly and efficiently. The behavior of bristle is firmer and springier than soft-haired brushes. It permits me to quickly lift a rich load of paint from the wet top of the semidry blobs of paint on my palette.

A chisel-shaped brush (where ferrule and bristles are slanted) is better than flats. Shorter hair is better than long because the short bristles sit tighter in the handle and hold less water, transferring heavier consistency paint. Don't use thick, opaque, smearing paint even though your bristle brush could transfer it. Rich paint must still be a liquid, not a paste. Often bristle brushstrokes on wet paper show some texture because the firm hair not only transfers the paint, but often is thirsty enough to absorb some of the moisture from the paper.

LIFTING OUT WITH BRISTLE BRUSHES

An even faster lift is possible if you use a firm bristle scrubbing brush. The misty sun shining through fog can be lifted with the continuous circulating movement of a wet bristle brush. You must move the brush until it loosens the dry paint so you can blot it off.

Soft ripples on calm water can also be lifted the same way. You must wet and then scrub small sections connecting them to the desired length, designing their shapes as you proceed. Use the tip of a slightly dampened sable brush because control of shape and direction is important. Your best round brush is well equipped to give you the necessary control.

BLOTTERS AND TISSUES

To get your brush into the proper condition, you must control its water load throughout your painting. For maximum control, I use a bundle of folded absorbent paper towels wrapped in a Handiwipe, or J-Cloth (a cheesecloth in little squares, for washing dishes)—or any material that permits the water to go through into the pad but that won't crumble under repeated wiping with the brush. This pad will soak out the excess water from the brush. If you want to reduce the moisture in your brush without losing the pigment in it, simply touch the damp pad with the neck of your brush.

When you clean your brush on this pad, it soaks out the paint with the water and carries it into the inner mass of the filtering pad. Because the color doesn't stay on the top of the pad but soaks deeper and deeper into it with each brush contact, it keeps a constantly self-cleaning surface.

When your pad is too full of water to absorb more, squeeze it hard with a strong grip. Remove the excess water, flatten out the pad, and it's ready for more punishment. I use these pads for five to ten paintings. I consider them one of my most important tools.

SHARP SCRAPING INSTRUMENTS

The use of a razor blade or any other sharp scraping instrument is effective only if its use is undetectable. The viewer should not be aware of any tool being used. When you're finished, a razor blade mark or other scraping should look like an essential technical part of your painting.

To scrape with the corner of a razor blade gives a sharp, crisp, white hairline. The broad side of a razor blade, held vertically and with firm pressure, gives a bright, drybrush-like sparkle, defining parallel shapes with both its edges. If you want only one edge straight and even, with the sparkle diminished on the other side and not showing the second edge at all, press the blade more heavily on the edge that is to show and release it on the other by lifting the blade slightly. This results in a gradation in the sparkling white dots that your scraping movement creates. You may draw the blade over the same area several times for maximum effect. However, don't move the blade back and forth over the same area; because it fuzzes the sparkle as it drags back the torn paper particles and rubs them back into the pure white dots. Repeat the movement only in the one, original direction.

METAL NAIL CLIPPER

Occasionally you run into a problem in texture where a light and dark, irregular, scattered line effect is desired—when painting loose straw, for example. You need a nonflexible tool with a smooth point that won't cut the paper. The chrome-covered, rounded-handle tip of a common nail clipper is my favorite tool here.

First I paint rich pigment onto dry paper on a small enough area that it can be textured in a couple of minutes—around 6–8 square inches (15–20 sq. cm). I like to use a bristle brush. It works fast with rich paint and leaves an irregular edge that makes it easier to fit the next wash to it without showing a sharp joining edge. They hook together like a loose jigsaw puzzle. I vigorously move the nail clipper back and forth into the wet brushstroke imitating the crisscrossed direction of straw. At first these lines look dark, because where the metal has damaged the paper the water soaks in paint faster than on the plain surface. These little dark lines act as filters, trapping the paint and letting the water through.

When the paper blots up the excess water, the lines start to turn lighter as you keep moving the metal tip without stopping. The combination of light and dark lines, together with the untouched spaces between them, will give the illusion of three dimensions. For best results, use a medium value in your wash. This way, light and dark show equal importance.

MASKING

Because of the transparent nature of watercolor, you can't paint light color over dark and expect color purity and transparency to survive. You must have white paper or a light color behind the painted area in order for it to look bright and clean.

When you know that you need light, well-defined shapes surrounded with other usually darker washes, a quick solution is to mask them out. Anything that will block out the paint from the paper is masking material.

For straight edges, masking tape or cellophane tape does a good job. You can also cut these tapes to a limited degree.

Rubber cement, because it's a liquid, also masks with a fair degree of coverage. But in places it permits the paint to go through, creating little drybrush spots. For a loose, uncontrolled result, use it, but you can't be sure of absolute coverage.

SALT

The use of salt sprinkled into a wet wash is very helpful for getting certain interesting effects in watercolor, for example, starlike shapes that imitate falling snow. The little sparkles of salt can also add to the effect of foaming water splashes, snow, and tiny flowers. Salt can also indicate a blowing blizzard—just tilt your painting so the water flows in the direction of the wind.

If you use strong staining color in your mix and allow it to stain your paper before you use the salt, it creates colored crystal shapes like flowers. The salt works only on the nonstaining pigments on top of the paper. The stained lighter paper dominates the crystal shapes.

The timing of salt application is crucial. When you sprinkle salt into wet paint, the granules will create little, light, crystal-like backruns. The shapes are as large as the amount the salt grain can melt in the wet paint. The wetter the paint, the larger the light spots. The drier the damp paint is, the smaller the snowflake shapes, until the paint reaches the point where it doesn't have enough water to melt the salt, and stops working. Once your salt is on the wet paint, leave the surface horizontal to prevent the water from flowing in any direction, since the melting salt shapes would run with the flowing water.

Salt won't react on pigment that has previously dried and is rewetted a second time. For best results the pigment must flow freely in the freshly painted wash. Experiment with the timing on small pieces of paper. Be careful not to put too much salt on. The little star shapes take a few minutes to start shaping; they don't form immediately. Try not to disturb your paper during this period, but apply the principle of the watched kettle and walk away from it.

The variety of salt effects is great but it can be an overdemanding gimmick if you use it all the time. Furthermore, all these technical hints won't work on poor-quality paper or with cheap paint. They're simple to use, but first you must become familiar with their behavior. They must always remain a complement to well-disciplined skill. Intelligent use of modern materials is one thing. To be trapped in the world of gimmickry, without the selective discipline of a creative artist, is another.

APPLYING LIQUID LATEX

Liquid latex is sold to artists under trade names like Miskit and Maskoid, to name a few. To mask out any shape so you can paint over and around it freely, you paint on the latex over the exact shape you wish to cover. Since it contains a coloring that renders it visible on the paper, you always know where you've placed it. The liquid latex dries into a tough, flexible film that completely blocks out moisture.

Since you're actually painting negative (white) forms on your finished painting when you put on the latex, use your best brush to do it. To protect your brush from the latex, which clings not only to paper but to the hair of your brush as well, rub it onto a wet bar of soap before dipping it onto the latex. Use any soap; just make sure that the ferrule and hairs of the brush are completely coated. If the latex dries on a brush unprotected by soap, the brush will be ruined. But latex does not stick to soap.

Right after use, rinse your brush in warm water to remove the latex while it's still liquid. Repeat the rinsing with soap and warm water to make doubly sure that all the latex has been removed. When the liquid dries into film, it repels watercolor. Paint over and around it as if the latex were not there at all. When finished, let the painting dry. Never attempt to remove latex from even a damp surface; it must be bone dry.

To remove the latex film, there's a better method than rubbing it off. In rubbing, sometimes the dry paint will rub into the white masked-out area, soiling the clean white paper. Use a strip of masking tape instead. Lay it lightly on the latex-covered area. Rub it gently and lift it. The latex will stick to the tape's sticky side and will come off with it. Repeat this until all the latex has been removed. Now the white paper is ready for more paint.

Like the other techniques I've mentioned, this works only on the hard surface of good-quality, pure rag paper. Rubber cement or latex tears pulp paper every time you try to remove it. When you pull up the masking tape, let it roll back flat against the paper, *not* at a steep angle.

Because liquid latex is dissolved in a solution, part of which is water, don't apply it on a painted area. During the drying process, the water in the solution will partly dissolve the paint and it will stick to the latex after it dries. As you peel it off, some of the color will come with it, changing the value of your colors drastically.

BACKRUNS

Backruns are those little, unpredictable, fungi-shaped hard edges that creep into your clear washes when you least expect them, unless you learn to prevent or control them. When your wet wash is in the process of drying, it's especially sensitive to extra moisture. During drying, the paper buckles and domes, the amount depending on its quality and thickness. As your paper buckles, more water flows down off the high spots and accumulates in the low spots. Excess water also collects in pools on the edge of your paper. If you don't remove it by touching it with an absorbent tissue or a thirsty brush, you reach a point where the high spots are completely dry and the low spots still wet. In between the two, the drying is irregular and the excess water tries to creep back through the damp edge into the dry and stops in an irregular, sharp edge. When this happens, allow all of it to dry and remove it at the edges with tiny wet-and-blot touches.

It takes a lot of skill to remove a backrun without a trace, and it's impossible with staining colors. It's much easier to prevent it by wiping off the surplus pooling water before it does the damage.

Backrun effects don't have to be mistakes. They'll work for you if you control them. The timing of the successfully controlled backrun is just after the wet shine has turned dull. At this time, the pigment is still loose and wet enough to attract moisture. When you drop extra water or wet pigment into this drying paint, the newly added water further dilutes the damp paint and starts to flow freely, again accumulating in hard, irregular, lichenlike abstract shapes around the edges of the newly moistened spots. This extra water can be applied as droplets of water, as large blobs of water of light color, or as a direction-controlled line with or without pigment in your wet brush. The variety of applications is endless.

WAX

Paraffin wax is another good method of masking. It is inferior to latex in one respect: You have to apply hard pressure to a solid stick of wax which crumbles slightly and can't give clean edges and slick definition as latex can. However, it has one advantage: It can be applied on dry paint without harming or changing the original modeling. In fact, you can apply it several times as partial resist cover on new layers of dried glazes. Wax masking is loose, semidefined, and gives good textures for moss, algae, stone surfaces, lichens, and the like.

The procedure is as follows: Break off a piece of hard paraffin wax. Shape it with a knife to the desired shape. Rub with hard pressure to the dry surface of your paper until you have enough wax on to repel water. Paraffin is transparent and is hard to see on the surface. Lift the paper to your eye level to see it shine. The edges will be rough and loose. For strong coverage, pile on lots of wax with hard rubbing on the inner arc. For partial cover, rub lightly. Paint on your wash, ignoring the waxed surface. Where the paint touches the paper, it will adhere to it, but on the waxy surface it will bead. You can repeat the light waxing after each glaze has dried, partly covering more and more of the previously exposed paper, resulting in an abstract design in several values.

After you're finished, you have to remove the wax. You need lots of the most absorbent-type paper tissues and a hot iron. Lay down several sheets of tissue over the wax on the cold surface. Press your hot iron to these tissues for a few seconds. As the wax melts toward the heat side, the tissue will absorb it. If you're quick, the wax won't go into the colder paper underneath, but will soak up into the more porous, more absorbent tissue. Lift off the wax-soaked tissue and dispose of it. Cool the painting and the wax on it and repeat the procedure until there's no more wax left to soak into the tissue. When your tissue stays dry after ironing, you've removed all the wax. The wax can be removed so well that you may even paint more onto the previously wax-covered area.

If you have a slight problem painting over a waxy area, brush a little soap into the paint to make it adhere. White crayon is easier to see than paraffin, but harder to remove. Usually some of it will remain on the painting. Try to remove as much of the wax as possible to allow your paint and paper to breathe.

TREES AND SHRUBS

It's not necessary for an artist to be able to scientifically categorize all the varieties of trees living on earth. However, knowledge of their visual characteristics is essential for the landscape painter. In this chapter I will talk about deciduous trees, evergreens, tropical trees, and shrubs.

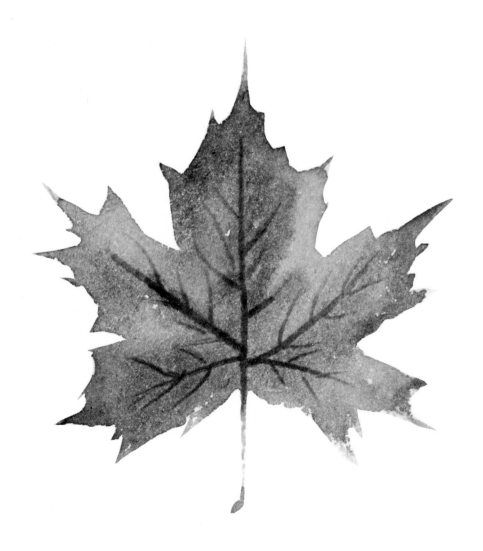

SPRING

The most important thing to remember about deciduous trees is that they shed their foliage each year. This process makes them ideal as representatives of each of the four seasons.

In springtime, tender, delicate hues appear on the trees. First there are the bursting buds, then the flowers, and later the young leaves. Their small size makes the forest appear translucent, but definitely under the color influence of young growth. Cadmium lemon yellow, new gamboge, and cerulean blue are good colors to represent these effects.

SUMMER

During the summer months, deciduous trees are heavy with lush foliage. Their branches are spread wide under tons of healthy leaves, and their color is a dark, rich green. Around August, just before fall, their green color mellows and becomes a little browner. Fruits such as apricots and cherries start to grow on some trees and ripen, adding touches of color for the painter. Groups of trees create a dark green glow under their foliage as they filter out the sunlight, particularly in a dense forest. I suggest using several combinations of blues, greens, and browns to paint this.

One of my favorite summer foliage colors is Winsor & Newton sap green. It's a staining color and lends itself beautifully to knifework, even if it's well mixed with other colors. The two Hookers greens — light and dark — behave similarly.

AUTUMN

Autumn is the season when deciduous trees really become colorful, their foliage varying from golden yellow, through rich reds and maroons, to browns. The trees glowing in the forest display the particular hue that their specie offers: birches and poplars are yellow, maples are red or yellow, and so on. On distant mountains, their colors can appear strongly mauve, particularly when lit by the sun. My favorite fall foliage pigments are burnt sienna, raw sienna, new gamboge, brown madder, and vermillion or cadmium red.

AUTUMN LEAVES

Fallen leaves in an autumn forest act like a colorful carpet. Don't paint them individually in a mass, but paint their effect instead. Brush on two or three large strokes of rich paint and knife light leaflike shapes into them. Continue doing this until you've covered the desired area. To clarify the meaning of this carpet of leaves for the viewer, carefully paint one or two specimens in the foreground so the hint of texture in the background is accepted more readily.

Leaves alone may be the subject of a painting, though in that case they must be carefully drawn. I usually cheat a little and carry a few nice ones into my studio, where I can paint their details more carefully.

WINTER

In late fall, when deciduous trees drop their foliage, their branches stand out in a linear pattern, exposing the structure of the tree. The many fine twigs at the end of the branches blend into a soft gray tone unless the tree is close enough to show more detail. The forest is no longer dark, because the filtering foliage is gone. Because of the subtle grays that dominate, any touch of bright color — such as that of a few leaves still clinging to the bare branches—can help a composition.

In winter, the forest takes on the mood and color of the day. On a sunny day it glows in a warm gray hue; on an overcast day it appears a little more neutral. Burnt sienna and French ultramarine are my favorite combinations for mixing gray. Mixed half and half, they form a perfect neutral, while just an extra touch of either color will make the gray warmer or cooler, depending on which is used in greater strength.

The mood of winter landscapes depends to a large extent on the effect of the distant, bare trees. To indicate their delicate lacy tone, I often use a wet-in-wet technique, adding some negative painting-knife definition while the paint is still damp. Using a split drybrush technique you can paint these twigs by touching the brush down at the outside edge of the tree and quickly pulling and lifting it toward the larger branch. I put the last few details on with a small brush when the wash has dried.

When snow is on the ground, tree trunks pick up its strong reflection at the extreme edge of their shaded side. This glow can be painted lighter, wiped back with a thirsty brush, or knifed out.

EVERGREENS

Coniferous trees or evergreens have needles instead of leaves. They keep them all year around, though their color changes subtly with the season. This is most obvious when the light green new growth arrives in the spring. Evergreens seen at a distance show as soft, blurred silhouettes and are most easily painted with a wet-in-wet technique.

PINES

Closer specimens of evergreens show structure. Their dark trunks and branches are exposed against the light background or inner foliage of the forest. Their branches have a light and a dark side and, when placed beside soft forms, expose needled edges. A flick of a split, drybrush stroke complements the soft edges on the dried surface and suggests texture.

Pine trees expose their heavy branches with an elbow-like bend near their trunk. Their trunks are gnarled and scarred where branches have broken off, and their bark is coarse and boldly textured.

I find a painting knife the most responsive tool for painting the rugged nature of these evergreen branches. If you use a brush, you must move it vigorously to show firm, strong limbs, not limp ones. If you use a knife, time the strokes carefully, working them not while your paint is still very wet, but just as it loses its shine, making sure that the paint doesn't seep back into the light, knifed-out shapes.

SPRUCE

Spruce branches on old trees are tight and furry, exposing fewer branches and less of the trunk. Young spruce branches are a fresh green and stand upright from the trunk, unlike the droopy, downward-slanting, heavier adult trees. I paint the young twigs with little moisture in my brushstrokes on damp (not shiny wet) paper. The fuzzy edges can be timed to look round and soft just like fur.

THE FOREST

A forest may be either entirely of deciduous or evergreen (coniferous), or a combination of the two. The mood, colors, and values with the forest vary with the type of trees within and the season.

The forests covering the mountainside often contain deciduous trees. The changing color of deciduous trees from season to season dominates the color and texture of mountainsides. The color of the mountains changes with distance, too. For example, the fresh, yellow-green hint of spring buds looks a clean, pale blue; a summer green appears deep blue; autumn red appears purple; and in the winter, bare warm-gray trees seem blue-gray in the distance. Frequently, these colorful slopes are sprinkled with the dark-green patches and accents of evergreen trees. Don't isolate these patches. Design them into your composition so the contrast of their darker values doesn't disrupt the total effect of the mountain.

A forest always has one quality — depth. The values deep within the forest are, of course, darker than those at the edge. Define the shapes and texture of these outside trees more carefully, making your edges blurrier and looser for the inner ones, until you're no longer painting trees, just deep forms. A forest with foliage looks mysterious and exciting — the color of the foliage is dominant. For instance, green foliage creates a green glow, a golden yellow umbrella of leaves makes you feel as though you're walking inside a light bulb, and so on. To reproduce this quality, stain your paper with the desired color before you start painting. This means that white paper won't show anywhere after you glaze.

SHRUBS AND UNDERGROWTH

Many of the shrubs in a forest are really small trees, but their numerous leaves dominate thin, woody branches instead of a wide trunk. The heavy forest undergrowth also consists of weeds and small plants. Paint these shrubs only as a pattern of shapes, unless they form your center of interest and thus assume a greater importance. Pay attention to accidental detail in spots instead of overworking the entire pattern.

TREE TRUNKS

Tree trunks must look strong, solid, and three-dimensional, but transparent enough to show the texture of their bark. I usually model the coarse surfaces of adult trees with my painting knife or the tip of a pocketknife.

The color and texture of the trunks of younger trees, though similar to older ones, is more subtle. For trees with a light bark, such as birch or sycamore, I advise you to pay extra attention to light values and transparency. In other words, use well-diluted paint and allow some of the paper's white sparkle to survive.

When snow is on the ground, tree trunks always pick up its strong reflection at the extreme edge of their shaded side. This glow can be painted light, wiped back with a thirsty brush, or knifed out.

THE TAMARACK TREE

I must point out a very unusual tree — the tamarack. This elegant, soft-furred tree looks like an evergreen, but sheds its needles in the fall a couple of weeks after the deciduous trees. However, it turns a golden yellow first, adding one last touch of color to the gray forest. This color can be painted with new gamboge, raw sienna, and raw umber, mixed in a combination of your choice. I use lots of new gamboge in the mix.

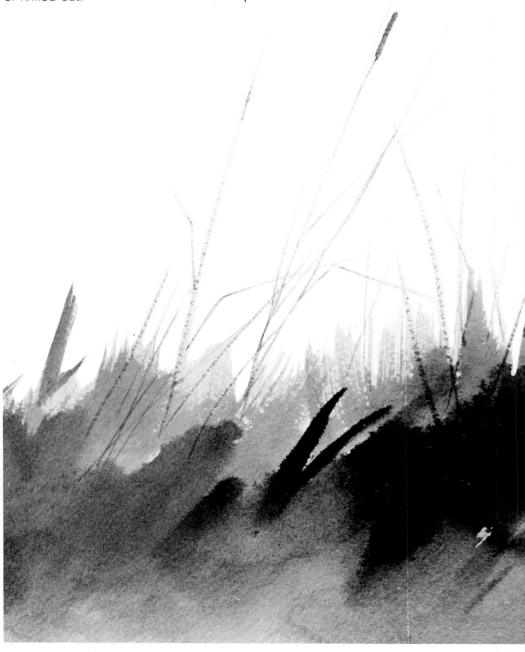

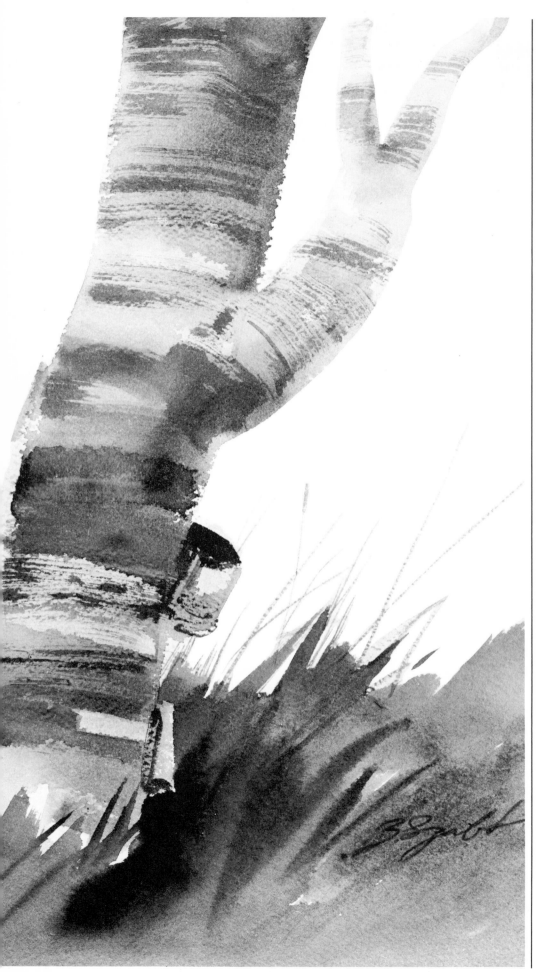

PALM TREES

Palm trees are characteristically equipped with heavy trunks to which growth rings are added every year. To paint them, first paint a gray cylindrical shape, one side light and the other shaded, by dipping one side of your brush into light paint and the other into the same color in a darker value, and running the brush down the length of the tree trunk. While the wash is still wet, you can knife out the growth rings from the trunk with horizontal strokes of your palette knife.

A firmly loaded (but not too wet) flat, soft brush can produce an equally good result. For this technique, you also double-load your brush with dark color on one side and light on the other. But this time when you paint the trunk from the top down, you start and stop at each growth ring without lifting your brush.

I like to establish the characteristic shapes of palm branches and their split-leaf structure with drybrush-flicked strokes of a flat, soft brush. These brushstrokes must identify the structure of the particular type of palm I'm painting. Light leaves are knifed out from this darker silhouette shape to add texture and accent.

OTHER TROPICAL PLANTS

Banana plants and tropical vines are similar in appearance to and often accompany palm trees. One good way to paint their shape is with a dark silhouette wash. If you use Winsor & Newton sap green or Hookers green light in your mix with a darker blue (French ultramarine or Antwerp blue) you can carefully recover the light green values by scratching them out with a painting knife.

GRASS, WEEDS AND FLOWERS

Weeds are abundant, insignificant-looking vegetation whose beauty is little appreciated and whose usefulness is often ignored. Their variety is infinite and changes drastically from season to season and from climate to climate.

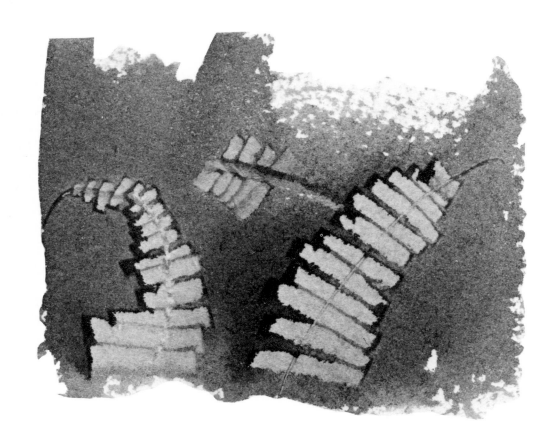

CUT GRASS

Grasses come in many varieties, but to a painter, only the visual differences matter. Fertilized, healthy grass must be painted to emphasize its even, carpetlike surface, using lots of clean color with drybrush modeling to show texture.

SUMMER GRASS OR HAY

When grass is not trimmed or if it grows wild, its height differs and its color varies as different species mingle. Summer grass is healthy, lush, and green, sometimes rolling in waves when the wind blows. It's best to model this effect with watercolor by first using a wet-in-wet technique for the more distant areas. For grass up close, start with a wet-in-wet approach, but then add crisper definition as you move into the foreground.

AUTUMN GRASS

When autumn comes to the more northern parts of the landscape, grasses ripen and turn brown-green and later dry to a rich yellowish color. This warm glow isn't just one yellow. Paint it as you see it in a variety of hues ranging from new gamboge or cadmium yellows, through yellow ochre or raw sienna, to raw umber and burnt sienna. *Never use just one color.*

GRAIN FIELDS

Grain fields on farmlands are more even than grass and tend to show the prevailing wind by pointing in its direction. They also wave like rippliing water when the breeze blows.

WEEDS IN MASS

Grassy fields in their natural environment are always sprinkled with weeds. They vary in size and anatomy not only from the grass, but from each other as well. In mass, weeds blend with the neighboring undergrowth, though at times showing some difference in color or texture. This variety offers an opportunity for you to introduce interest and harmonious and complementary design elements into your composition.

INDIVIDUAL WEEDS

Up close, the same weeds take on a much more important role. They become individual design elements with a personality all their own and may even become the center of interest in a painting. To get to know these delicate little plants, I make studies of them and often paint them in my studio. In this way, I prepare myself for the ultimate experience of on-location painting. The careful study of a milkweed pod leads to a better painting of a field where milkweeds grow. The soft head of a cattail or bulrush, and its brittle leaves and stem, are easier to interpret outdoors if you've painted a few of them in your studio first. Their charm is infinite, particularly if you consider the other life that clings to them, such as cobwebs, insects, etc.

SEEDING WEEDS

Weeds put on a special parade when they're seeding. Many have fine, soft, umbrella-like flying mechanisms that allow the seedlings to spread in the wind when released by the mother plant. Their brittle stems and drying leaves are tacked in between soft puffy masses of cottonlike seeds, challenging a painter to design them with every brushstroke. The subtleties of color and contrast cannot be overemphasized, and demand perfection of technique and brush control. A wet-in-wet approach combined with lost-and-found additional soft details is most effective.

INFLUENCE OF WEATHER

The influence of weather on grass and weeds adds another touch of interest and variety. A weed with dewdrops on its leaves presents a totally different problem from one flooded with sunlight against the shaded side of a tree trunk. The same weed, covered with a thick coat of ice after a freezing rain or with a furry jacket of hoarfrost, again has a totally different story to tell. Always consider weather conditions when you're painting grass and weeds.

FERNS

There are many varieties of ferns, and they're all decorative in appearance. To paint their brilliant green color against a dark contrasting background, mix Winsor & Newton sap green or either of the Hookers greens (light or dark) with French ultramarine and/or burnt sienna or cerulean blue or warm sepia, and apply the dark wash first. While the paint is still damp but is just losing its shine, knife out the shape of the fern, applying even pressure with the dull tip of a pocketknife. Because the bright green pigment in your dark wash has already stained the paper, wherever you've knifed out the dark colors a bright green shines through with contrasting brilliance. This technique can also be applied to other grass and weed details using any of the staining colors you wish to dominate the knifed-out values.

LICHEN AND MOSS

All the previous suggestions for painting weeds apply to lichen and moss, with one important exception. Their shape and size is very different from other weeds. They usually grow in patches and their low, well-textured surfaces contrast with the surrounding species. I prefer to paint them with a drybrush and wax technique. (For details of these techniques, see Chapter 2. For information on painting lichens and moss on rocks, see Chapter 5.)

SPANISH MOSS

Spanish moss, a nostalgic part of the southern landscape, hangs from trees in the deep South. Its light gray color blends well with and is influenced by the color of its surroundings. Its delicate softness is best painted with a drybrush technique.

VINES

Vines and other weeds too numerous to list, particularly·in tropical landscapes, are painted with many of the techniques already discussed in this chapter. Again, I suggest whenever you're painting a new environment that you first familiarize yourself with the characteristics of its weeds and plants. Make a few studies of them in your sketchbook before including them in a composition. These studies are not only invaluable, but also serve as a permanent source of reference.

FLOWERS

Painting flowers mean using pure color. You must analyze their colors first and choose the simplest, most appropriate palette possible. Because of the importance of color in painting flowers, there is a real danger of garish results. Their overwhelming beauty doesn't excuse a lack of close attention to light and dark values. On the contrary, it demands flawless value judgment.

Occasionally I like to emphasize the shape or shapes of individual flowers, while at the same time maintaining my freedom to paint a loose background. A good solution is in the use of masking, as described in Chapter 2, to cover up the floral shapes while the background can be painted freely over them. The location and design of these shapes must relate to the total compositional structure of the painting or they look too sharp and artificial and divide the painting into a loose and a tight style. When you apply the latex, keep the silhouette of the flowers as interesting and well-defined as your skill permits. When you remove the latex, you won't want to discover sloppy, coarse edges as you start to model the floral details.

Avoid dark pencil marks or, heaven forbid, charcoal. Your washes must stop cleanly where the petals stop. Dark outlines either glare through the bright color, or mix with and soil your wash.

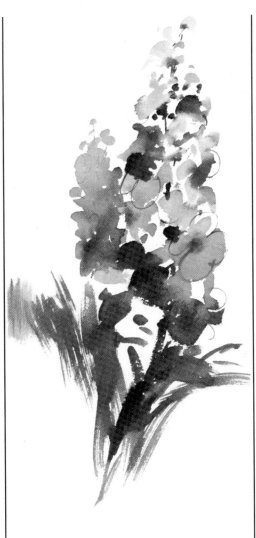

GARDEN PLANTS

When you analyze the color impact of well-developed, cultivated plants, try to choose one that serves as a unifying color; the most obvious hue, so to speak. Paint a freely flowing, semi-abstract glaze over your paper with a light wash of this color. Then paint the rest of your composition onto the glazed surface either while it is wet or after it dries. Your design and contrasting forms can be strong to help the impact of color. Background, light condition, contrast, stem and leaf structure, and nearby objects are but a few elements that help your composition because they're readily available.

Needless to say, the botanical structure of flowers, however freely and imaginatively you paint them, must be true to the species. For example, you'd never paint thorns on a violet.

FLOWERS IN MASS

Wherever flowers appear in mass, their strong colors unite. Colors of individual blooms only play a secondary role to the colors of the flowers as a whole, and should only be defined individually at close range. The shape of floral groupings must be treated as an essential part of the design. As abstract as their shapes seem, their relationship to each other and their surroundings, as a negative or positive value, must feel comfortable and instinctively correct in your composition. Don't be afraid to change these ·shapes or move them around for the sake of a good design. I suggest that you make a few thumbnail sketches first before you proceed with a larger painting.

FLOWERING BUSHES

Individual blooms on flowering bushes can be treated similarly to a garden plant. However, when bushes are loaded with blossoms, the approach to painting them differs drastically. The shape of the bush gives them a form, and the blossoms supply their color.

A good way to paint them is to first paint your background on wet paper, leaving the silhouette of the trees as a soft edge. As the paper is drying, just after it's lost its shine, put on new droplets of clean water, or in the case of colored trees, add slightly colored droplets around the edge and to the inner structure of the loaded branches. The newly introduced moisture will create small backruns that look like clusters of flowers. Connect some of these backruns in a free and irregular way. After this wash has dried completely, paint in the branch structure.

WATER FLOWERS

Water flowers are seldom painted successfully. The most common mistake that artists make is that they're too literal. A harmonious relationship between the contrasting flowers, the reflection beside them, and the transparent but darker underwater structure must be maintained.

Wind direction not only changes the reflective quality of the water, but changes the angle and shape of the floating leaves and blossoms next to it. Also, water plants usually grow in clusters, and their perspective must be consistent. The style of your painting will determine just how much you want to interpret rather than slavishly detail. But again it's better to err on the side of greater design. Paint your impressions, rather than making photographs with a brush.

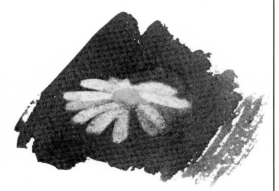

WILDFLOWERS

Wildflowers usually have a more humble and subtle impact on a painting than other flowers, especially if they're there only to complement the center of interest and provide scale. When you move in for a closeup of a wildflower, let the nature of the particular specie dominate the mood of your painting; for example, the softness of an edelweiss, the fragility of a limp, delicate poppy, or the dainty, minute proportions of snowdrops. Carefully observe your own mood at the moment you spot these little subjects. The spark that originally triggered your interest should determine your creative approach.

PAST-PRIME FLOWERS

While most painters like to paint healthy, fresh flowers, occasionally I like to reach for the nostalgic touch of flowers past their prime. While an artist cannot paint the passage of time with a brush, a withering flower can imply it. Because we're usually more familiar with healthy blooms, I like to paint studies of dying flowers. These studies are invaluable because they permit me to correct an outdoor painting or to use them for a fresh studio painting. And I love flowers in this condition because their color is more muted and they are less likely to scream for attention. Even the most colorful, proud blossom becomes quiet and diffused after it's past its peak.

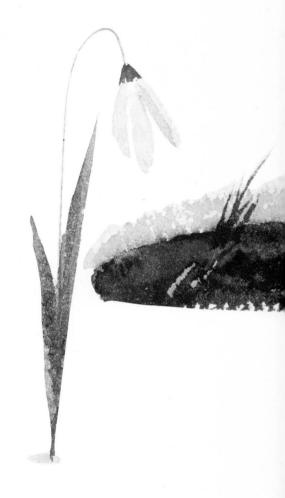

ROCKS SOIL AND MOUNTAINS

To understand the reason behind the formation of the rocky areas on the surface of our earth, we must look to geology. For the artist, it's not important to get too involved with scientific research, but careful observation combined with a little research is a helpful approach.

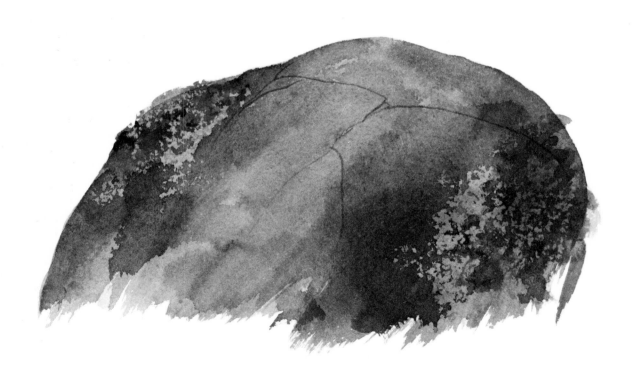

FORMATION OF THE EARTH'S SURFACE

The origin of all rocks started with the cooling off of the earth's crust. This process has taken virtually billions of years and is still going on wherever there is volcanic activity. As the molten liquid was cooling, it shrank and moved, creating fantastic pressures that rolled, compressed,and bulged enormous amounts of massive formations, creating mountains and valleys.

When this cooling period had reached a point where water vapors would stay on the earth's crust as a liquid, water joined the slow but persistent process of erosion. The severe temperature changes in the atmosphere, the extreme heat fluctuating with hard cold, along with the constant wind, forced further erosion. Throughout the history of our planet, other forces have also influenced these geological changes. During the ice ages, incredible volumes of glaciers moved over the area that is now dry land, grinding and carving the earth in its path. It carried broken-off chunks of mountains, depositing them thousands of miles away after the ice started to melt. The results of these and other geological forces are visible on the rock formations exposed today.

ANGULAR ROCKS

Angular rocks that show sharp squarish edges are usually hard and/or brittle types; for example, granite, quartz, and coal. To paint them you must define their light and shaded sides, letting the reflected light reveal detail on their dark sides. The direction of these angular edges, combined with the splits and cracks, are excellent design elements. Take advantage of them as you paint, making sure their designs complement your composition. Their color, variety, texture, as well as their contrasting value, can be richly modeled with a painting knife as well as a brush. The sharp, straight edge of the knife naturally lends itself to modeling angular shapes.

If you paint units of these rocks in a dark value, you can knife out the light sides of the stone by applying extreme pressure with the knife, squeezing away all paint in its path. The speed of the knife must also be even. When you stop, stop sharply and lift the knife without hesitation to get clean, straight edges. You may repeat this knifing procedure two or three times back and forth, providing you hold your knife on a very low angle, permitting it to slip on top of the wet paper and squeeze-dry the surface instead of tearing it.

GLACIAL ROCKS

Glacial rocks are characteristically rounded on the surface. Their type and composition varies infinitely, but their rounded, ground-off surface gives them away. Their texture is weather-beaten and pockmarked.

One way I paint them is by applying a general wash on their surface in order to define the light and dark values. After it dries, I add some drybrush modeling, or more often, particularly on smaller specimens, I knife off the top surface where the stone is lighter, exposing the light transparent side with an even pressure on the knife. To do this, I hold the palette knife so its soft tip points to the shaded lower part of the stone, and its firm knobby part (near the handle, where the pressure is strongest) defines the light edges of the stone. In appearance this grip is similar to a left-handed person writing. This seemingly awkward technique is very quick and extremely effective.

Some mottled effects on rocks caused by the presence of lichen or moss can be painted very effectively with an ordinary synthetic household sponge. You may either dip the sponge into liquid paint and press it on the dry surface of the rock, or press the clean, thirsty, damp sponge onto the painted surface just at the time that the shine has left the drying pigment. This light touch leaves the impression of the sponge texture by lifting off the paint. Wax, salt, and sand applied to the wet paint are also useful techniques and are discussed at greater length in Chapter 2 ("Special Techniques"). Additional information on painting moss and lichen on rocks appears in Chapter 3 ("Trees and Shrubs").

SMALL STONES AND GRAVEL

Small stones and gravel are the most common type of stone we paint. They occur everywhere and are an essential part of the foreground. Drybrush combined with splatter are effective techniques for painting them. However, irregular knifing into the still-wet pigment applied in the manner previously described for angular rocks adds to the brittle definition of the larger pebbles.

ROCKS IN GRASS

At this point I would like to solve a problem commonly faced by painters. If any of the rocks you're painting are nesting in grass, you have to allow for the light blades of grass by painting the dark, shadowed, bottom edge of the rock with a quick drybrush stroke. This will look like the dark space you see between blades of grass. When dry, you then paint the light grass color over the still-exposed white sections of paper. This way the rock, or any solid object, appears to sit in the grass, not on it, as it would seem if the bottom were painted sharply and straight across.

STONE QUARRIES

Stone quarries can be painted by a technique similar to that used for angular rocks, but some trees, machinery, or other familiar objects could be included in the composition to indicate the relative proportions of the quarry.

LIMESTONE FORMATIONS AND BUTTES

Finally I would like to discuss a few unusual types of rock. Their most obvious characteristics are their color and relative softness. Protruding limestone formations, with their off-white, yellowish (light raw sienna) coloring, and the typical monumental statuelike red buttes in the American deserts are special treats for painters. These eroded sculpturelike formations totally dominate their environment because of their magnificent size, usually contrasting with gentle plateaus. Their surface is rather crumbly at the bottom slopes and is rounded and eroded at the top from the wind. Their layered effect also adds to the harmonious structure of the scene.

To paint these magnificent freaks of nature, I never treat these buttes as individual shapes but instead knife my overall impression of them into the wet wash. The amount of attention I pay to a mountain or a hill depends on its distance and its aesthetic relationship to the rest of the painting.

For the colors of limestone, I use raw sienna, yellow ochre, and/or cerulean blue in a light value. For the red buttes of the desert, I use brown madder, burnt sienna, or light red.(These are, of course, all Winsor & Newton colors.)

MANMADE RUTS

Man has also contributed to the changing evolution of the earth's surface. These artificially created rock cuts are visible where construction or industrial work carved them away. Their manmade nature is usually given away by their relative newness. Natural changes can take millions of years, but man has had the necessary technology to carve and blast rock only for an historically short time. These new rock cuts are shaped with geometric simplicity for the convenience of the engineers. The beauty of the surface is still the natural color and form, with some aging shown by texture or by the amount of vegetation growing on them.

PLOWED FIELD

Any cultivated soil has a geometric shape and linear pattern that must be designed to complement your composition. When working with large masses, such as the vast farms of the prairies and the midwest, you need to create some relief in your design from their potential monotony. The following are just a few ways of adding interest to a scene: a distant clump of trees; a few fence posts; strong perspective effects, showing large lumps of earth up close; the change of direction of the linear plowed pattern; and the addition of windmills and farm structures. Cultivated fields seldom can be painted as a center of interest, but they do serve as great complements.

MUD

After rain, the dry soil turns to mud. Water makes the soil appear darker, adding a shiny contrast where reflections make it glitter. Dark value and drybrush sparkle is typical of the nature of mud, and you should paint it this way.

LAVA

Wherever there is volcanic activity, you can find lava formations. Lava comes to the surface of the earth from the erupting volcanoes in the form of ash-like cinders or as a flowing liquid that cools and solidifies very much like flowing mud. One well-known location for new lava is Hawaii, where volcanic eruptions are common. But you can also find lava rocks in parts of Idaho, California, Arizona, and several other states. Lava rocks are porous and dark brown or blackish in color. Their desolate mass is influenced by the color of the sky and should be painted that way.

Their jagged texture is a natural training ground for palette-knife work. I usually apply sepia, burnt sienna, French ultramarine, and Antwerp blue in various combinations, starting wtih a dark wash containing little water. I model the lighter values by knifing them out with a palette knife.

SOIL

Nature doesn't always cover the soil with vegetation. When man cultivates the land, he reveals the natural color and texture of the soil while plowing. Also, the elements, such as wind, water, and temperature, constantly influence the soft granular surface of the earth. Thus, by both artificial and natural means, soil is often exposed as a visual part of our landscape.

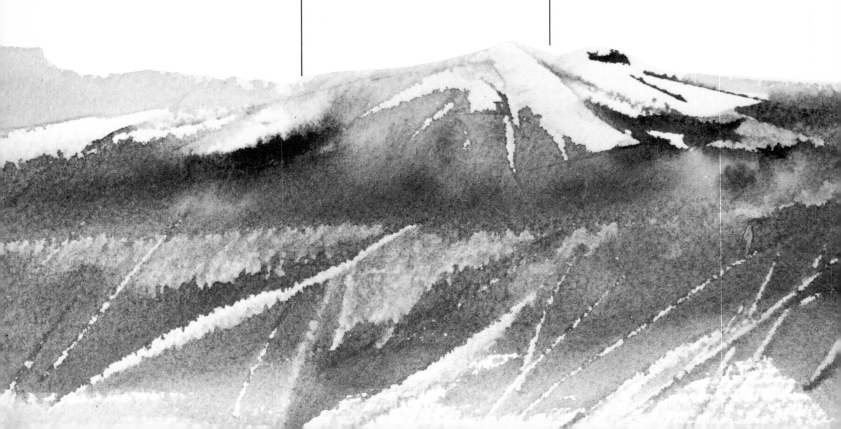

EROSION

After fast floods caused by heavy rains or melting snow, the soil shows signs of erosion where it crumbles and collapses, exposing ruts or cavities, particularly on hills. To paint these spectacular forms, analyze the contrast and the newly exposed details such as roots, boulders, etc. These often have exciting color qualities, such as the red soil in Oklahoma or the rich black top soil in northern Ontario. A closeup study, with the subtle details, offers beautiful subject matter for a center of interest.

I must warn you of another danger for the watercolorist. Because you're dealing with dark pigments, it's easy to slip into opacity and end up with a dull, uninteresting, colorless wash. Keep your pigments liquid and transparent. Don't glaze with potentially opaque colors. This can build up opaque paint even though each layer you have applied was transparent at the time.

If you must glaze, use a transparent color. You can achieve the best results with just one application of correctly judged dark wash rather than from a series of layered washes. This single layer can be lifted with a brush or palette knife for lighter values. This way, you also recover transparency.

BEACH SAND

A combination of all these techniques is an effective way to paint not only desert sand, but any exposed sand such as that found on our beaches. Beach sand varies tremendously in color, from the snow-white, saltlike shore of the Gulf of Mexico in Florida, to the pale off-white vast shores in Hawaii where the ground-up lava has also created their famous black sand beaches, to the more familiar yellow-gray Atlantic shores of Canada and the United States, to the golden sands of California and the pale fine gray colors of the Pacific northwest coast. All these beaches have things in common: tide, storms, and wind constantly change their surface appearance. Scattered vegetation breaks into the beaches' outside edges as do the decorative seaweeds, shells, driftwood, and other clutter that the water leaves ashore. These all help a painter to add design elements.

Because grains of sand and grains of separating colors behave similarly, I strongly recommend the use of separating washes to indicate the granular texture of the beach. Even in painting the white dunes of Pensacola, Florida, when you let expanses of white paper represent the dunes, you still need the contrast and texture provided by cool separating colors—such as cerulean blue and/or manganese blue, with a touch of sepia or burnt sienna—in painting the shadows. (For more information on separating colors, see Chapter 1.)

DESERT SAND

One of the most common soils is sand. It appears in deserts, beaches, and in small quantities just about everywhere. To paint desert sand, let its color determine the combination of pigments you use. The separating tendency of some pigments (as described in Chapter 1) is the natural way to approach the granular texture of desert soil. One of the warm colors (sepia, brown madder, warm sepia, burnt sienna, burnt umber, raw umber, yellow ochre, etc.) in combination with a cool color (cerulean blue, French ultramarine, cobalt blue, manganese blue, etc.) will most likely give you the colors, the correct value, and the necessary texture to represent sand by separating in a combined wash. Foreground sand can be further textured with a drybrush glaze and/or with some splatter.

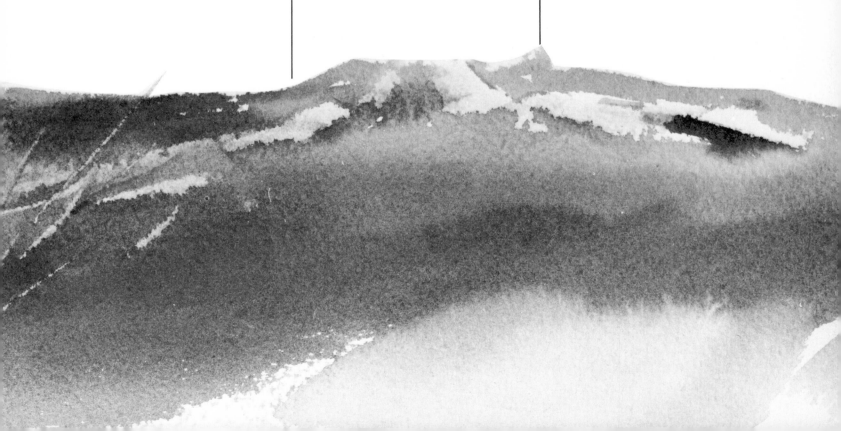

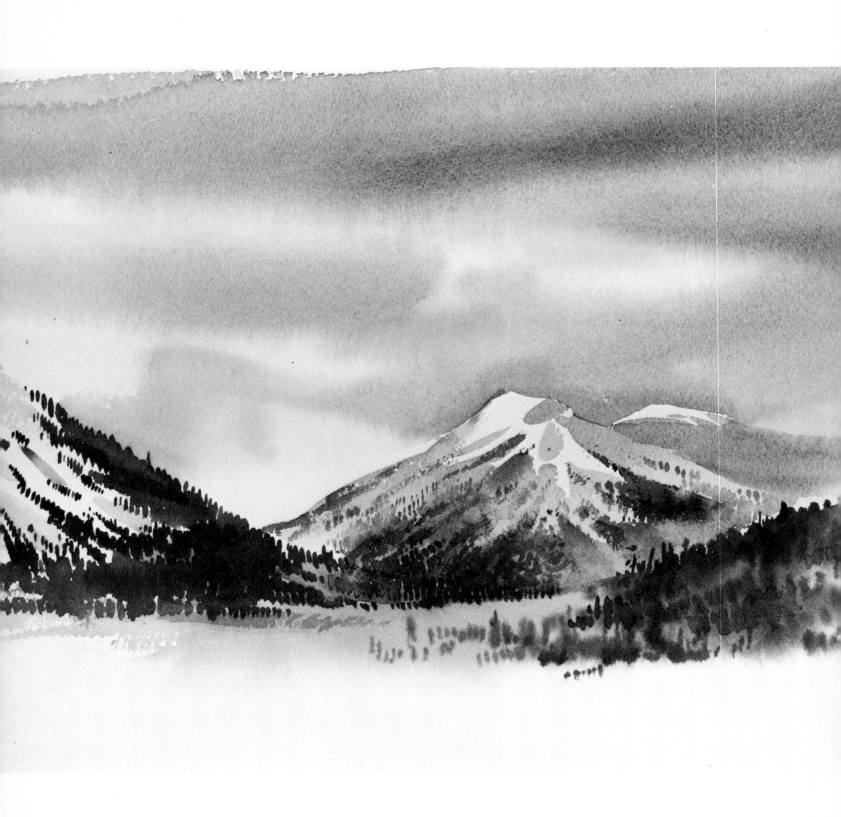

DISTANT MOUNTAINS AND HILLS

Mountains and hills are similar, their primary difference only being one of size. However, because they're so often seen at great distances, the effects of atmosphere on their color and details must be taken into consideration. The atmosphere acts as a filter, its degree dependent on the amount of humidity and/or pollution in the air plus the distance of the objects from the viewer. Under foggy conditions, where there's high humidity and strong filtration, you probably wouldn't be able to see a mountain unless it was close enough for its silhouette to penetrate the mist. To capture this effect, paint the sharp upper edges of the mountain slightly darker than its softly fading base, which is usually partially covered by the darker, more detailed and richly colored foreground elements. Don't confuse the yellow-brown mist of pollution or smog that hangs over large cities with fog. Although it acts as a filter too, it also adds its yellow-brown haze to the landscape.

When the air is clear, especially in areas of low humidity like the desert, mountains are often visible at great distances. Their silhouettes appear in layers of varying size, color, and value, according to their distance. The closer ones show sharper edges and more textural definition than the distant ones, while the furthest peaks appear just as a faint wash.

I start painting the mountains at their sharp outer edges, quickly establishing their shape, color, and value. I then lose their lower edges at the ground level by working back into the wet wash with a clean, thirsty brush— one that picks up excess paint and thus lightens the wash. I always start with the palest, most distant forms, and gain strength and definition with each closer layer. Before applying each layer, I allow the previous wash to dry.

SNOW-COVERED PEAKS

Very tall mountains can be and often are snow-covered all year round because the temperature never gets warm enough at very high elevations to melt the snow, and the precipitation at those elevations is always snow. I'm sure you are familiar with the awesome beauty of the white peak of Fujiyama in Japan, or the impressive sight of Mount Baker in the state of Washington, or the rows of white peaks beside the Jasper National Park highway in the Canadian Rockies. These snow-covered peaks help to simplify the form and shape of the mountain, but they're not just white. You must show some form through subtle shading to make sure that the peaks look three-dimensional, not flat.

CLIFFS AND BLUFFS

Some of the most impressive natural rock formations are the cliffs and bluffs that occur where there is a quick change of elevation. To paint this type of natural form, first analyze its colors to choose an appropriate palette. Very often these exposed rocks show layered texture.

Drybrush strokes with a split or separated brush that holds just enough paint is one good way to paint these layers when they're distant. When they're closer, the palette knife is a more exciting way to represent the details of their rugged surface. Whatever their size and shape, or distance, the visible texture on the surface of these formations must be carefully observed and painted as it appears.

SURFACE DEFINITION

Mountains and hills show detailed texture if they're close enough. These details are best painted as well-controlled texture, as you actually see them, not as you *think* of them. For example, 30-foot (9-meter) trees in the forest creeping up on the side of a 12,000-foot (3,657-meter) snow-capped mountain will be visible as a *drybrushed green shape,* and have to be painted as such, not as little trees. (See Chapter 3 for additional information on painting distant forests on mountainsides.)

LIGHTING AND OTHER COLOR EFFECTS

Hills and mountains are most dramatic when strongly lit by the side light of a low sun or when backlit—with the sun behind them increasing the contrast between the light sky and the dark silhouette of the mountain. In the first case, the brilliant, clean color of a sidelit mountain, contrasted with the dark, sharp shadows, also simplifies the problem of designing the form and modeling the mountain's surface. Don't use an opaque dark for the shadows. There should be a slight variation of values in the shadow detail.

The color of a strong light source, such as the golden orange, red, or purple of a setting sun, influences the lit side of the mountain. This is particularly obvious when snow covers the mountains, because snow is such a strong reflector. The color influence of the moon, storm clouds, and other factors must also be considered in your color composition. Frequent and careful observation is by far the most dependable way to study the unusual effects of these conditions.

STILL AND MOVING WATER

Water has no shape of its own but instead takes on the contours of the container that holds it. It's transparent in small quantities, but has its own color in mass, which is usually blue or green, depending upon the chemicals (organic, mineral, or synthetic) it contains. Moving water is one of nature's most complex and beautiful acts. Learn to interpret it, because you'll never see any two conditions alike.

THE COLOR OF WATER

As an artist, you don't need to know what causes the variations in the color of water, but you must be able to paint its colors correctly. A mountain lake in the Rockies will have a different color from a muddy lake or from a large lake like Lake Superior. Before I start painting, I always spend a few minutes analyzing the colors I see before me and then selecting the appropriate colors from my palette that will enable me to mix these colors. It's a sound investment of time in the interests of a good painting.

Incidentally, I never use just one color for water. If it's blue, I use several blues in combination. If it's green, I paint several greens into one wash and allow them to blend freely. This way I can't repeat the same color exactly and get into a monotonous rut.

THE OCEAN

Moving water is one of nature's most complex and beautiful acts. Learn to interpret it, because you'll never see any two conditions alike. The great mass of the ocean, together with internal forces such as currents and tides, and external forces such as the wind, almost guarantees a variation of movement on its surface. Occasionally it can be still, but this condition is the exception rather than the rule.

WAVES

Waves vary in size and shape and respond to the laws of perspective. The farther away they are, the smaller they appear. In order to understand the movements and see the reflections and colors in waves, I suggest you take several photographs of waves in rapid sequence, holding the camera in the same position for all shots, and using a tripod if necessary. When you study these photographs, you'll see the effects of active, reflecting waves in periodically frozen positions. Once you understand the principles involved, you'll have no trouble painting waves.

When you paint a wave, think of it as a curving tube rolling toward you, showing its concave, usually darker, inner curve. Convex white foamy bubbles appear on the near side of the tubular curve and are sharp at their top edge where they turn. These white surf heads are broken and irregular, splashing freely on the front of the wave before they land.

To paint waves, I start on dry paper, using a richly loaded large, soft, brush. Beginning with the water in the most distant part of my painting, I apply my washes with quick, wet brushstrokes, letting them blend as they touch on the dry paper. Occasionally, I move the brush along the rough surface so fast that it skips an area, leaving an irregular white shape with drybrushed edges. I take advantage of these white shapes and make them into white surf heads. To define their character, I quickly even their top edges with a curving stroke. I encourage these white shapes to differ from each other in shape, to gain in size as they come nearer, and to be surrounded with enough variety in the color and value in the water next to them to show action and varying depth.

WAVES AGAINST THE SHORE

These heads last a while on the surf, but eventually break up as they tire or as the water gets shallower by the shore.

As the waves break up near the beach, I lighten the washes in my brush. I hold the brush at a low angle and scumble their bubbly drybrush texture, imitating the churning surface by dragging and pushing the brush against its ferrule. I actually push the brush rather than drag it. This way I get an accidental design that simulates the real texture very well.

CHOPPY SURF

When the bubbles have died down but the waves are still in turmoil, they make irregularly shaped, smaller diamond-shaped wavelets within the larger wave shapes. I wipe some of these out with a clean, thirsty brush from the drying damp wash, and/or lift them out after the surface has dried by first dampening, then blotting them with a soft, pointed brush.

WAVES AGAINST ROCKS

If the shoreline is formed by a high wall-like edge such as cliffs and rocks, these large waves are stopped abruptly and break up with a loud, roaring splash. In both cases, the result is a churning, foaming mass of bubbles covering the entire settling surface of the salty water.

When the surf strikes against rocks, I imitate its splash with fast brushstrokes moving in the same direction, on dry paper. If the splash is slow and lazy, I spatter some beads of paint back into the white splash, encouraging some to survive. When the water hits the rocks hard and fast enough to vaporize and turn to mist, I soften the outer edge of the splash with a thirsty, damp brush to indicate the mist.

STORMY OCEAN

A stormy ocean behaves in a similar way to a calmer one, except that the dark, overcast sky above acts as a weak light source and its deeper, more neutral colors have a graying color influence on the water. I don't intend to oversimplify the stormy ocean, but until you've experienced it personally, your paintings will lack conviction. You owe it to yourself to encounter an angry sea first-hand, and to try to paint even a small study right then or immediately afterward, while you're excited and can still recall what you saw.

LAKES

The moving surface of large lakes resembles the behavior of the ocean, but on a smaller scale. Its waves are smaller and the depth of the lake influences the water's response to wind. Its color differs as well because of the difference in chemical composition, mainly the lack of salt. The bubbly white wave heads break up much faster than in salt water, reducing the white drybrushed shore action.

One of the most interesting conditions on lakes occurs when the wind is too weak to create waves but is still strong enough to rough up the smooth surface. The resulting breeze patterns supply excellent design elements for strong composition and reinforcement of perspective. To paint these breeze patterns effectively, drybrush on the color of the water using an even pressure and fast speed with a soft, loaded brush over dry paper. It is important that this brushstroke be in an even and horizontal direction. Before the freshly applied drybrush can dry, paint in the darker shapes of the remaining still reflections with rich, wet brushstrokes of a contrasting value.

On a calm day, forms appearing above the waterline, such as distant points, islands, trees, stumps, and rocks, reflect well in the dark washes representing the quiet water. But when there's a breeze, none of these reflections will show because the waves are broken up into tiny ripples that blend into a single, solid, light shape showing only the slight color influence of the sky.

RIVERS AND CREEKS

The shallow edges of flowing creeks and rivers show the transparent qualities of moving water, although their deeper sections usually behave more like lakes. To paint underwater details beneath transparent, churning water requires a keen judgment of values. The forms below the water's surface are gently defined and are interrupted only by the highlights of the reflecting water and by the distortions of refractions. Painting the impression is what's most important.

When creeks pour into a steep downgrade in a rocky basin, the blocking boulders divert the rapids around them and the encircling water shows brilliant highlights. Don't apply color to these highlights; they must provide maximum contrast to the darker surfaces below.

Instead, to show the downstream flow of water around the edges of obstructions such as rocks, your darker, transparent brushstrokes must move in the direction of the flow. The underwater shapes and colors of the objects now represent the forms refracted by the transparent moving water.

WATERFALLS

When flowing water drops off a ledge to continue at a lower level, it breaks into bubbles or shows a sheet of thin, brightly reflecting form. To paint it, you must think in terms of contrasts in value. The downward curve of smoothly falling water shows brighter highlights at the top of the falls then at the base. I like to apply my brushstrokes from the bottom up, against the direction of the flow. These quick, drybrush strokes represent dark tones, the reverse of the white highlights. This way the white highlights appear to flow downward.

PUDDLES

Small shallow bodies of water, such as puddles, are also found on the landscape. Viewed from a steep angle, they appear clear and transparent and you can see the bottom, which is usually dark. The texture and value of the water's surface contrasts with the solid materials at its edge.

To paint a puddle, draw its outline in perspective, keeping its surface flat. At the outer rim of the puddle, look for a light, sparkling line where the concave edge of the water reflects the light of the sky. If the puddle is on solid ground, this line will be thin and sharp, but if the ground is soft mud, the white edge will sparkle as it widens. A drybrush technique is a good way to paint this condition.

When you view a puddle from a low angle, the reflections in it are strong and you don't see much of the bottom. Paint reflections carefully and with a strong contrast of values. Also, since water never settles at an angle (because of gravity), and reflections conform to the water's surface, they must be painted according to the laws of nature. Remember, well painted, reflections enhance a painting; wrongly applied, they confuse it.

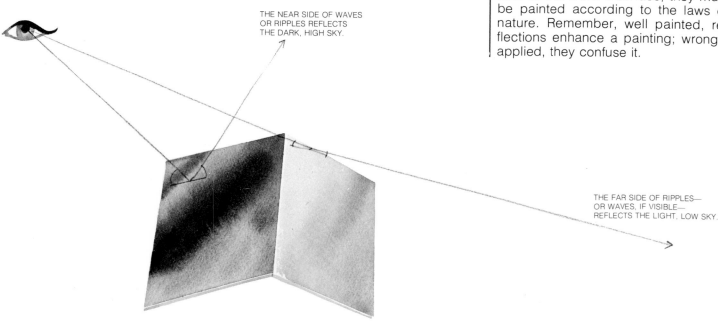

THE NEAR SIDE OF WAVES OR RIPPLES REFLECTS THE DARK, HIGH SKY.

THE FAR SIDE OF RIPPLES— OR WAVES, IF VISIBLE— REFLECTS THE LIGHT, LOW SKY.

LIGHTS ON WATER

On bright days or on nights with a full moon, we often see a sparkling shimmer of light below the high sun or moon. To paint these brilliant sparkles, I like to use a piece of paraffin carved or scrubbed perfectly straight on one edge. I hold the bar of paraffin wax diagonally to the edge of the water and almost parallel with the surface of the dry rough paper. "Almost parallel" means that I have the sharp end of the wax where I intend the sparkle to be straight and strong (top edge close to light source) closer to the paper than the lighter part of the shimmer even before I touch the paper. After this, I pass the wax bar over the area of sparkle on the dry paper with more pressure at the highlit top edge than the weaker low side. I repeat this two or three times, holding the wax rigidly, depending on how large the sparkling spots must be. After this I apply contrasting dark, wet color over the water area and right through the waxed-out shimmer. The wax will resist water and the tiny sparkles will immediately show how effectively the wax has designed the lighted dots.

The advantage of this technique is the pure and brilliant sparkle you get. The disadvantage is that you can't see the wax resist area until you apply the paint, and by then it's too late to add more wax because the paper is wet. However, if you find you still need more sparkle, wait until the paint dries completely and scrape off the additional white spots with a razor blade held in a similar firm grip as you held the wax. This is a good technique by itself, even without the wax, but the shimmer won't be quite as sparkling as with the paraffin wax. To remove the wax, see Chapter 20.

REFLECTIONS

The reflection of objects above the surface, the color of the sky, for example, affects the colors you see in the water. The extent of an object's influence depends on the angle of your vision. When the water is viewed from a distance, the color of the sky dominates its surface; seen up close, the water's own color or that of nearby objects appears.

There are several rules to keep in mind when painting reflections on the water's surface. First of all, whatever reflects appears as an exact mirror image. A stick slanting to the left reflects to the left of the point where it touches the water's surface. The angle of reflection is also identical to that of the object reflected. Objects tilting toward you appear shorter than their reflection — the more severe the tilt, the greater the difference. When an object tilts away from the water, its reflection gets shorter than the image itself because, according to the laws of perspective, the foreshortened angle appears shorter than one that is not. The undersides of protruding objects such as branches are visible because that is the side presented to the surface of the water. When a reflection stretches across the water and reaches the shallow edge of the water by your feet, it follows the gentle movement of the ripples and appears as a wiggly rather than a straight line. The principles are similar for waves.

Because still water reflects like a mirror, its effects can be simulated with glass for study purposes. You may also place white, black, or colored paper under it to change its reflective quality. You'll have fun experimenting and, after demonstrating the principles of reflection visually, you'll probably remember them better, too.

REFRACTION AND SUBMERGED OBJECTS

Another factor influencing the appearance of water is refraction. It determines the color, shape, and value of what you see at the bottom of the water — sand, rocks, weeds, etc. Refraction is also responsible for showing structures submerged in water with a slight distortion.

Submerged things have color, value, and form that influence the appearance of the water. If these forms are partly above the water, you can detect that at their point of entry into the water, their angle changes. They're even better defined if you look at them through a dark reflection, where the bright value of the sky can't dominate. When these submerged objects are clearly visible, you must paint them looking wet; that is, darker than if they were dry.

If you want to paint a rock that's partly submerged and partly exposed, you must use two different combinations of colors — related in hue, but vastly different in value. The dry part of an object (stump, rock, etc.) in water looks paler and lighter than its wet or submerged area. The contrast is strong, and I usually paint it in two steps: First I paint the light areas, complete with modeling and texture. After this has dried, I glaze on the value of the wet area as needed.

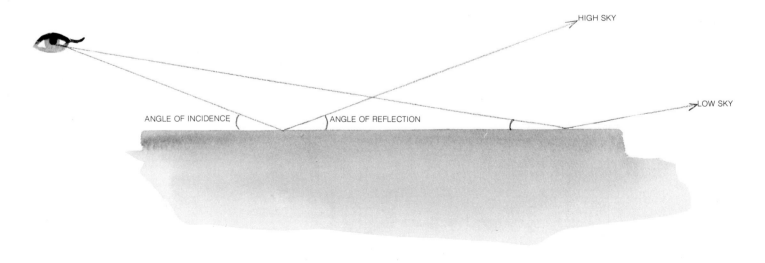

HIGH SKY

LOW SKY

ANGLE OF INCIDENCE ANGLE OF REFLECTION

SNOW, ICE AND FROST

Winter painting requires a positive attitude from the watercolorist. You can't let the cold weather rob you of the creative satisfaction of painting an exciting winter landscape. Painting outdoors in winter is an endless challenge with watercolor because the water freezes in the cold weather. You must overcome this handicap with ingenuity.

PAINTING OUTDOORS IN WINTER

I paint snow scenes in my car (if it's too cold outside) on a small 12" x 16" (30 x 40 cm) paper. I often use these paintings as finished products or as reference studies for larger studio paintings. When the temperature is around or above the freezing point, I paint outside, but stay close enough to my car to speed up the drying of washes with the car heater. Small thumbnail sketches or photographs are helpful aids to capture conditions for later studio paintings.

SNOW

In painting the purity of white snow, watercolorists have a special advantage—the white is already supplied by the paper. However, it would be a mistake to accept snow simply as a vague, colorless shape surrounded by other well-defined colors, values, and forms. Snow does have color and value. It's also a good reflector, and other factors, for example, trees and buildings, influence its coloration. The reflections of these forms are stronger and easier to see in bright sunlight than under an overcast sky.

BRIGHT SUNLIT SNOW

I use two different sets of colors, warm and cool, for modeling snow. Bright sunlight shows snow as the purest white on the highlit areas. When there is sunlight, there are also strong shadows, their details modeled by the neighboring objects reflecting into them. For sunlit snow, I use French ultramarine, cerulean blue, manganese blue, and Antwerp blue in various combinations. When warm, neutralizing colors are needed, I add raw sienna, burnt sienna, charcoal gray, or sepia to the blues.

Because the manganese, cerulean, and French ultramarine blues are granular colors, they separate in washes in the shadow areas and thus give the appearance of brilliant, sparkling snow. Let the lines and shapes of the shadows define the forms beneath the snow, their designs following the rise and fall of the earth's surface. Paint these shadows as one continuous wash, without hard overlaps, and quickly so that they can blend as they touch. Shadows are darkest at their outside edge, because the inner areas pick up some reflected light on their details and thus look lighter. The rule is that in sunlight, shadows always appear directly behind the object that causes them, exactly opposite the sun.

SNOW ON AN OVERCAST DAY

On an overcast day, the sky is the major source of light. There are no sharp shadows (as there are when the sun is out), only soft shading. The value of snow varies with the thickness of the overhead clouds. Sometimes when an angry blizzard approaches, the snow on distant peaks is often lighter than the storm clouds above it. The reason for this is that the pure white snow at the top of peaks catches more light than the grayer clouds, which are in shadow. Their thick, dark, shaded layers are also seen in perspective, making them appear even darker. This condition is an excellent one for creating a mood. I like to use French ultramarine, Antwerp blue, burnt sienna, raw sienna, and brown madder in various combinations.

The surface of the snow shows subtle differences in elevation, with dips and heights. A lost-and-found brush technique on dry paper is ideal for painting this effect. To model the lightest mounds of snow, since there's nothing lighter than the white paper, you must define the highlights in the snow by painting the near side of the next elevation behind, with a gray wash. As soon as you do this, rinse and squeeze your brush between your thumb and finger, leaving it moist. With this clean, thirsty brush, wet the paper above the still-wet brushstroke, making sure that you touch its top edge. This way, the color will partly soak up into your brush, blending toward the wet paper, and leaving the lower edge sharp. Because the lost edge of the brushmark partly spreads in addition to losing pigment into the thirsty brush, your first brushstroke must have a little more paint in it than necessary to make sure that just enough survives. When the finished stroke dries, it will be softly modeled toward the top.

OBJECTS IN SNOW

Snow, however deep it is, often exposes parts of protruding forms above the ground, such as stumps, rocks, twigs, and weeds as abstract shapes. They add interest in the way of color, line or texture to the otherwise white area. These contrasting shapes enjoy extra importance and have to be designed and modeled to fit naturally into your composition. Weeds, twigs, rolling leaves, and other natural color accents in snow should not repeat mechanically in an even rhythm but should differ slightly in shape and size.

When snow falls it not only lands on the ground but on all objects whether they are on or above the ground. Roof tops, branches, wires, and posts are all covered. As the thick snow piles up, it shows a variety of smooth, soft mounds on branches and wires resembling sausages. These forms have light and dark sides. Because of the sky light, their tops are usually lighter than the sides. To keep the fresh, clean appearance of snow, paint these snow-covered shapes with a single application of paint or with one wetting procedure for lifting snow out of a darker background. If objects appear in front of a brightly lit expanse of snow, they seem slightly darker by comparison because you're viewing their shaded sides. These same shapes, however, look light against dark background because their real value is light. They may be left out or lifted out by wetting and blotting, as I explained in Chapter 2. The damp colors can be lifted up with a soft edge. However, if you wish them to have a sharp edge, you must mask them out. (Again, see Chapter 2.)

Objects sticking out of snow, like tree trunks, posts, rocks, and weeds cause little drifts and reflect heat, causing nestlike dimples in the snow next to them. These circular forms can be painted with a lost-and-found technique, losing one or both edges to soft blending.

FALLING SNOW

Falling snow is a beautiful, nostalgic experience. The sky is moody and dark and you seem to hear a breathtaking silence.

To paint this, you must think of snow as a filter, like fog. Distant forms look blurred with little, if any, details. Paint them on wet paper with soft brushstrokes. The sky and distant objects can be painted simultaneously by applying grayish washes varying them slightly in color and value with each brushload and blending them loosely on the wet surface.

Before your wash loses its shine, sprinkle a few grains of salt into the drying paint on the horizontally held painting. If you then tilt your painting, the melting salt will flow down with the water and will later give the light salt-caused shapes a smeared kind of direction. On a horizontally held paper, the granules will slowly absorb the moisture and pigment — creating crystal-shaped snowflake-like light spots. After drying, just brush off the salt granules.

Timing is crucial. If you apply the salt when the wash is very wet, much of it will melt and the snowflakes will be large and bulky and blend together. If you wait too long and the paint does not have enough water in it to melt the salt, it won't cause any change. Be cautious not to use too much salt because it will look artificial if the technique is overdone. Sprinkle only a few granules. Don't try to aim the salt into an exact spot. The granules bounce and roll and choose their own location. Snow falls in a similarly haphazard way.

BLIZZARD

An oncoming blizzard usually comes with wind that bends the exposed, delicate weeds and blows the snowflakes around in an angular direction. All soft, flexible objects like weeds and evergreen branches that wave and bend with the wind must move in the same direction as the wind, when you paint them.

I like to start by establishing the larger forms with this wind-blown directional design on wet paper. I sprinkle salt into this wet wash and tilt the paper in the direction of the wind. The water flows with the melting salt in it for about five seconds. Afterward, I level the paper again to a horizontal position and let the paint dry. The result looks amazingly like a blowing blizzard. I then brush off the dry salt, which now looks dark from the absorbed pigment. The snowflake-like shapes are there to stay. I complete the painting by adding the details on nearby objects, including some deep mounds of snow on the ground.

SNOWDRIFTS

During wintertime, the wind constantly shapes and models the snow. The loose, white powder blows in the wind until some solid obstacle stops it and causes it to pile up in a drift. Fences, houses, rocks, mounds, posts, trees, footprints, and the like may be the cause of drifts. Drifting snow creates and constantly changes abstract shapes in an otherwise flat landscape.

To paint these seemingly simple forms, you must carefully apply the rules of perspective and apply skillful lost-and-found washes. The design of these drifts and their location complements your composition. At times, drifts may be the center of interest because of their sculptured forms. Their shaded sides will be blue and sparkling in bright sun, but quieter and grayer under a cloudy sky. Competing details like fences, weeds, and leaves must be played down if your snowdrift is to be the center of interest.

Forms that are partly covered with snow and partly exposed are painted most effectively if you think in terms of the whole form, even while you're painting only the exposed part. Snow has thickness and this thickness can be implied.

PUDDLES

Puddles are usually the first bodies of water to freeze because of their small quantity of water. The ice on them is thin, transparent, and a fair reflector, though not as good as water. All kinds of objects — like pebbles, grass, and twigs — protrude through puddles. Painting these protrusions help show the nature of a puddle.

There is a little touch of Jack Frost common to all frozen puddles. On the lower sides of the ice where the water moves, air-bubble marks show in an abstract, whiter, curving, circular design. These marks are fun to paint and are made with translucent, grayish-blue washes. I like to use raw or burnt sienna with French ultramarine, Antwerp blue, or cerulean blue. Paint these washes carefully and avoid touching one wash with another. The light line between these washes will look like air bubbles.

If you accidentally interrupt some of these white lines by touching an earlier brushstroke with a later one, let the paint dry. With the tip of a pointed wet sable you may wet and blot out the light line to connect into the design. This is also a good way to lift out additional air-bubble shapes.

MELTING SNOW

Winter isn't all cold weather. Warm winds often melt the snow, exposing some of the ground's surface, a melting process that certainly happens at the end of winter. The melting edges of the snow patches appear icy, wet, and irregular.

To paint them, first paint the darker shapes touching the snow patches with a dry brush imitating the negative silhouettes of the brittle, icy edges. When it's dry, drybrush on a gray-blue glaze over the white edge of the snow. I suggest using Antwerp blue, a touch of French ultramarine, and/or burnt sienna to cut the raw blue and to let the paint appear more wet and translucent, as it will be when influenced by the dark, wet ground color underneath. Apply several layers of this lightly glazed drybrush in irregular shapes. A little of each layer will be visible, as well as a little of its overlapping texture. Its edges should look wet and melting.

Melting icicles of dripping water usually appear when the snow starts to thaw. Add these touches of action to your painting as a hint of springtime activity.

ICE

Ice is brittle, cold, and translucent. To paint it, you must imply these qualities. If it's made from pure water, ice has a slight bluish color of its own. The original color of the water remains when it freezes into solid form. Ice is more opaque than water; consequently, the reflections on its surface are duller. To make your painted ice realistic and believable, I strongly urge you to paint it from nature as often as possible.

ICE STORMS

Ice storms are common events during the winter. When the objects on ground level are colder than the in-moving warmer air mass, the precipitation falls as rain, not snow. As soon as the rain hits the cold objects, they freeze and build up ice heavy enough to break tree limbs, and tear wires. However, for an artist, the glistening ice is beautiful.

After a storm, seeing the sunlight hit the ice-covered objects is a breathtaking experience. It's difficult to paint this. Sharp, brittle, white edges will survive if you mask out closer objects on the white paper from the deeper background values. Therefore, the design of the masked-out shapes is important because their contrasting shapes influence the composition. (See Chapter 2.) When you remove the masking agent, complete the glasslike forms of the ice, allowing lots of pure white highlights to appear.

FLOATING ICE

Ice floats on water because it's lighter. Floating ice may range in size anywhere from a small slab to an iceberg. Two-thirds of it floats submerged, and one-third is visible.

When the top of a large body of water starts to freeze and the ice is thin, water movement can break it into sheetlike slabs. They are transparent, but the pattern of reflection is different from that of the waves on which they're floating.

In late winter, when the ice is thick and solid on large lakes, strong winds can smash its frozen edges with the great force of rolling waves. These thick ice slabs show their color and thickness as they pile up on the solid ice on shore.

Although, as a rule, reflections in water are generally darker than the objects reflected, reflections in the shallow water on top of ice are an exception because the light color of the ice affects the color of the objects reflected. (A similar situation exists in reflections of water on top of another light-colored, shallow base — light sand. It also exists in the case of muddy or polluted water where its muddy contents render it opaque, and therefore less reflective.)

SNOW ON ICE

When the temperature is cold enough for ice to form, it's cold enough for snow to fall. When snow covers ice with its blanket, the ice takes on the appearance of a flat sheet of white snow without much surface disturbance, with the possible exception of snowdrifts.

ICEBERGS

Arctic ice breaks off on the edges, creating icebergs. Salt water ice is bluer than fresh water ice. To paint ice, I like to use mostly transparent colors. However, there's one exception. I prefer cerulean blue to be one of the pigments in the mix because it has an easily maneuvered, grainy quality and doesn't stain the paper as much as Antwerp blue, phthalo blue, Prussian blue, or Winsor blue. It sits on the surface of the paper and can be lifted quite easily. I never use it alone; I like to mix complements with it—a touch of raw sienna, sepia, or burnt sienna, for example. But I allow cerulean blue to dominate. I model the thick ice slabs with a painting knife while the paint is still damp.

When very cold air reaches floating ice chunks in calm water, they freeze into a solid translucent layer of ice with linemarks at the joints. This pattern creates a fascinating design.

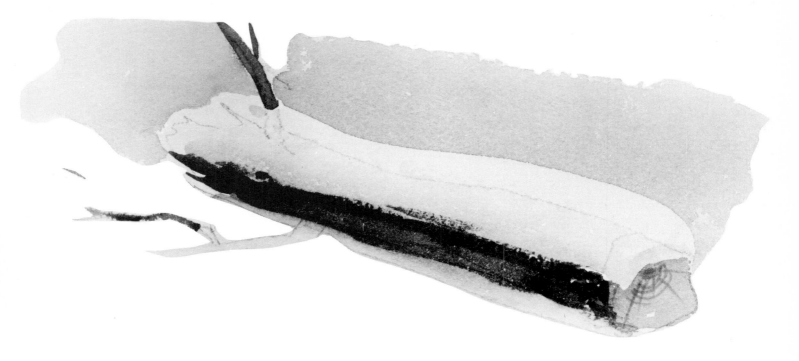

FROST AND HOARFROST

Moisture is constantly present in the air. When the temperature of the air gets warmer than the temperature of solid objects on earth, the vapor or fog lands on colder material and freezes as a fluffy, white coat or hoarfrost. If you examine the structure of frost, you'll see that it consists of crystals.

Because air and the moisture within it engulf everything, hoarfrost lands on all objects. Because water is heavier than air, however minute its quantity, it will tend to fall downward with gravity. Consequently more frost accumulates on top of suspended objects than on the sides or bottom (leaves, wires, branches, and so forth). Air movement is also responsible for a little frost landing on places other than the top surfaces of objects.

ICY ROADS

Paved roads are also affected by freezing rain. The shiny, glasslike coat of ice on the dark asphalt is a reflective surface. The hint of a reflection is pale and straight, not wiggly as it would be on a rainy surface.

To suggest ice on a road, paint a few ice-covered twigs and weeds at the road's edge. Subtle reflections and diffused forms are important ingredients for painting ice on solid surfaces.

FROST IN SUNLIGHT

The appearance of frosty trees and objects and their mood-creating power depends much on light conditions. When they're sunlit, they appear pure white, contrasting strongly with the background.

To paint this condition, you must catch this *value contrast* with the first application of washes. Surface damp, not wet, paper is most responsive to establishing the contrasting edges without leaving them looking too sharp and solid.

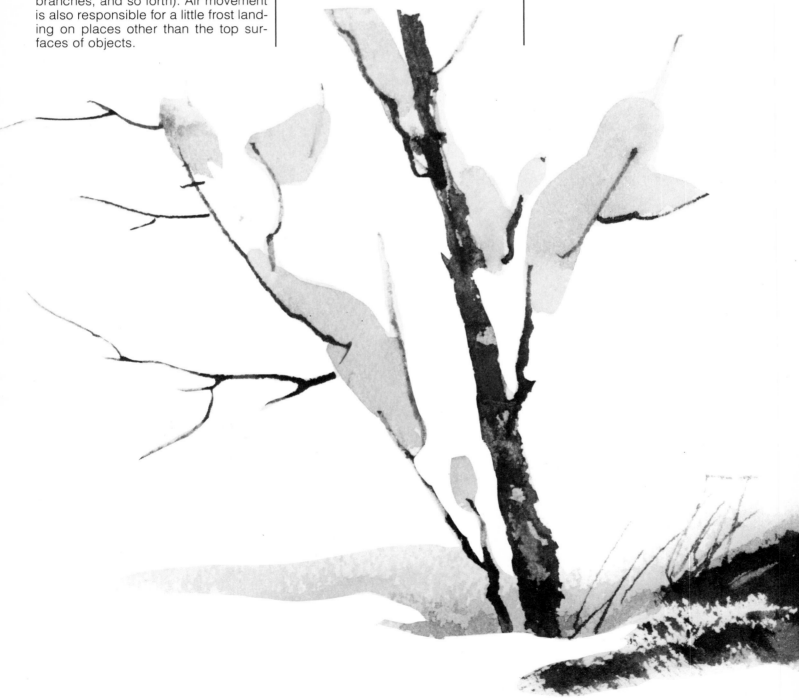

FROST UNDER AN OVERCAST SKY

Under a gray overcast sky, the same frosty trees take on a more gentle less contrasting appearance than in bright sun. This time, by adding a little touch of gray to the light frost and by using a somewhat wetter paper, you can establish the first masses in one wash.

Details and modeling must be designed into this accident-filled wash. Spontaneous application and exact moisture judgment in your brush and on your paper is essential. After these first washes lose their shine, you can add more of a three-dimensional feeling by painting in wet, linear brushstrokes with only a small amount of clean water in your brush. When your paper dries, you can then proceed to add sharper definitions.

FROST ON DELICATE SHAPES

Frost decorates not only massive solids but even the most delicate shapes such as cobwebs, wire fences, and electric wires. These thin lines look softer if you lift them out of a darker dry background with a wet-and-blot approach. (For details, see Chapter 2.)

FROST ON WEEDS

The character of weeds is modified under the weight of icy frost. They're best painted with soft edges for which, of course, you need damp paper. Against a light background, paint them with a mixture of the weeds' original color plus a bluish complement like cobalt or cerulean, without adding excess water to your brush. In painting weeds against a dark background, use clear water brushed into a damp, dark wash that has lost its shine.

FROST ON LEAVES AND BRANCHES

Nearby shapes such as leaves and branches appear paler under a filtering coat of frost. To paint the effect, use the same sensitive, blurred, wet technique as above, but pay more attention here to the soft modeling of nearby forms than to modeling of distant or slender shapes. After you establish the soft, larger forms on your damp paper and your paper is dry, you may paint the diffused details of smaller forms such as veins of leaves and the bark texture of a tree trunk or branch, using a disciplined drybrush technique. Even for this final touch, it's best to use pale colors.

FROSTED WINDOWS

As condensation freezes on the inside of a cold windowpane, the resulting shapes and design are not only beautiful, but are always unique. Since the degree of humidity and the speed of freezing are never the same, consequently the results aren't either.

Salt is an important technical tool in creating similar designs and texture. Sprinkled into wet washes with a directional control (similar to that used in Indian sand painting), salt will make frostlike shapes as it dries. The careful timing of the application and amount of salt will determine the result. (See Chapter 2 for more details.)

Hoarfrost usually doesn't last long. The exciting light conditions it's seen under are even more brief. Photography is a good way to capture the effect for future reference. Take as many photos as you wish, but paint some thumbnail sketches, too. Remember, there's no substitute for first-hand experience. A photograph is only a second step from reality, at best.

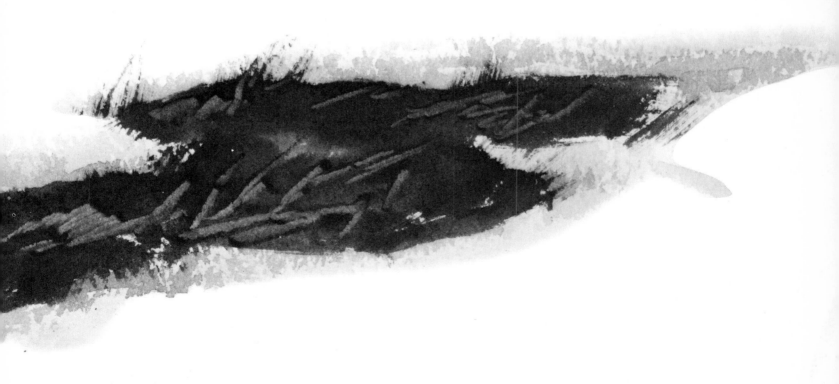

SKIES AND WEATHER

The bare, bold, blue sky of a single value and color—seen so often in poor paintings—simply doesn't exist in nature. Even in deep summer, the cloudless blue sky has subtle variations in color, particularly around the low sky area close to the horizon.

CLOUDLESS BLUE SKY

The zenith of the sky is always darker than the low sky, with a gradual change of value between them, because the atmosphere, which has an even thickness of air, follows the curvature of the earth. When you look directly overhead, you are looking into outer space through less atmosphere; therefore the color is darker. When you look at the horizon, you look through a thicker layer of atmosphere, so the color of the sky is influenced more by the color of the atmosphere and appears lighter. (See diagram on page 106.)

Since the sky constantly changes in hue as well as in value, it is wise to take advantage of these shifting colors and exaggerate them to harmonize with the colors in your painting and thus insure color unity. I never mix a single blue for the whole sky. Instead, I use a freely blending, but separately applied, combination of two or three blues together with some other warmer color (yellow, red, or green), depending on the surface coloring of the landscape area. Technically, this wash has to be painted quickly for best results. Wet paper plus a wide, soft brush and very rich pigment offers a chance for the fastest application. Paint spreads and becomes much lighter on wet paper than it does on a dry surface. Allow for this.

Another approach is to paint your large brushstrokes of varied blue washes onto dry paper fast enough to permit the brushstrokes to blend as they touch. These brushstrokes should not create a mechanically spaced, even rhythm unless this is your intent. This is your opportunity to design an interesting balance of colors using some texture in your sky area.

TEXTURING BALD SKY

Texturing smooth, large forms like the sky is important to prevent monotony. Avoid a sharp linear approach unless your whole technique in that painting demands it. Sharp edges indicate forms and break up the illusion of a vast expanse of blue sky. Softly blending but detectable variations of color and value in the same area encourage your eyes to roam back and forth and enjoy the charm of the technique without losing the feeling of vastness. Your own good taste is the best guide to knowing where and when to stop.

COLOR INFLUENCES

Certain conditions add unusual color influences to clouds: sunrise, sunset, moonlight, a vast expanse of autumn-colored forest are a few examples. These conditions must be massive and colorful enough to have the color strength to affect clouds a great distance above them. Paint the clouds with these colors added to the gray hue of their shadowed bases.

UNITING SKY AND GROUND

You must somehow create the illusion on your painting that the blue sky relates to your center of interest on the ground. A good way to achieve this is to mix a little of some or all the blues of your sky into the ground colors, and at the same time to accent your sky with a little of the strongest, most influential colors from the ground.

SKY ABOVE WATER

When you paint a bald sky above a body of water such as the ocean or a lake, you should carefully harmonize the forms your brushstrokes create in the water with the action indicated by the directions of your brushstrokes in the sky. They must complement, not compete. Color unity between sky and water is equally important, even though it is a little easier to achieve because the water reflects some blue from the sky that can be observed. In addition to this reflected color, all bodies of water have their own color. This color should not be left isolated, but should be made a harmonic part of your controlled color unity.

COLORS WITHIN SHADOW

A blue sky always means bright sunshine, which automatically demands strong shadows. These shadows are not necessarily the same color in every painting, though they always contrast sharply in value with the sunlit surface on which they fall. Because the blue sky itself is a secondary light source, it influences the color of the shadow to a great extent. This means that the color of your shadow is a dark combination of the blue of the sky, the natural color of the surface it falls upon (its "local color"), plus other less important color influences, such as tree foliage. The blue tones in the shadow area offers one of the strongest opportunities to carry the sky color onto the ground surface. Use great discretion in choosing the hue of the blue you use so as not to make it too colorful at the cost of correct value.

SUNSET

Sunset is one of the conditions where a cloudless sky creates new dangers for the painter. Its short duration prevents long observation. To study the unique nature of sunsets, color slides are helpful, but they're no substitute for personal experience. Nothing is better than painting from nature.

The size of your study of a sunset sky should be determined by the extent of your experience. A 3" x 5" (7.5 x 13 cm) thumbnail sketch can have as much reference value as a half-sheet watercolor. The important factor is to get the color and value relationship plus the excitement of the moment down on paper. Don't use muddy colors. Only the purest, well-diluted, *transparent* pigments have a chance to get close to the brilliant luminosity of a colorful sky at sunset. Even these pigments can only approximate, but never exactly match, the strength of light. To exaggerate this relative luminosity, all solid objects that are backlit have to be painted as dark as transparency permits, letting the contrast help further the illusion of brilliant values.

CLOUDS AND STORMS

When water evaporates, it turns from a liquid to a gas. The air can absorb a certain amount of water vapor without the humidity becoming visible. As warm air rises, it cools at higher elevations until it reaches a low-enough temperature for the water vapor to become visible as clouds. This elevation is called a *ceiling* or *condensation level*.

Clouds are never still, but move with the blowing wind. As an artist, you should learn their basic forms. Never attempt to paint one specific cloud, because clouds change their shape constantly while you paint. Instead, paint their approximate shape. Feel free to design their form and choose their location to complement your composition.

Clouds, because of their density, filter out the sun's light and are white on top but darker on the bottom. Their light and shaded sides however depend on the location of the source of light (sun or moon), their color on the time of day, and their value on their thickness and density. Their shaded side has a gray tone influenced by the reflecting colors of the earth below. This reflected light again offers an opportunity for encouraging color unity in a painting.

CUMULUS CLOUDS

Cumulus clouds are white, fluffy shapes with light, rounded tops and flat, darker bottoms where the condensation level cuts them off. They get smaller in perspective and less defined in the distance than they are when they're closer. They're moved by a slow and even wind.

FRACTO-CUMULUS CLOUDS

As the wind gets gusty and blows a little faster, it rolls the cumulus clouds and bounces them around, breaking them up on the edges. These broken or fractured clouds are called *fracto cumulus* clouds. They're generally smaller, more translucent, and appear whiter, with fuzzier edges than their cumulus cousins.

STRATO-CUMULUS CLOUDS

The wind blows faster at a high elevation where the strato-cumulus clouds form in long, sweeping, wind-blown rows. These are the easiest type of clouds to paint in watercolor. All you need is wet paper and a few angular brushstrokes of color to paint and define the color of the sky between the white rows of clouds. The color of these brushstrokes should relate to the colors of the sky as well as those on earth.

COMBINATION LAYERS (CIRRUS)

Sometimes the wind blows these anvil clouds in layers at different levels of elevation, and not necessarily in the same direction. This natural phenomenon offers angular and linear design elements that are helpful tools for good composition.

BACKLIT CLOUDS

Backlit or silver-lined clouds are visible when the sun is behind or directly above them. Their broken edges are white all around and darker in the center where they're thicker. The closer they're located below the sun, the greater the contrast in value between their center and edges.

STORM CLOUDS (NIMBUS)

When a thunderhead passes overhead, the inner darkness of the heavy layer of clouds dims the light on the ground beneath them. The strong contrast of light and shadow turns the scene into a drama of rich, dark values. The influence of ground colors unites sky and earth.

Don't be afraid to use rich colors, but unite all of them with a transparent, dark, neutralizing color. This neutralizer can be Paynes gray, neutral tint, or a mixture of the complements with the colors you're presently using. I prefer the latter solution because Paynes gray and neutral tint have a bluish hue, and not every storm is dominated by blue. Burnt sienna or raw sienna can be a dominant color influence, yet, mixed with Paynes gray, they sometimes turn muddy-looking instead of translucent. In this mixture, for example, I'd prefer to use French ultramarine to neutralize the burnt sienna or raw sienna. The resulting color remains clean and fresh even when dark.

The largest portion of storm clouds is best done with a wet-in-wet technique. This approach allows you to paint with rich pigment and vigorous brushstrokes, permitting the odd backrun to texture the clouds. This effect occurs when the paper is starting to dry in spots but is still damp, and you apply more water or an additional brushful of paint with lots of water in it. If you can control a backrun, it can add excitement; out of control, it can mean disaster. *Caution:* don't overwork the loose, wet washes to death. The quick application of rich pigment with a large brush, freely blending, is an exciting experience. Don't try to perfect these drying washes by picking at them.

THE WIND

Stormy clouds are always accompanied by strong winds that rip and blow them to pieces. A favorite technique of mine goes a long way to illustrate this effect: First I establish the wet-in-wet cloud structure, using a soft flat brush, until I'm satisfied with the values, color, and composition. As the liquid paint starts to dry, just before the shine turns dull, I clean the same soft, flat brush and squeeze out all the water to permit it to soak up the still-damp pigment in its path. I lift off some of the damp, loose paint with this thirsty brush, using a rolling motion and an even speed. From now on, each time I lift off some pigment, I clean and squeeze my brush dry before I touch the paper again. Otherwise I'd retransfer the paint I picked up from one spot to another. Speed and a sure hand are important when you touch your damp painting with this thirsty brush and drag and twist the brush on the surface, imitating the rolling wisps of clouds. This way you remove some dark pigment and if you don't have too much water on your painting, the soft, light brushmarks will survive as lifted out.

If you see the dark paint creeping back, it means your wash was still too damp. Squeeze your brush dry and remove more and more water from the painting until your brushstroke stays as applied. If your brushmark creates backrun edges, your brush was too wet as you touched the damp painting. Quickly squeeze it dry and soak off the excess water from the painting before it runs back and sets. To assure speed, I keep a large supply of tissues near my left hand and grab a clean one each time I squeeze my brush dry. This approach sounds complicated, but it must be performed with graceful ease and simplicity. Even the condition of the dry paper is important. These brushstrokes are fun to do, but don't get carried away and do too many. Too much technique is as bad as insufficient skill.

THE APPROACHING STORM

When a storm is approaching, a towering stack of billowing cumulus clouds is at the forefront. The dramatically large, turbulent clouds are usually accompanied by a striking dark contrast. The brightly lit white or golden yellow of the sunset's low brilliance is seen next to a deep blue sky and blends into deep greens, blues, and maroons, neutralized by even darker grays in the shaded parts of the storm clouds.

Don't try to paint this condition from your imagination. Each experience is unique and leaves a personal impact on you that enables you to capture the mood of the storm. The best way I know of to fix the condition in your memory is with a small, quick sketch and/or an accompanying photograph or two.

I can offer an important hint at this point. Regardless of how strong your center of interest may be, because of the gigantic dimensions of the billowing clouds, you have to minimize its importance to do justice to the magnificence of the storm. Consequently, the clouds are likely to be your center of interest, and everything else should complement it.

DOWNPOUR

A heavy downpour is an exciting experience. In the foreground, where the raindrops strike the blurred reflections on a wet surface such as a pavement or puddle, little white funnels splash up. The same effect, seen in the distance, can be represented with a light drybrush technique.

When you're finished with your composition, you can indicate rain direction by wetting the path of distant raindrops with a clean, damp brush and wiping off the loose pigment. However, the influence of these soft, light strokes on your composition is great. Be careful where you place them and how strongly you allow them to survive. Again, I caution you to use restraint.

GENTLE RAIN

The gentle sprinkle of droplets of rainwater tend to make us relax; its soothing sound seems like gentle music. One of the more obvious ways to represent—or it's better to say "hint at"—this experience is to paint the raindrop-caused ripples on the surface of quiet water. This water surface may be a puddle, a river, a lake, or an open barrel outside. Any similar water outside will serve the purpose. You should paint the reflective quality of the water first without the droplets, carefully watching its color and value. After your wash dries, wipe out the design of the circular ripples by wetting them, using the tip of a fine sable brush with a little clean water in it, then blotting up the loosened pigment with a tissue held in your other hand. This process has to be done carefully, obeying the laws of perspective. Remember, as the ripples get larger they lose sharpness and definition. This is a time-consuming technique that demands much discipline and a sense of design. However, it's fun to watch the ripples come to life. In fact, because it is so enjoyable, beware of doing too many.

RAIN ON WINDOWS

Another effective way to illustrate rain is to paint the running droplets on a glass surface such as a windowpane. One approach is as follows: If you're looking outside through a rainy window, first paint the landscape effect through each pane of glass exactly as you see it. After your washes are dry, put a drop of clean water at the top edge of one of the windowpanes on your painting and raise your paper to a vertical position until the droplet starts to creep down, leaving a path of moistened pigment behind it. Blot off this wet pigment with a tissue and repeat the process if necessary.

You need only a few well-designed dripping tracks of dripping rain to hint at water on glass, but you must carefully wipe them still lighter and sharper, as well as model their bottom sections where the accumulated bead of rain is round and shiny.

Another way to achieve a similar result is to blow the waterdrop across your painting while it's in a horizontal position, and then blot its path.

WET OBJECTS

During and shortly after a rainfall, when objects are wet, their surface becomes shiny and reflective, and they take on a richer, darker color and value than they had when dry. It is this contrast of dark values and sparkle that makes them look wet and shiny.

Take advantage of this opportunity for strong contrast by applying rich pigments with a drybrush technique. However, you must work quickly and decisively. Practice on a separate piece of paper if you're not sure of yourself; once you touch your painting, you cannot change your mind. Remember, hesitation is the enemy of freshness.

RAIN ON PLANTS

The waxy surface of leaves and flower petals forms a natural protection for the plants. Rainwater collects on them in jewel-like beads. Similar beads of water also frequently decorate wires, delicate weeds, cobwebs, and so forth.

When you paint these drops, a sure way to keep them crisp and shiny is to first mask them out with liquid latex. But define their shapes carefully when you mask them out, because they'll remain shaped exactly as the latex is applied. Don't be careless in your masking and then hope to correct the irregularity later. It's a sure way to invite trouble and kill freshness.

After you mask out their forms, paint the surrounding surface with rich, deep washes. When it's dry, remove the latex (as described in Chapter 2) and finish the shiny bead of water as you see it, with a rich contrast of light and dark modeling.

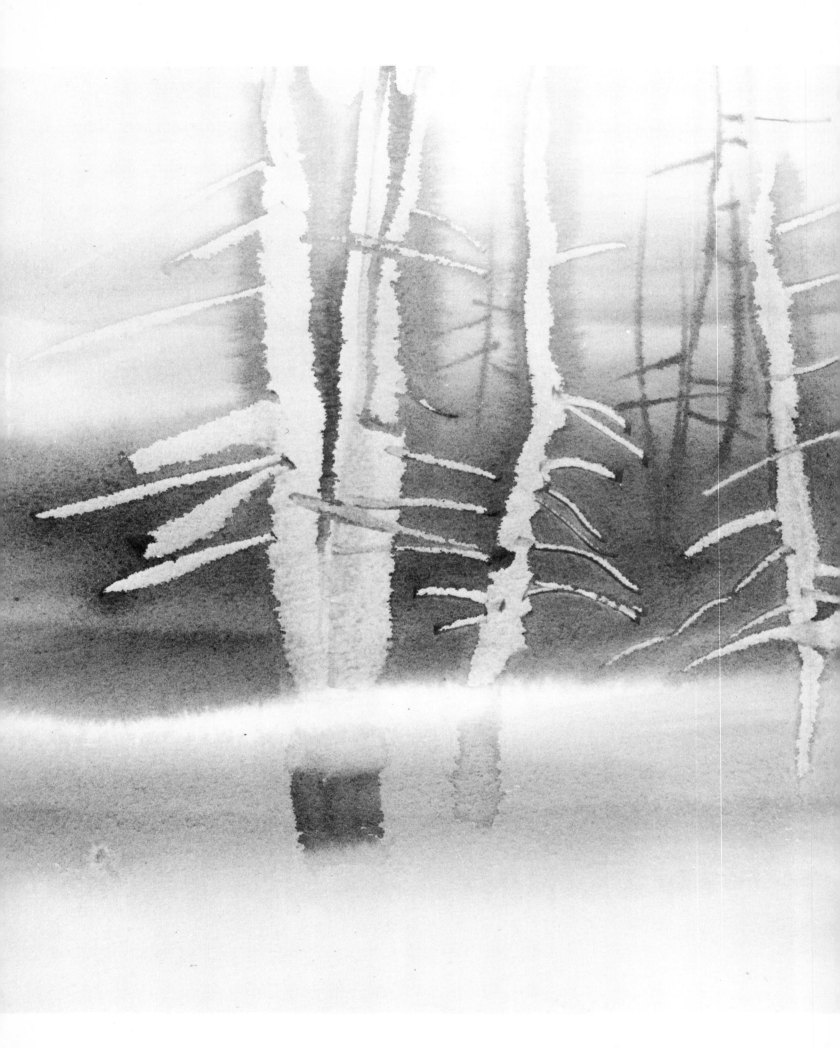

FOG AND MIST

When clouds are at ground level, we call them *fog* or *mist*. For a painter, the visual experience caused by misty conditions is the most important objective. The extreme humidity that can no longer be absorbed by the air becomes a visible vapor. This vapor acts as a filter, cutting down visibility drastically and simplifying forms. Details are visible only on close objects; all others show their silhouetted shapes without textural definition. Because the forms are extremely simplified, accurate application of values is of the utmost importance. The center of interest is almost inevitably a closer object because it can bear the richest details.

COLORS IN FOG

The filtering effects of mist or fog mean a reduction in color. Fog has a gray quality but it varies from cool to warm gray depending on which color dominates it: the blue sky from above, the orangy sunlight at dawn, or the ground's surface coloring. I usually exaggerate these qualities to assure color unity.

Because the distant forms are reduced in hue, the closer ones naturally appear more colorful by contrast. The dampness in the air wets their surfaces and deepens their value as well. Correct judgment of color enhances the believability of fog.

ROLLING MIST

Fog or mist is very seldom stationary. It rolls with the breeze even when it completely surrounds us. Objects constantly hide and reappear. The mist looks darker and more dense in some spots and lighter, more transparent in others. I suggest that you exaggerate this light and dark play of values by starting your painting with a wet-in-wet approach, using a large, soft brush. The design pattern of these soft shapes must complement your total composition.

The rolling mist doesn't always surround us completely. At times it appears as ground fog, hiding only the low parts of objects. This familiar scene is a natural condition for watercolor. I usually start by wetting the paper first. Then I establish the soft values on the wet surface.

LIGHT FORMS AGAINST DARK

If there are any light forms against a dark background, for example, large, bleached, tree stumps emerging from a fog-covered lake, I knife or wipe them out while the paper is in the receptively damp condition. To do this, I always start the knife at the fog area, moving upward toward the sharper top. If I were to move the other way, the paint accumulated under the knife would leave a dark lump of rich paint at the edge of the mist when you lift the knife, at the spot where soft blending is necessary.

DARK FORMS AGAINST LIGHT

When darker shapes emerge from a soft, light background, I carefully lose their edge by wetting the fading end of the wash with a thirsty brush, allowing them to lose their value completely.

EDGES

The careful location of forms in and out of the fog must follow the laws of perspective. They all shouldn't be cut off at the same level. Also, the closer forms fade more slowly, the more distant ones, quicker. They can never stop sharply or they'll appear suspended. Soft and well-controlled lost-and-found edges are extremely important technical touches. There simply is no room in watercolor for backruns or unsuccessful brushstrokes when you paint soft forms. The fine balance of edges, values, and color will give life to a misty watercolor.

MANMADE STRUCTURES

In time, pleasing objects become even more so, and ugly ones become more bearable and sometimes outright charming after exposure to the elements. A new fence post distracts from a landscape; a weathered, cracked, moss-covered one blends with its environment. A new cottage on a neat, barren lot appears raw, but the same structure twenty years later has mellowed, and when trees and shrubs have grown around it, it belongs to its surroundings.

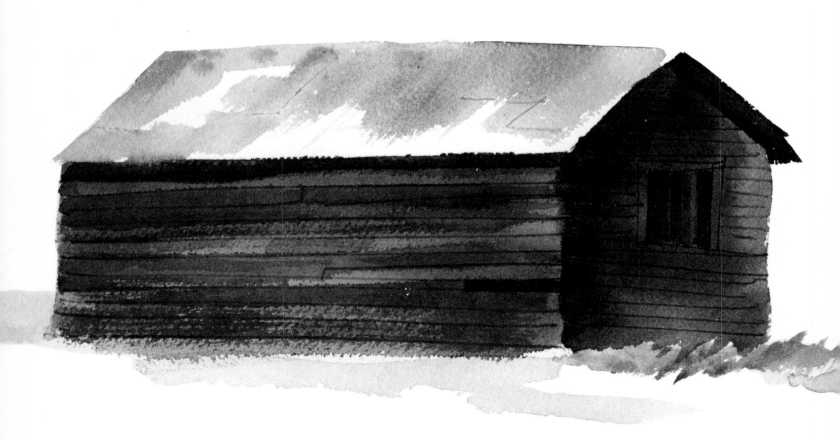

WOODEN STRUCTURES AND BARNS

Through history, man has made structures out of wood. Wood is an easy material to build with because it is soft enough to cut and carve. Wood ages quickly. Therefore modern structures are varnished or covered with some protective cover to extend the life of the wood. The aging texture on wood finishes is a very paintable and challenging problem for the watercolorist.

I won't attempt to list the potentially paintable wooden structures, but I will mention a few typical examples that should start you off on the road to understanding their nature. Besides the usual rules of good value, form, composition, and color control, you must pay special attention to texture.

TEXTURE OF AGING WOOD

Because of its organic nature, as wood ages, it responds to weather by changing color—becoming duller and grayer—and it begins to collect living organisms, such as moss, on its surface. During the aging process, the wood also suffers wind damage; it cracks from frost when it is wet, it splits, and so forth. The chips, tilted angles, exposed grains, and cracks must be carefully designed to complement your painting. Don't paint them exactly as they appear. Instead, recreate the mood they inspire, but design their details. A crack or a missing board on a wall or other strong features based on the real subject, should be painted where and because it's needed and not because it's there, especially if it adds superfluous detail.

At first you must consider the wall surface and its texture as a whole, without the details. When the same structure is closer, details such as the cracks between boards take on more significance. To quickly render these lines into your wet wash, draw them in with the sharp point of your brush handle. These dark lines can't be blotted or lifted up, so draw them carefully, keeping this in mind.

COLOR OF AGING WOOD

An aging surface changes color constantly. The severity of the climate determines how fast this deterioration shows. The color turns darker than the original color, first, followed by a graying hue. The value of aging wood also gets darker after exposure to the elements. Gray (French ultramarine plus burnt sienna), burnt umber, sepia, and burnt sienna are expressive colors to be used.

Pay careful attention to metal objects on aging wood. Nails, hinges, locks, and so forth, rust. The rusting metal releases a reddish brown color that runs down the wood after many years of rain, and stains it. This corroding metal adds a beautiful warm touch of color to the wood's surface.

Burnt sienna and brown madder, occasionally with some cadmium orange, are useful colors for painting rust stains. Apply them while the basic wood color is still wet so they blend softly. The locations of these reddish accents must be well designed, too. If the wooden surface is no closer than middleground, avoid adding extremely sharp details.

A wall made entirely of boards may be painted with parallel, medium-strength brushstrokes in varying widths, overlapping loosely some of the earlier brushstrokes. The result is varied values that look like boards, resting side by side.

NEW WOODEN SURFACE

My own personal preference is to paint manmade objects after nature has had a chance to improve on them. However, newly made objects can also be beautiful and rewarding to paint, depending upon the mood they set and the attitude of the artist toward them.

In the case of a freshly built wooden structure—a building, a fence, a boardwalk, or whatever — new wood tends to make it look too clean and well-tailored. Don't deny this sense of newness in your painting. It should reflect the color and the texture of this fresh-smelling wood. Your colors can be in many shades of pale yellows, reds, or greens, but they're always warmer and brighter when new.

On newly cut wood, the grain that shows the fibrous structure and the knots is clearly visible and should be painted carefully if the wood is seen close up. To paint this, you must apply your light values first with the appropriate color—without texture. During the semidry condition, you can paint the soft blurry knots and some of the soft wood grain with hardly any water in your (bristle) brush, but with rich paint. Your brushstrokes should resemble drybrush, but applied to a damp surface instead of a dry one. The moist surface softens the brushmarks and prevents them from turning sharp and hard like a drybrush stroke. After your paint is thoroughly dry, add the texture with fine drybrush strokes.

Some of my favorite colors for this are raw sienna, burnt sienna, yellow ochre, new gamboge, aureolin yellow, or cadmium yellow, diluted for the basic washes. For modeling and the wood grain, I like to use sepia, burnt sienna, or warm sepia blended with other hues like yellow ochre, new gamboge, or another strong yellow or some of the complementary blues for controlling intensity. The color of new wood can and should be used for sawdust and wood chips, and not only for a neatly finished exterior.

SUNLIGHT ON OLD WOOD

Old surfaces are especially appealing when they show sunlight and shadows. Sun patches under trees, overhanging ledges, and the like add attractive touches to an already interesting surface. Shadows are usually glazed onto the lighter, sunlit surfaces.

But there's another more interesting way — the sunlit areas can be lifted out. First finish all the drybrush texture on white paper with a dark color like sepia and add the tone value on top to the whole surface as though it were entirely in shade. When it dries, rewet the area to be sunlit, a brushstroke at a time, with a soft, wet brush. Rub off the loose paint with a crumpled, soft, paper tissue, holding the brush in your painting hand and the tissue in the other. This gives you the shortest time between wetting and blotting so that you won't lift off too much color. Repeat this process until your sunlit area is light and the shadow remains as dark as the original wash. Most of the texture as well as the same general tone will survive in the sunlit area, but it will be lighter. This is a time-consuming technique, but it's a safe way to avoid hard edges on the shadows and to assure color unity between light and shadow areas.

MOSS ON WOOD

Living organisms such as moss find a home on decaying wood, where they supply rich color accents. Analyze their color and choose the appropriate pigment to paint them with. Manganese blue, cerulean blue, cadmium orange, burnt sienna, and sap green in varied combinations are good, applicable colors. A good approach is to paint your wooden surface with the first washes, soft modeling them without the mossy patches. Before your drybrush texturing, drop the clean colors mentioned above (cerulean blue and sap green or cadmium orange and manganese blue) into the still-damp paint. These droplets will create little backruns and push the original paint out of the way, forming irregular bright color spots that will dry with hard edges looking like mossy patches. After drying, you can add more texture with drybrush. The important thing is the contrast in texture, brushstroke direction, color, and the value between the wood and the mossy patches.

ENVIRONMENTAL INFLUENCES

The surroundings also add touches to the aging process. A dusty road beside a barn, a cobweb or a fence post with a thick layer of dust creates a feeling of time gone by.

To paint a dusty surface, use a little of the more opaque colors in your basic wash. The addition of diluted opaque pigments like yellow ochre or cerulean blue will give the wood a chalky, dusty appearance after the wash dries. Be careful not to add too much of these colors or you'll muddy your basic wash.

When I paint light cobwebs against a dark background, I first finish the wood without them. After the wash dries, with a damp sable I rewet and lift them out one brushstroke at a time. This way the cobwebs will look light and sharp in front of the dark value. The shape and structure of the cobwebs should be soft and delicate but believable in design.

Natural additions to the wood — moss and cobwebs, let's say—should differ in texture from the wood itself. Manmade additions — such as poles, fenceposts, and the wall of a shack— should be designed to complement and enhance your wooden structure.

SHINGLES

Wooden shingles are used for wall or roof coverings, farm buildings, sheds, carports, barn walls, and other structures. Better-quality structures often have cedar shingles because of their decorative and lasting qualities. Cedar has a warm, reddish brown, natural hue that browns and darkens with age.

Shingles overlap each other to stop the rain from going under them. Under the overlaps, the color of the shingles stays brighter because it's protected from the elements by the thick lip of the shingles above. To paint this, first paint the shingles one horizontal row at a time with a double-loaded flat brush, dark on one half and light on the other. With one double-loaded brushstroke, you can apply both colors simultaneously. Into this wet, split-brush wash draw the cracks, separating the shingles with the tip of your brush handle or the thin edge of your knife. Finish the texture with drybrush strokes. Don't overemphasize the rows of shingles against the wall unit. And don't make the shingles even in size and shape.

HAND-CARVED WOOD

Old timbers were formed with crude instruments such as axes that left clearly visible nicks and marks. When you paint them, show the change in the surface modeling and the sharp edges where the axe marks stop. These marks don't show on distant beams, but in foreground areas they add textural interest and date the wood.

The edges of shadows against sunlit areas help to play up these forms, so exaggerate them a little. Hand-carved wood like totem poles may be painted similarly. Pay attention to the shadows of the angular sides. They must be on one side only, opposite the light source, the sun.

Wooden surfaces are basically studies in texture. If you're hesitant about technique, try small texture studies. When these studies or "decision makers" are satisfactory, carefully follow that particular technique on your painting. Don't change your style in midstream and create conflicts that may break up a potentially good painting.

WOODEN FENCES

Fences vary from old, wooden, log fences—perhaps of cedar—to snake fences, split rail fences, lined-up root fences, and carefully carved picket fences. But, in time, all fences attract moss, algae, and other living organisms. The wood itself gets gray from the sun and weather. To this neutral tone come bright colorful touches, such as green moss, orange fungi, and white snow. I like to exaggerate these supporting influences. I paint the wood a little more textured, but duller, and contrast it with brighter and more colorful growth than is there in reality.

METAL FENCES AND HARDWARE

Metal fences, such as wrought iron, wire, corrugated tin, and hinges, eventually rust with age, even if they were painted originally. The reddish brown corrosion adds a warm color and hints of passing time. I like to paint rusty metal fences in burnt sienna, brown madder, cadmium orange, with the occasional cooling influence of a green or a blue.

STONE FENCES

When the pioneers cleared fields for agriculture, they found glacially deposited round boulders sprinkled over good farmland. They removed them from their fields, piled them in rows, and made fences of them. These stone fences follow the contour of the land and are excellent subjects for a painting. Acting as a buffer from the wind, they trap flying seedlings and offer protection to weeds and young trees. As a result, there's an increase of vegetation directly around them. The fence itself, nestled among this lush growth, contains some outstanding boulders, attractive in size, color, and contrast.

WIRE FENCES

Wire fences are usually tied to wooden or steel posts. My favorites are the crudely cut fences with their tipsy, wobbly posts. They age beautifully and along with other fences, offer excellent design possibilities. You can paint the wire stretched between them in several ways.

One way is by scratching or knifing in the wires. As you apply your textured wash on the spaces between the posts, draw a thin linear design of the wire fence into the very wet pigment with the edge of a firmly held palette knife or pointed object such as the sharp tip of your brush handle. After the wet wash dries, your wires will show as a thin, dark line.

Another way to treat this is by drawing the wires in. First, finish your basic wash and let it dry. On the dry surface, draw the wires with the edge of a lightly loaded palette knife using dark *liquid* paint. Be sure to hold the knife carefully with an edgewise contact of its tip and drag it quickly. Caution: If you have too much wet pigment on your knife or if your paper has damp spots as it attracts water it will run into a lump of paint and blob. If this should happen, blot it off immediately with a clean tissue. Let it dry and proceed again on the completely dry surface, this time with less paint on your knife.

STONE BUILDINGS

Stone buildings, stone walls built with mortar, fireplaces, and masonry structures where the stone is visibly exposed can be painted effectively with a combination of drybrush and palette knife modeling. If the mortar is darker than the stones, apply your wash as a dark value and knife out the irregular forms of the stones from the damp wash with vigorous pressure of the firm part of your knife. The accumulated narrow, dark spaces between knifestrokes serve as the dark mortar. For a stone wall where the mortar is lighter than the stones, paint the uneven sizes and shapes of rocks with drybrushing and knife modeling, ending up with medium-value shapes. You may leave the thin mortar area pure white and put a light glaze of the desired color over the white lines or the whole wall including the white mortar if the first touches are dry. You must glaze quickly so as not to disturb the texture of the stony surface. Another approach to painting light mortar is to allow the dark stone washes to touch and then knife or wipe off the light mortar before the paint dries or afterward by rewetting the dry pigment.

PARTS OF BUILDINGS

When you paint units such as walls or fences, don't overemphasize the individual elements at the cost of the whole. A stone wall shouldn't look like many irregular stones around each other, but like a flat surface made of these irregularly shaped stones. If there are unifying surface decorations, such as smoke on the fireplace, vines, washmarks of rusty metal, and slimy seaweeds on a breakwater, use them to unite the composition.

STUCCO, PLASTER, AND CONCRETE

Stucco, plaster, or concrete as they appear on house walls, floors, breakwaters, dams, and such, usually show as mottled, grainy surfaces. Stucco often shows layered patches. Concrete and stucco chip and crack.

I use a combination of one or several glazes with separating colors, while holding the paper in a horizontal, level position. I allow these washes to dry undisturbed, then touch up this granular separated texture after it dries with some drybrush modeling, some splatter, and a few cracks of dark lines painted on with the tip of the palette knife, dragged against the back of its round tip.

BRICK

Brick structures and walls should be approached with a painting technique similar to the one for stone walls. The difference is in the color of the pigments you use in the wash and in the more regular sizes of your knife-strokes. Don't paint every single brick, but design the wall with some irregular units of bricks knifed, glazed, and in harmony with your total composition.

GLASS

Glass, like watercolor, is transparent or, at least, translucent. This natural affinity between subject and medium makes it necessary to understand the principles involved. Transparent window glass permits clear vision of objects through it, without visible distortion. However, bent into other forms, such as drinking glasses, it still permits the light to pass through, but now with distortion. The degree of distortion depends upon the glass' thickness and on the amount of angles and curves. In addition to its transparency and distortion, the generally shiny surface of glass is also reflective if the area behind it is dark enough. The amount of dirt on its surface also affects these qualities.

In short, the principal qualities of glass are transparency, reflection, distortion, color — and the effects of surface soil, which can negate these first four properties. If you're hesitant to paint glass because of its complexity, make separate studies before trying a major composition, to gain confidence and familiarity with the subject.

WINDOWS AND CRACKED PANES

In the daytime, if you look through windows into the darkened interiors of buildings, you won't be able to see in. Instead, if the window surfaces are clean, they're good reflectors and mirror the sky or the outside surroundings. However, if you're inside looking out, you can show the transparency of the windows by painting the light values of the outdoors against the relatively dark contrasting values of the window frame and interior details.

To paint cracks in windowpanes seen against a light background, scrape them into the still-wet wash of the window with any sharp, firm object — such as the pointed tip of a brush handle, a palette knife, or a pocket-knife. To paint cracks seen against a dark background lift the thin lines of the crack with a knife while the paint is still damp or wet, and blot it off with the tip of a pointed, soft, thirsty brush and a tissue.

Remember, because glass is brittle, cracks in it are fast and sharp — and should be designed accordingly. Avoid rubbery, hesitant lines — they look like they're on the surface of the glass, not within it.

Sometimes in painting old structures, you'll want to paint the overlapping jagged layers of broken glass occasionally found in old windows. Where glass overlaps, dust tends to accumulate and transparency is reduced. When viewed toward the light, this appears as a double layer of values that can be painted with two overlapping washes of a light gray glaze. When viewed against a dark background, you can paint layers of glass by using a wet-and-blot technique to lift off the overlapping area from the dry paper, leaving the edges sharp and keeping the entire single layer glass area darker and the same value.

DUSTY OR DIRTY GLASS

If glass isn't constantly cleaned, it attracts dust and dirt. This condition is very paintable and can be used to create a mood of nostalgia. I like to paint dusty glass with a combination wash of several colors, each brushstroke having a little different mixture of a preselected number of pigments. Examples of the pigments I choose from are: yellow ochre, sepia, cerulean blue, Antwerp blue, raw sienna, burnt sienna, French ultramarine, Paynes gray, and Davies gray. I usually select two or three of them and, as I slap on my wash, let each brushload flow and blend on the paper, confined only by the edges of the glass shape.

PAINTING TECHNIQUES IN COLOR

Color and Watercolor Pigments

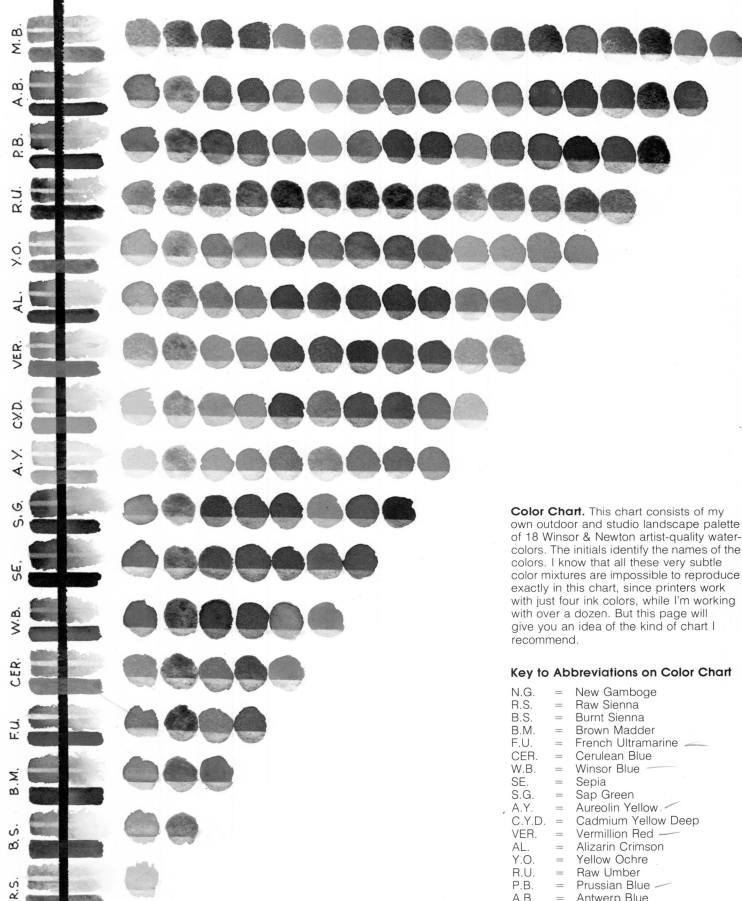

Color Chart. This chart consists of my own outdoor and studio landscape palette of 18 Winsor & Newton artist-quality watercolors. The initials identify the names of the colors. I know that all these very subtle color mixtures are impossible to reproduce exactly in this chart, since printers work with just four ink colors, while I'm working with over a dozen. But this page will give you an idea of the kind of chart I recommend.

Key to Abbreviations on Color Chart

N.G.	=	New Gamboge
R.S.	=	Raw Sienna
B.S.	=	Burnt Sienna
B.M.	=	Brown Madder
F.U.	=	French Ultramarine
CER.	=	Cerulean Blue
W.B.	=	Winsor Blue
SE.	=	Sepia
S.G.	=	Sap Green
A.Y.	=	Aureolin Yellow
C.Y.D.	=	Cadmium Yellow Deep
VER.	=	Vermillion Red
AL.	=	Alizarin Crimson
Y.O.	=	Yellow Ochre
R.U.	=	Raw Umber
P.B.	=	Prussian Blue
A.B.	=	Antwerp Blue
M.B.	=	Manganese Blue

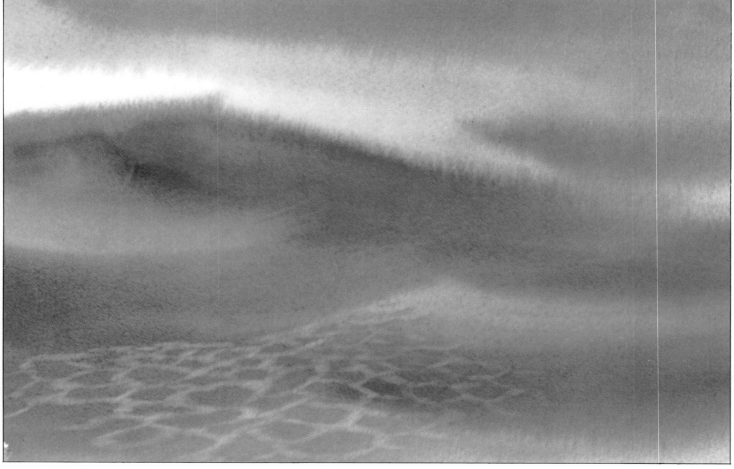

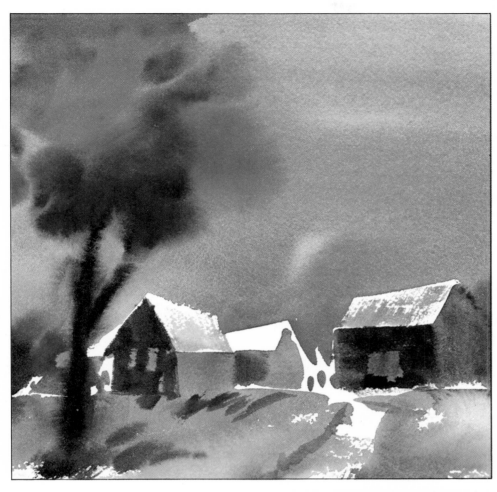

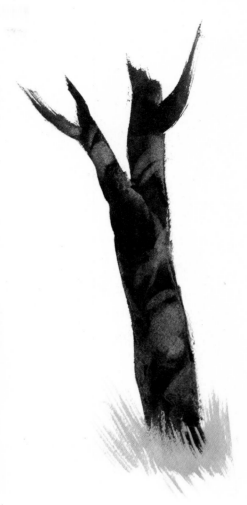

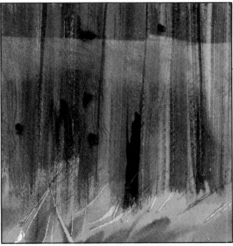

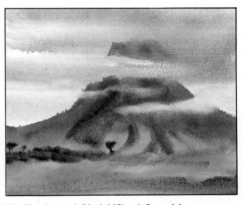

Wetted and Blot-Lifted Petals. (Above) I wiped out the petals of the daisy using as a guide a small paper stencil shaped like a single petal.

Thirsty Brush for Wisps of Clouds. (Top left) I washed in the sky with burnt sienna, brown madder, Antwerp blue, and French ultramarine, leaving some spaces white. I squeezed a soft 1″ (2.5 cm) flat brush thirsty dry, rolled it in the damp paint, and lifted off the wispy shapes. I finished the foreground with a wash of Antwerp blue, sepia, and raw sienna.

Thirsty Brush for Refractions in Waves. (Left) I started with rich washes of raw sienna, Antwerp blue, French ultramarine, and sap green for the large waves. After they dried, I lifted out the diamond shapes within the waves with the tip of a damp brush, using a wet-and-blot technique.

Bristle Brushstrokes on Wet Paper. (Top) I wetted the paper around the white roofs of the buildings. Using a 1¼″ (3 cm) wide, slanted, bristle brush, I painted in the lighter sky and hills, squeezed out the brush and painted in the tree, then I finished by painting the walls.

Wetted and Blot-Lifted Rays of Sunlight. (Above) I painted on the wood-grain first with a drybrush technique, using sepia. After it dried, I glazed on sepia and burnt sienna. When this wash had dried too, I wetted the area where the light starts and wiped off the loose paint with a bunched-up tissue. I repeated this technique several times.

Wetted and Blot-Lifted Sunshine on a Tree. (Top) I painted the tree with burnt sienna, sap green, and French ultramarine. I wetted and wiped off the sunspots after the paint dried.

Wetted and Blot-Lifted Clouds. (Above) I painted the mountain wet-on-dry and wiped off the top cloud while the wash was wet, but I wetted and blot-lifted off the lower ones.

Special Techniques

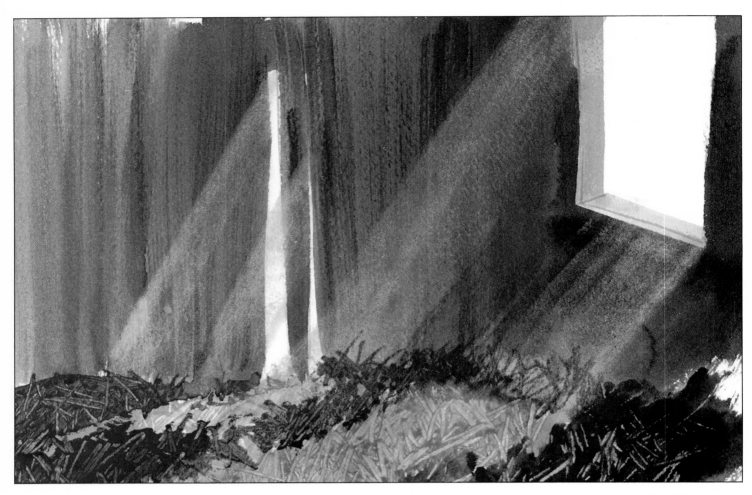

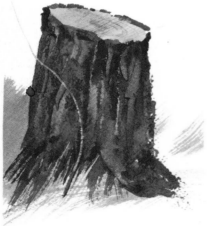

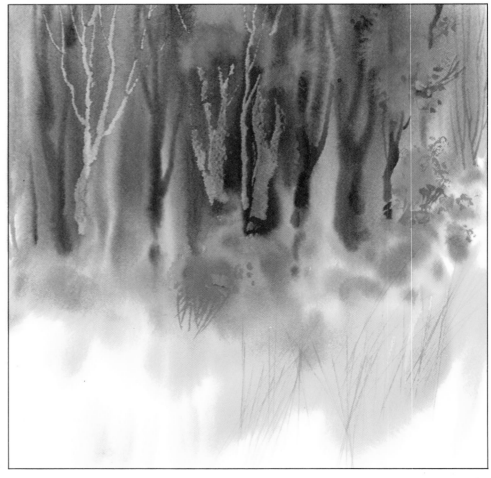

Scraping Out Light and Dark Lines.
(Top) Depending on the colors I use—
burnt sienna, raw sienna, French ul-
tramarine, or sepia—I will get light and
dark, or warm and cool values. I got this
texture by moving the tip of the nail clipper
handle in the wet paint, pressing vigor-
ously back and forth.

Scraping Out Dark Lines. (Above) I
created the growth rings and sawed edges
of the tree stump by scraping them into the
wet paint with the handle of a nail clipper.

Scraping Out Light Lines. (Right) In this
sketch of a forest, I washed some burnt
sienna and yellow ochre onto the paper
and scraped in the foreground weeds.

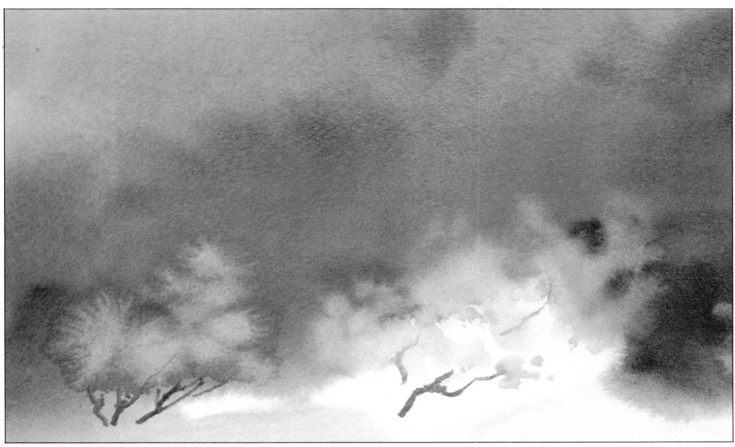

Color in Droplet Backruns. Just before the shine left the wash, I dropped clear water and alizarin crimson into a background of neutral colors (any dark mixture will work). The finished effect looks like small tree shapes.

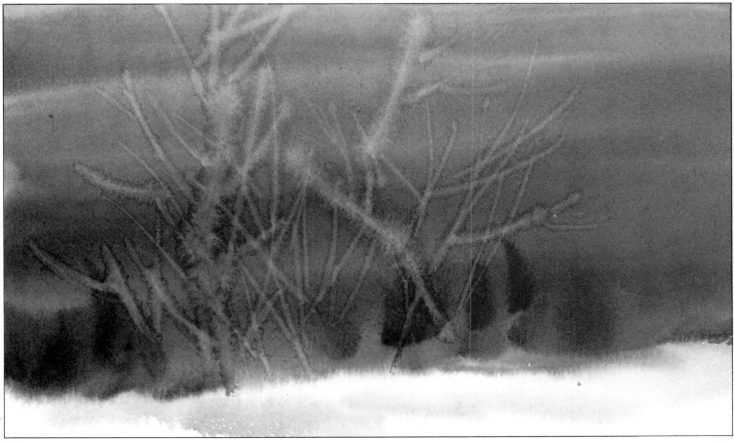

Linear Backruns. I applied a mixture of brown madder, Antwerp blue, French ultramarine, and burnt sienna to wet paper. As it lost its shine, I painted thin lines of clear water into the drying pigment with a rigger brush. I then added the snow at the bottom.

Special Techniques

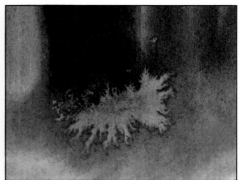

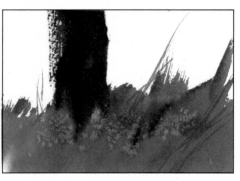

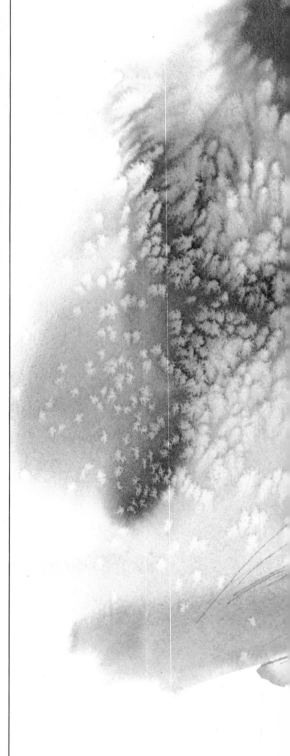

Salt with Staining Color. On these samples, one staining color dominates a mix, and the salt picks up that color. I used Winsor blue and sepia for the night sky (upper left), after painting it around the shape of the moon. The stars are blue spots created by the salt. The jungle plantlike shape (upper right) is dominated by the sap green color; the melting salt has defined its form. For the red flowers (lower left), I used a mixture of alizarin crimson and sepia. The alizarin crimson dominated the mix. I threw the salt into it before the wash dried. The blue flowers (lower right) were also created by the salt. I used Winsor blue together with raw sienna for the grass, but the Winsor blue is dominant.

Flowing Salt for a Blizzard. I started with a wet-in-wet background of French ultramarine and burnt sienna. The paper buckled under the wet wash. I sprinkled salt onto the wet paper and the salt melted and flowed into the water. This snowy blizzard was the result. Later, on the dry paper, I painted the foreground stump and grass with burnt sienna, French ultramarine, and raw sienna.

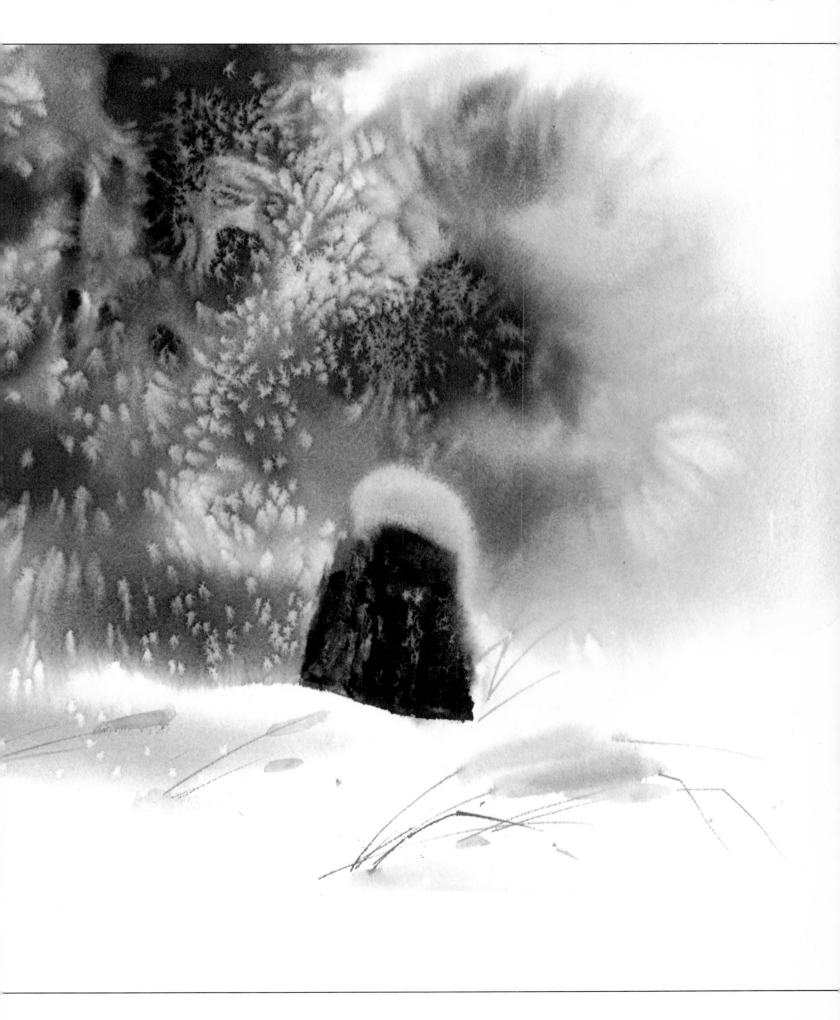

Special Techniques

Masking Out Floral Shapes. (Right) First I painted rubber cement onto the pure paper and let it dry. Then I painted the background over it wet-in-wet, using sepia, French ultramarine, and raw sienna. After this dried, I removed the rubber cement and exposed the white masked-out shape. I glazed a little raw sienna over the white area to show how I'd color it.

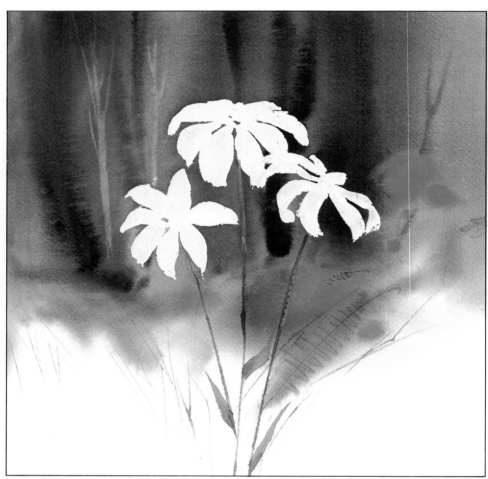

Masking Out a Wide Variety of Edges. (Above) These two unfinished closeups of weeds demonstrate that both fine and bold lines can be masked with latex. On the unpainted areas, note how sharp the edges remain.

Masking Out Foreground Details. (Right) I used liquid latex to mask out the fine weeds in the foreground. Next, I painted the water and trees over the dry latex, using French ultramarine, Antwerp blue, burnt sienna, and raw sienna. After these washes dried, I lifted off the latex with masking tape and finished the exposed white shapes with fresh colors of raw sienna and Antwerp blue.

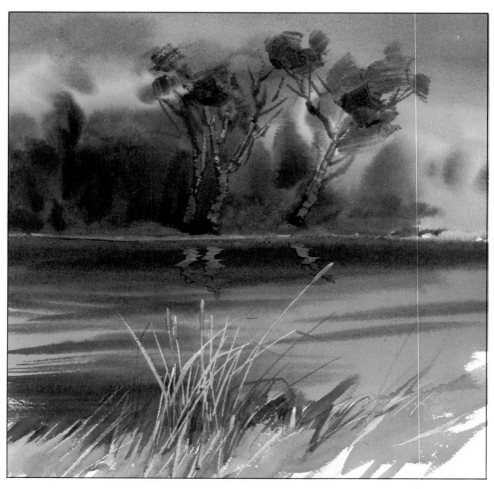

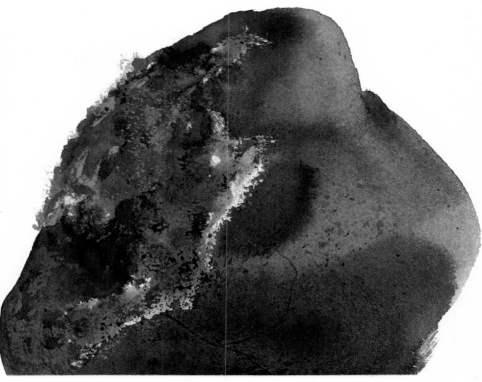

Waxing Out Cement Blocks and Woodgrain. (Above) In both cases, I applied paraffin wax over a light, dry wash and painted a darker shade on top.

Waxing Out Moss on a Rock. I waxed out the lush texture of the moss in three steps. Each time I rubbed on a little paraffin wax, I glazed on more color and let it dry. Finally, I removed the wax by ironing a paper tissue on top. As the wax melted, the tissue soaked it up. I started modeling the rock with wet washes, followed later by drybrush texturing.

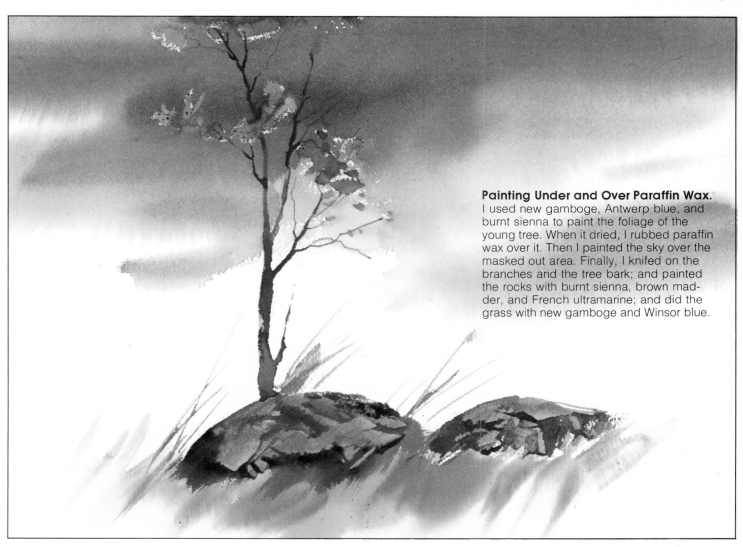

Painting Under and Over Paraffin Wax. I used new gamboge, Antwerp blue, and burnt sienna to paint the foliage of the young tree. When it dried, I rubbed paraffin wax over it. Then I painted the sky over the masked out area. Finally, I knifed on the branches and the tree bark; and painted the rocks with burnt sienna, brown madder, and French ultramarine; and did the grass with new gamboge and Winsor blue.

Trees and Shrubs

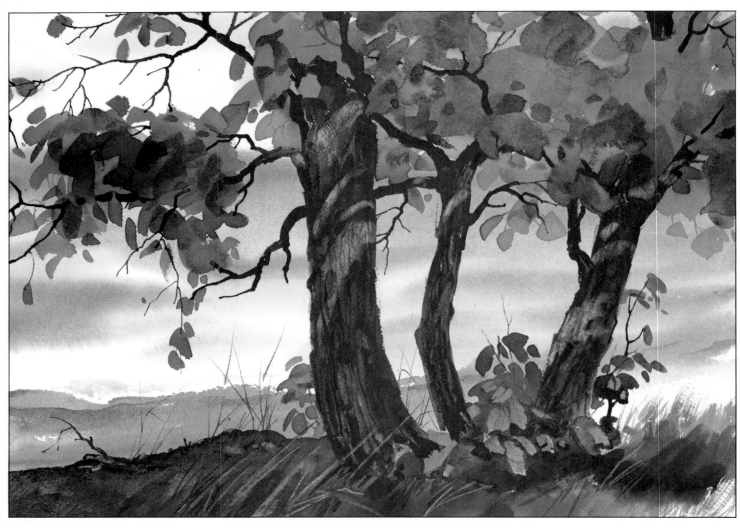

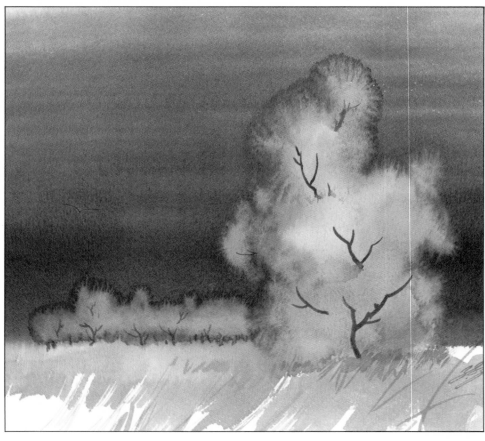

Deciduous Trees in Summer. (Above) For the rich, dark-green foliage of deciduous trees in summer, I applied a dark silhouette wash of French ultramarine, a little burnt sienna, and lots of Winsor & Newton sap green. I glazed it on with separate brushstrokes in several layers for the crowns of the larger trees. Then, before the paint dried, I knifed out the shapes of the lighter green leaves, allowing them to shine through. Note how the sap green color has tinted the paper.

Deciduous Trees in Spring. While the background wash of sepia and French ultramarine was still damp, I sprinkled clean droplets of water into it to create the flowering branches. In some places I added a little alizarin crimson to make the backruns look pink. The nearer blooms are better defined than those in the distance.

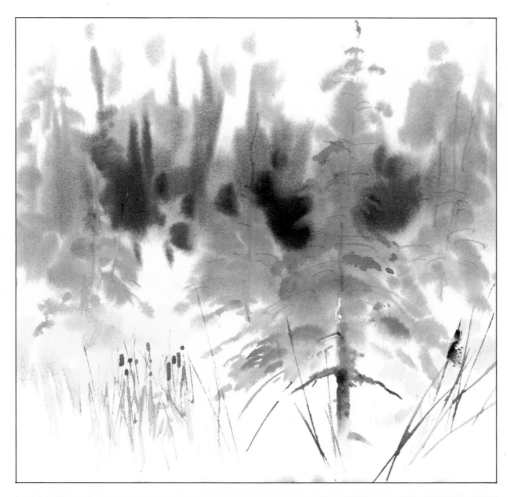

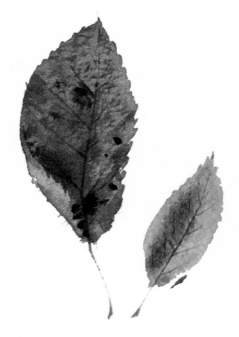

Fallen Leaves. (Above) To paint the leaves, I wet blended the colors and scratched the veins into the wet wash with the point of my brush handle. I drybrushed some texture onto the dry surface.

Tamarack Trees in Autumn. (Left) I painted the autumn colors of the tamarack trees wet-in-wet with a combination of raw sienna, new gamboge, and burnt sienna against the cool grays of French ultramarine and burnt sienna. I scraped in the dark branches with my brush handle.

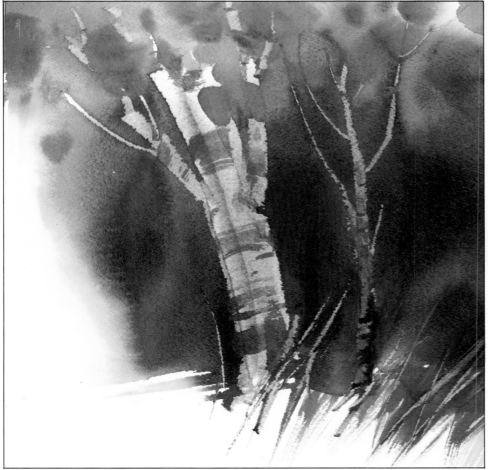

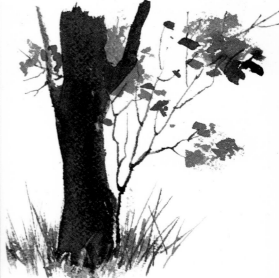

Autumn Maple. (Above) To paint the young maple, I knifed on brown madder by tapping the paint on with the flat of the knife. With the tip of my knife I added a few defined leaves to the edges of the red clumps.

Birch Trees in Autumn. (Left) To start the autumn foliage of a birch, I painted rich brushfuls of new gamboge, cadmium yellow deep, and burnt sienna onto a wet background. Burnt sienna and French ultramarine appear as a deeper value next to the yellows.

Trees and Shrubs

Winter Scene. (Right) The fine, lacy twigs were painted with a damp, round, No. 11 sable brush, using a split drybrush technique. Starting at the outside edge of the tree, I pressed down the neck of the brush at the ferrule (where it joins the handle), forcing the hair to spread out like open fingers. With just a touch of warm sepia, I drybrushed the delicate lines from the outside edge of the tree inward, quickly pulling and lifting the brush toward the larger branch. I put on the last few details with a small brush when the wash was dry.

Young Spruce. (Below) To make the fuzzy edges of spruce needles look round and soft, you must time your wash carefully. I first wetted the paper slightly so that it was damp, but not shiny wet. With very little water, using a No. 5 round sable, I brushed on a strong mixture of Antwerp blue, burnt sienna, and raw sienna. My brushstrokes blurred and softened on the damp paper. I drybrushed on some texture as a final touch.

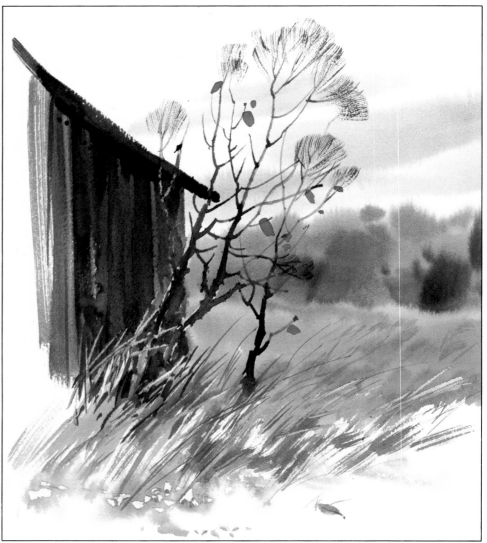

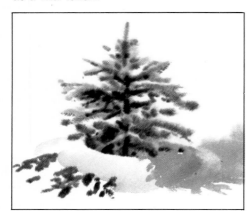

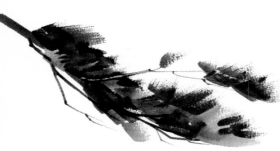

Closeup of a Pine Branch. (Above) I drybrushed on raw sienna and sepia first, and then added the darker, cooler Prussian blue with flicks of my brush. The supporting branches are knifed in after the needles are painted.

Dying Pine. (Right) I knifed on the trunk of the pine tree and the woody parts of the branches. I painted the needles with a bristle brush, flicking it upward on an angle and connecting my brushstrokes beside each other first in a medium value, then later in a dark glaze for the deeper modeling. Finally, I created depth by knifing out a few light lines on the pine needles.

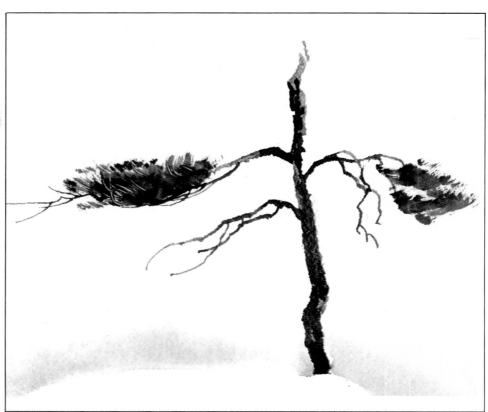

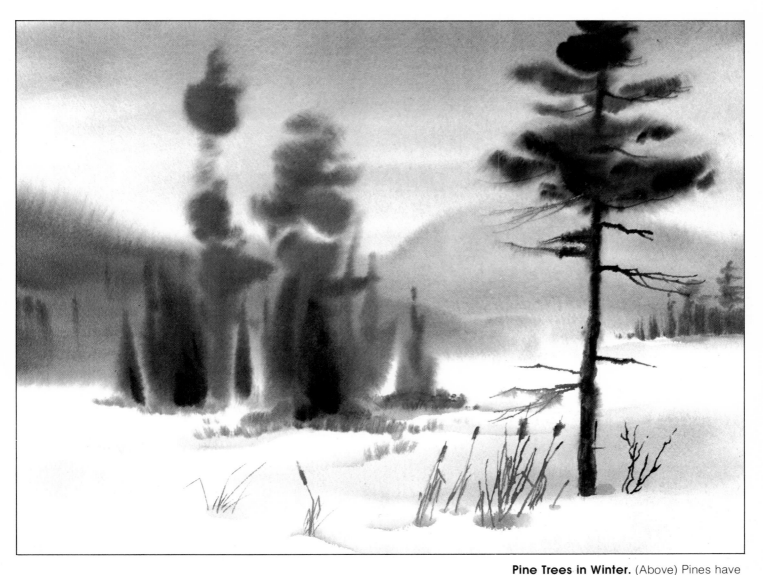

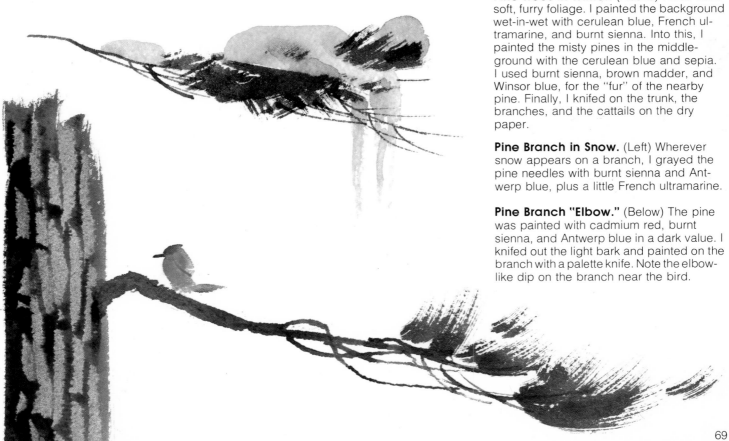

Pine Trees in Winter. (Above) Pines have soft, furry foliage. I painted the background wet-in-wet with cerulean blue, French ultramarine, and burnt sienna. Into this, I painted the misty pines in the middle-ground with the cerulean blue and sepia. I used burnt sienna, brown madder, and Winsor blue, for the "fur" of the nearby pine. Finally, I knifed on the trunk, the branches, and the cattails on the dry paper.

Pine Branch in Snow. (Left) Wherever snow appears on a branch, I grayed the pine needles with burnt sienna and Antwerp blue, plus a little French ultramarine.

Pine Branch "Elbow." (Below) The pine was painted with cadmium red, burnt sienna, and Antwerp blue in a dark value. I knifed out the light bark and painted on the branch with a palette knife. Note the elbow-like dip on the branch near the bird.

Trees and Shrubs

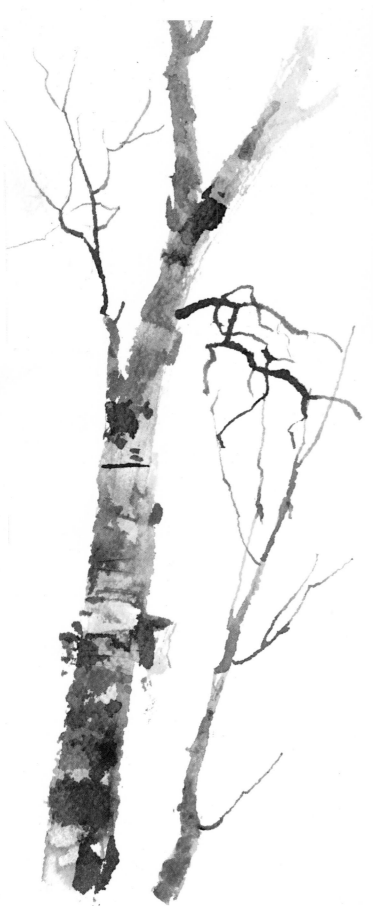

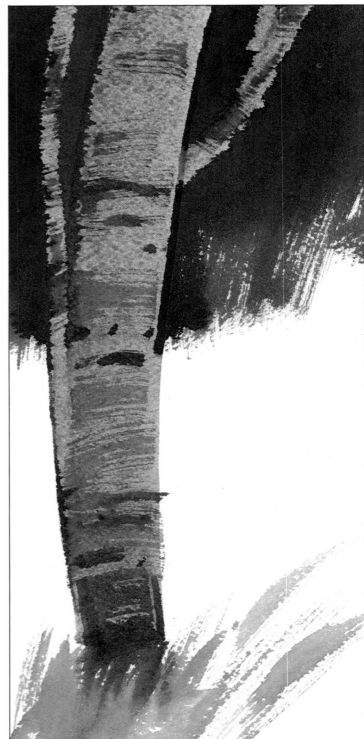

Modeling Birch Tree Trunks. (Above) A tree trunk must look strong, solid, and three-dimensional, but transparent enough to show the coarse texture of its bark. I usually model the bark of adult birch trees by brushing burnt sienna and French ultramarine onto the paper with a bristle brush. Then, as I did here, after letting the wash sit a few seconds, I knife out the birch trunk with an ordinary metal spatula, running it down the trunk until I run out of paint. I repeated the process here for the smaller branches, but this time using my painting knife or the tip of my pocketknife.

Young Birch Trunks. (Left) The trunk of a birch is light with white sparkles. Its young shoots are red and as dark as the branches. I started painting the larger trunk with a fast wash of burnt sienna and French ultramarine. I knifed out a few light bark strips and drybrushed on more texture later.

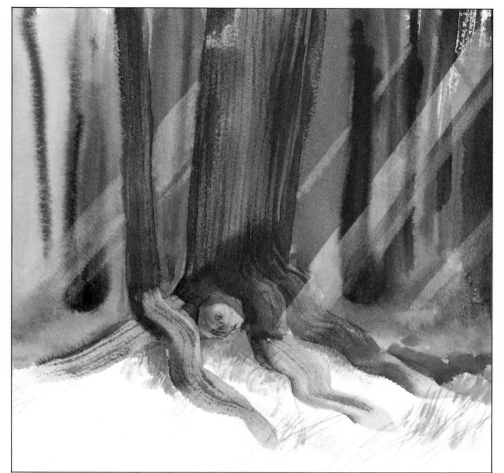

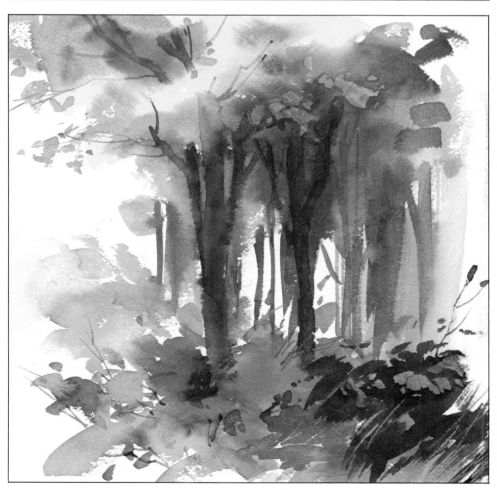

Tree Trunks in a Forest. I started painting the forest with wet brushstrokes of Antwerp blue and sepia. Into this, I added burnt sienna. French ultramarine, and new gamboge at the bottom. After this dried, I drybrushed on the bark of the closer trees. Finally, I lifted off the sun's rays with a wet-and-blot technique.

Texturing a Tree Trunk. (Above) I used a dark wash of Winsor blue and burnt sienna to paint on the pine bark. While it was still wet, I immediately knifed out the lighter texture with my palette knife. Both colors stained the paper. The tone behind the tree was added with a sponge.

Forest Shrubs and Undergrowth. For variety in the color of the shrubs, I used sap green, new gamboge, French ultramarine, burnt sienna, and Antwerp blue. The pattern of the shrubs stems from a natural variation of shapes, colors, and texture. I was careful not to paint the shrubs merely as a mechanical repeat, but varied them for interest. I wet blended, glazed, knifed, and drybrushed on the colors. The trees merged with the shrubs.

71

Trees and Shrubs

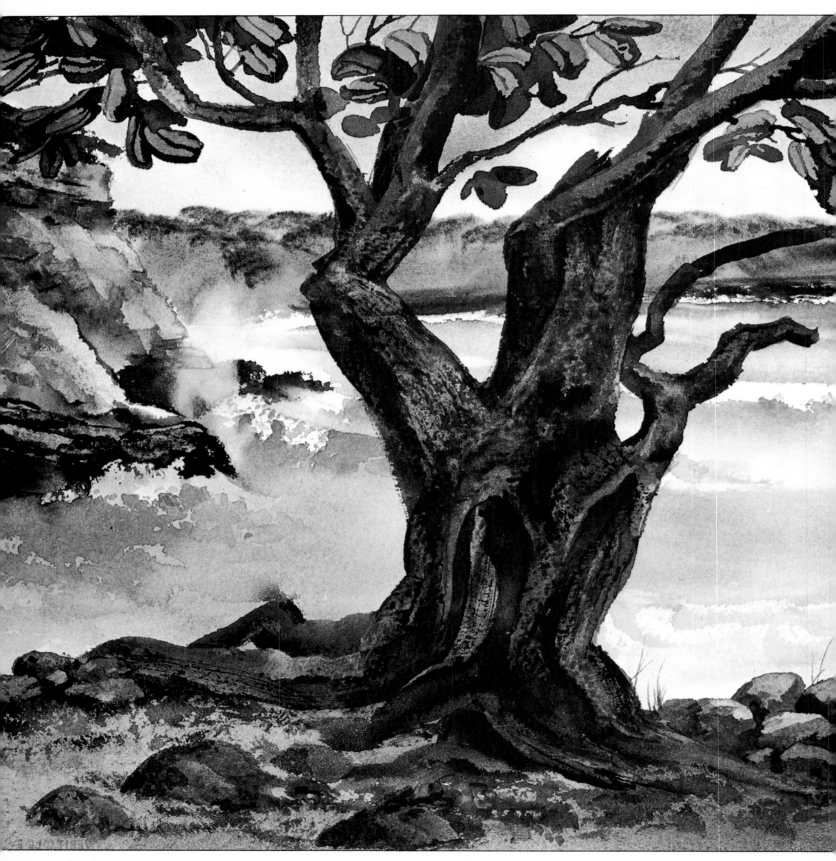

Tropical Tree. I painted the large leaves of a Hawaiian Falls camani tree with lots of Winsor & Newton sap green, French ultramarine, and burnt sienna in a dark silhouette wash. I knifed out the light green leaves with a single stroke for each leaf half. The sap green stained the paper and showed up as a light green after being knifed out.

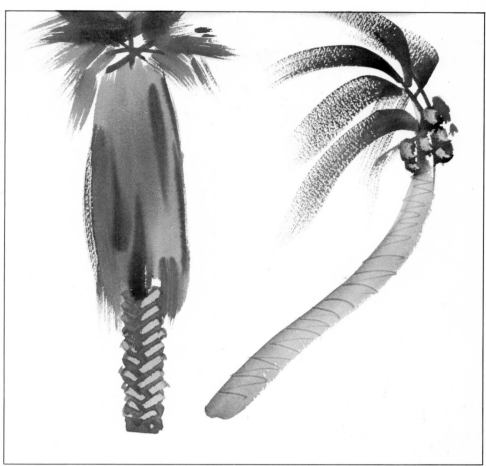

Palm Trees. First I brushed on French ultramarine, burnt sienna, and new gamboge. Then I knifed out the angular marks on the Washingtonian palm tree trunk (left). The curving zigzag rings of the coconut palm (right) were scraped on with the end of my brush handle. I drybrushed on the branches and knifed out the coconuts.

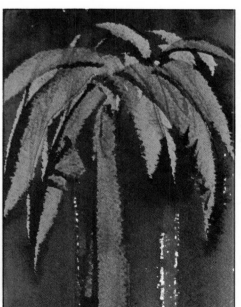

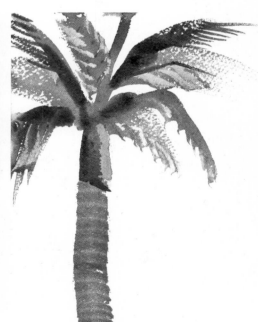

Palm Knifed Out of a Sap Green Background. For the palm, I brushed on a dark wash of sepia and sap green. I knifed out the light shapes with my palette knife. The sap green color remains.

Growth Rings on a Palm Tree. I painted these growth rings with a ¾″ (19 mm) soft, flat brush, starting at the top of the tree and pausing at every ring on the way down without lifting my brush. I had just enough water in the brush to carry the form—more would cause the paint to blend too much.

Grass, Weeds, and Flowers

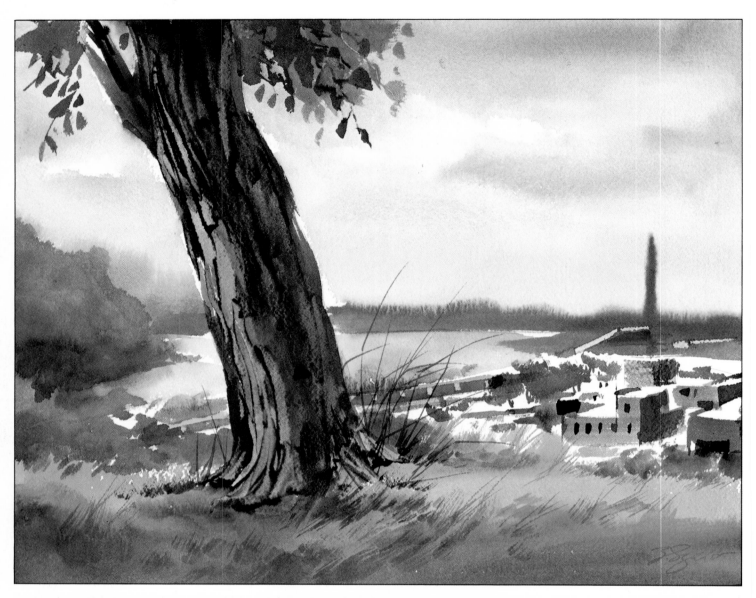

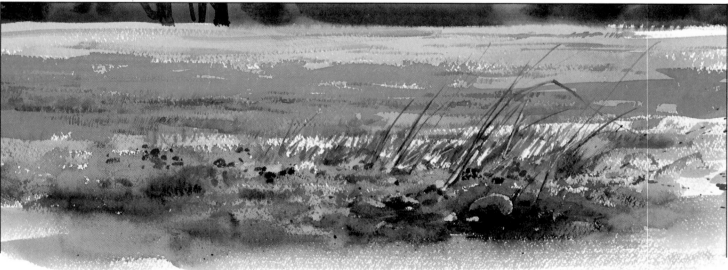

Summer Grass. (Top) My palette for this study of grass was new gamboge, raw sienna, and Winsor blue. I wet blended the sunlit and shaded part and drybrushed on the darker, taller grass afterward. Summer grass growth is typically of varied sizes.

Cut Grass. (Above) New gamboge and sap green are the basic wash ingredients for the sunny color of the short grass shown here. I painted it on dry paper and then added drybrush texture with burnt sienna. After drying, I glazed on Antwerp blue for the cast shadow. I modeled the shadow area with short, split drybrush strokes of dark Antwerp blue, sap green, and burnt sienna.

Grass, Weeds, and Flowers

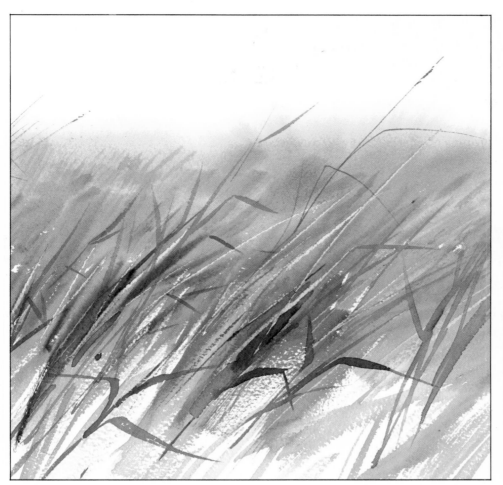

Autumn Grass. I started painting the grass wet-in-wet, my brushstrokes getting sharper as the paint dried. I knifed out some thin, light stems and glazed on a few darker, well-formed blades of grass in the foreground. My colors were yellow ochre, raw sienna, burnt sienna, Antwerp blue, and sepia.

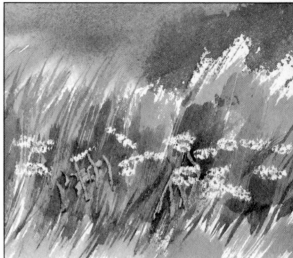

Summer Grass and Daisies. (Above) I used paraffin wax to mask out the shapes of the daisies around a few orange dots that later formed their centers. My drybrush glazes of Antwerp blue, raw sienna, and burnt sienna just slipped over the waxed white spots. Finally, I knifed out a few light flower stems from the dark grass.

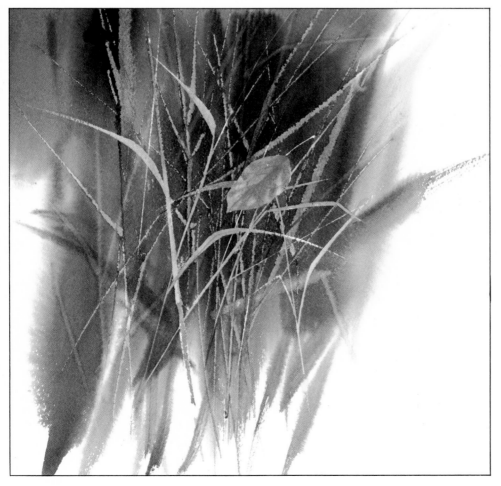

Dried Leaves and Grass. I used Miskit to mask out the fallen leaf and a few sharper blades of grass, and I wet painted the background with burnt sienna, Antwerp blue, and French ultramarine. I knifed out some of the weed shapes. After it dried, I removed the latex and started to paint the leaves and grass with yellow ochre, burnt sienna, and Antwerp blue. I left the painting unfinished.

75

Grass, Weeds, and Flowers

Cobweb on Weeds. (Right) I started with a dark wet-in-wet wash of raw sienna, burnt sienna, and French ultramarine for the weeds in the background. When it was dry, I wiped off the design of the cobweb with the thirsty point of a fine sable brush and blotted up the loosened pigment.

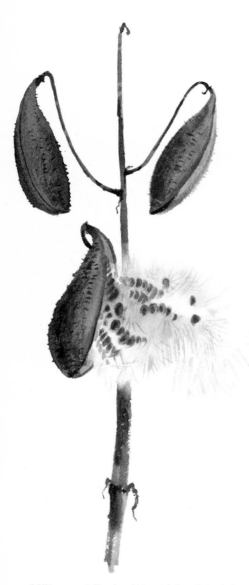

Milkweed Pods. (Above) I painted the pod shells and stem with the combined palette of French ultramarine and burnt sienna, and raw sienna and cerulean blue on dry paper. I textured the pod shells with a dry brush. Where the stem disappears behind the soft seedlings, it was wet blended. I painted the soft fluff wet-in-wet. Later, I added the seeds on the dry surface and finished with the fine, light, split drybrush texture on the soft fluff.

Fireweed and Flying Seedlings. (Right) I started painting the soft values of the fluffy fireweed seedlings on wet paper with French ultramarine, burnt sienna, and brown madder. I painted the fine lines of the seed pods with brown madder and Antwerp blue and lost part of them by wet blotting. For the leaves, I added raw sienna and Antwerp blue.

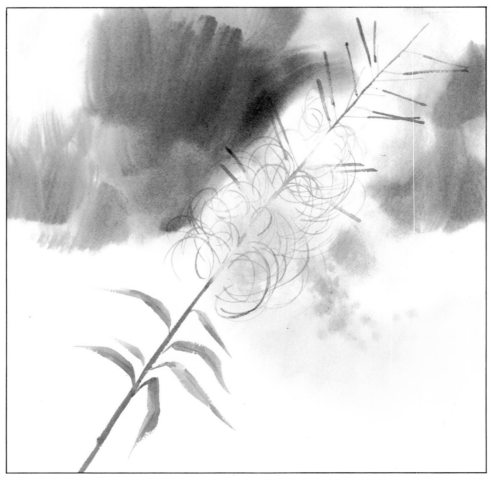

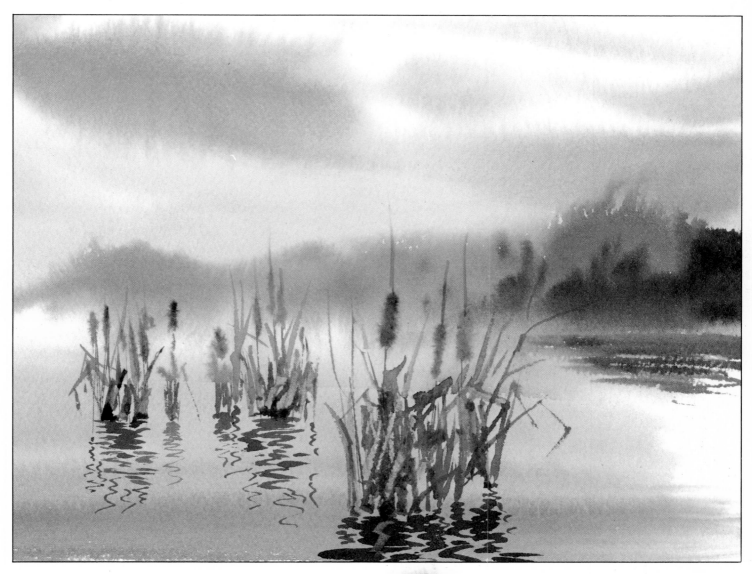

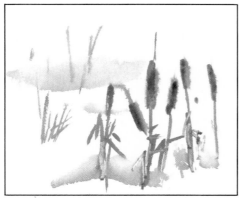

Variations in Cattails. Here are several cattails painted with sepia and burnt sepia. Split-second differences in timing and moisture explain the slight variations between them.

Swamp. (Above) In the swamp scene, I painted the clusters of cattails into a wet background, adding the stems and leaves along with the reflections after it dried.

Cattail Heads. (Left) I painted the head of a single cattail on damp paper with a bristle brush and rich paint, but without excess water. Its soft edges blurred instantly. I modeled the inner area quickly while the paint was still wet.

Grass, Weeds, and Flowers

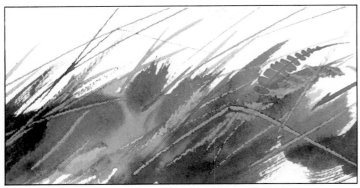

Knifed-Out Ferns. I used a dark mixture of sap green, burnt sienna, and new gamboge for the grassy area in the background. While it was still wet, I knifed out the shape of the fern. The dominant staining color came through.

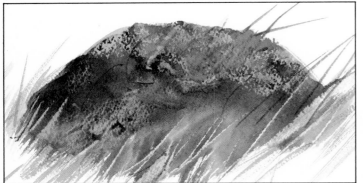

Waxed-Out Moss. I added two layers of wax and paint over the moss on the rock.

Ferns in Grass. I knifed out the shape of the fern from the sepia and burnt sienna background. The burnt sienna color remains.

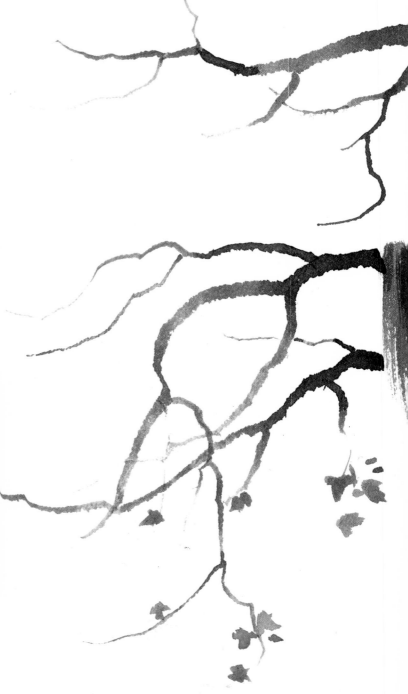

Spanish Moss. (Right) On the branches of a sycamore, I painted a few hanging strands of Spanish moss with brown madder and Antwerp blue, using a drybrush technique. I moved my brush-strokes downward in the direction of the hanging moss. I dry-brushed glazed on several layers of paint for a three-dimensional effect. I used the above colors, plus raw sienna, for the sycamore and its leaves.

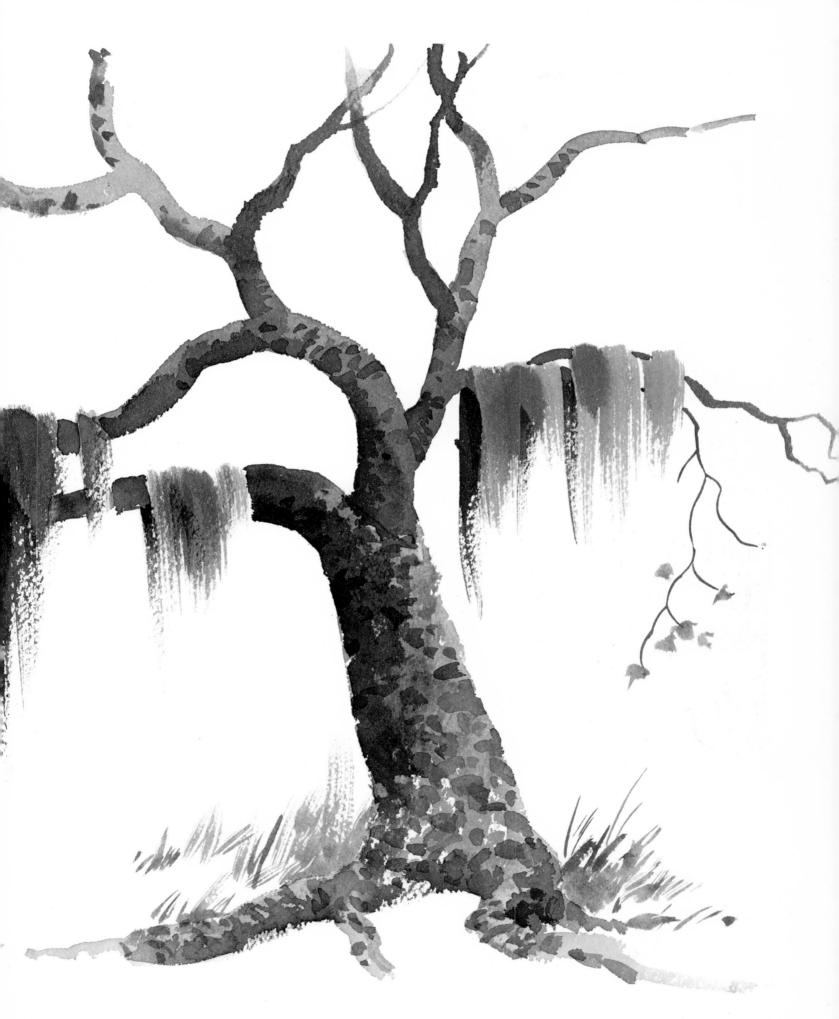

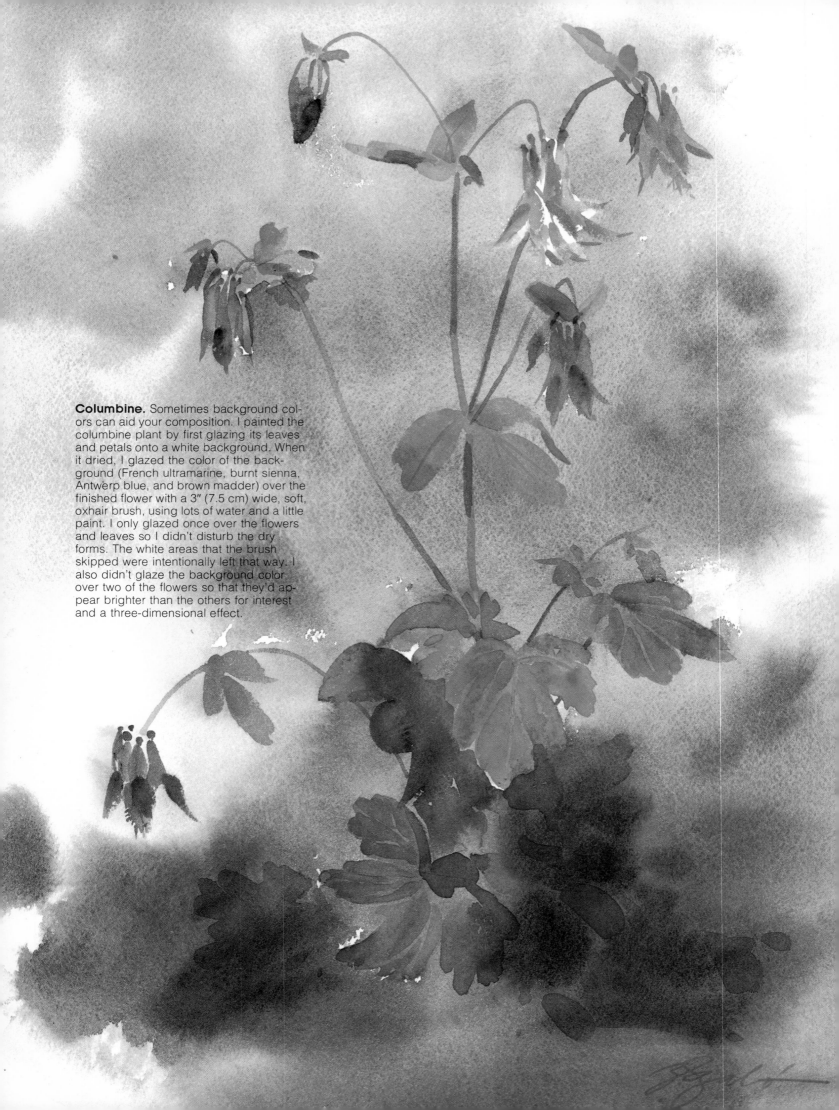

Columbine. Sometimes background colors can aid your composition. I painted the columbine plant by first glazing its leaves and petals onto a white background. When it dried, I glazed the color of the background (French ultramarine, burnt sienna, Antwerp blue, and brown madder) over the finished flower with a 3″ (7.5 cm) wide, soft, oxhair brush, using lots of water and a little paint. I only glazed once over the flowers and leaves so I didn't disturb the dry forms. The white areas that the brush skipped were intentionally left that way. I also didn't glaze the background color over two of the flowers so that they'd appear brighter than the others for interest and a three-dimensional effect.

Grass, Weeds, and Flowers

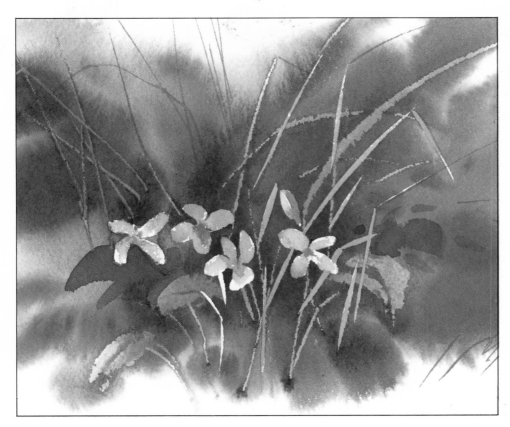

Violets. The contrasting forms of stems and leaves can strengthen the design of a painting. Here I masked out the violets and the dry grass with latex. I washed dark green grass onto wet paper using burnt sienna, Hookers green light, and Winsor blue. While this was still damp, I knifed out a few blades of grass and some leaves. I glazed the shaper, darker leaves onto the dry paper later. After removing the latex, I painted the flowers and the yellow ochre grass.

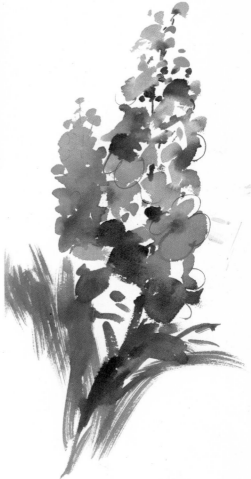

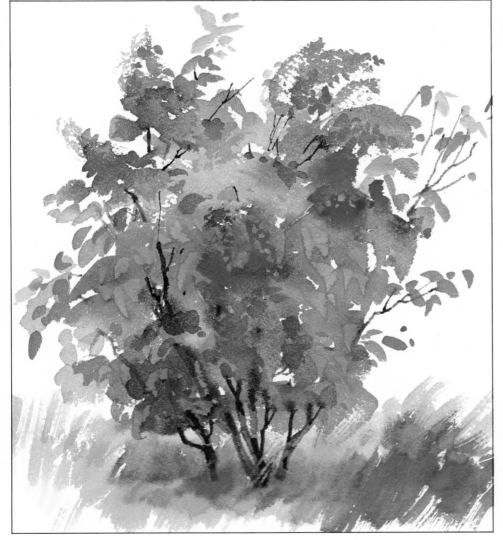

Flowers in Mass. (Above) This quick study of the color and values of a flower took about four minutes. I wet blended French ultramarine, cerulean blue, cobalt blue, and Winsor blue on dry paper. I dry-brushed the grass with raw sienna and Winsor blue, and added touches of orange for the stamens and touches of sepia for the dark stem.

Flowering Bushes. I painted this lilac bush as a single form with French ultramarine, Antwerp blue, alizarin crimson, aureolin yellow, and sepia. I knifed out some of the triangular leaves and a few light flowers and glazed on others. The lilacs at the outer edges are drybrushed on. Finally, I knifed on the dark branches to give the shrub structure.

Grass, Weeds, and Flowers

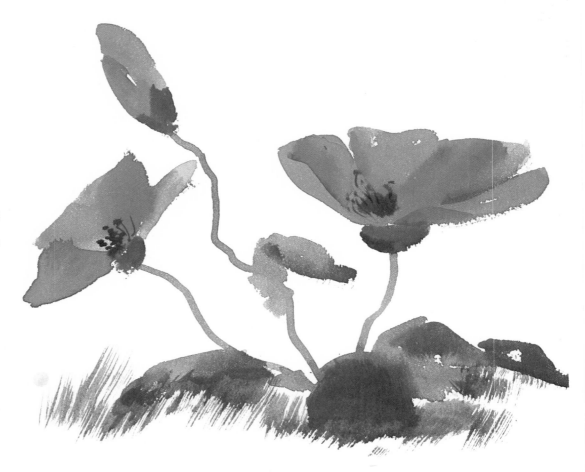

Poppy. (Right) I used vermilion, cadmium orange, and alizarin crimson for the petals of the California poppy, and Antwerp blue and raw sienna for its wobbly stems and leaves.

Waterlily. (Below) I unified the color of the lily pads and the water by using the same colors for both: raw sienna, new gamboge, Antwerp blue, and burnt sienna. I painted the dark wash around the lily pads, then added the reflections in the water with a still darker value of the same mixture. For the blooms, I used a light mix of French ultramarine, burnt sienna, and a little raw sienna.

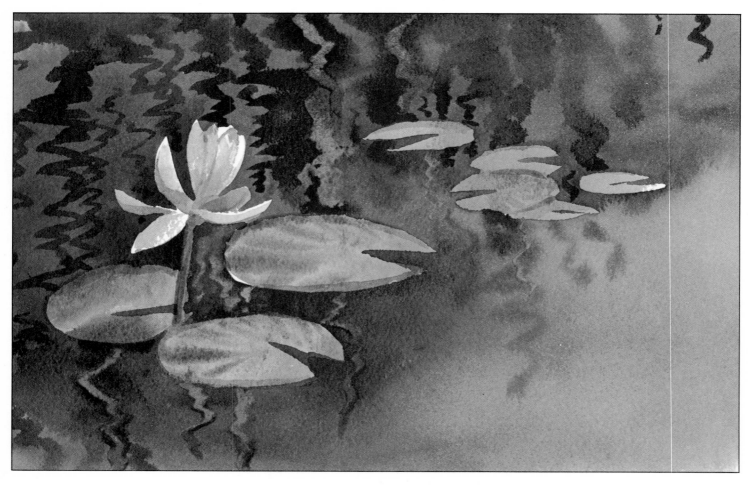

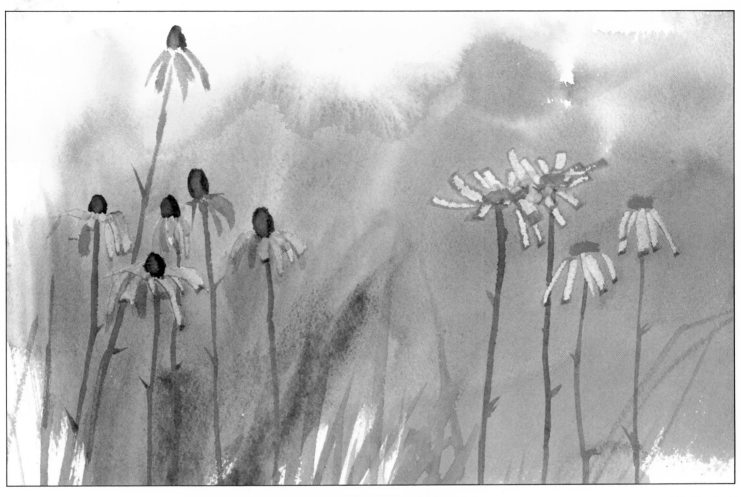

Fading Flowers. (Above) I started with a loose background wash of medium value, using raw sienna, French ultramarine, cerulean blue, burnt sienna, and sepia. I knifed out the shapes of the flower petals while the wash was still damp. Later, I glazed on the yellow of the brown-eyed susans and added their dark brown centers. I also placed the yellow centers on the daisies and painted the stems on all the flowers.

Trillium. White flowers such as the trillium look whiter against a dark background, but appear pale gray against a light background. I established its shape and structure with a subtle mixture of raw sienna, warm sepia, Antwerp blue, French ultramarine, and a touch of cadmium orange.

Rocks, Soil, and Mountains

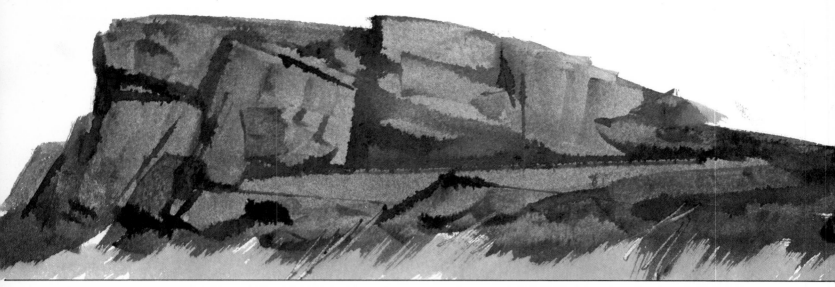

Granite Rock in Grass. The jagged granite rock is modeled with a bristle brush and a knife. The dark, negative spaces at the base of the rock contrast sharply with the dry, yellow-ochre grass.

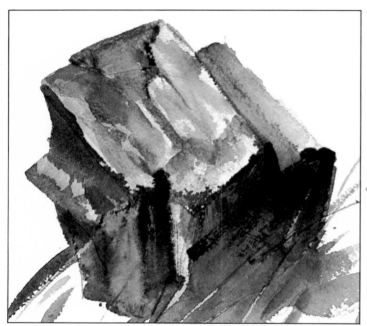

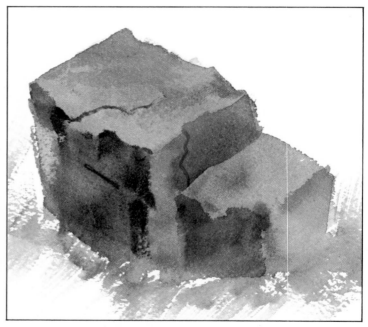

Angular Rocks, Knifed Out. I brushed on a medium dark wash of a varied combination of burnt sienna, French ultramarine, cerulean blue, and sepia. I knifed out the highlighted jagged edges, then I roughly knifed and scratched out the top edge of the dark side of the rock and added sepia for more contrast.

Angular Rocks, Brushed On. I painted the silhouette of the granite block with a flat 1" (2.5 cm) sable brush, using French ultramarine and burnt sienna. I scratched in the cracks with the tip of my brush handle while the wash was still wet. After the wash dried, I glazed on the shadowed sides of the rock.

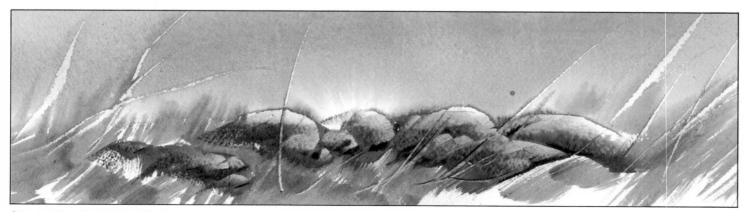

Glacial Rocks, Knifed Out. I painted on the rocks as dark values of sepia on a wet surface. I knifed out the light side of the rocks with a knife held upside down. I applied heavy pressure at the top edges of the rocks with the firm knobby spot on the blade, and released the pressure on the knife at the bottom. The result is a textured surface with a gradual change of value.

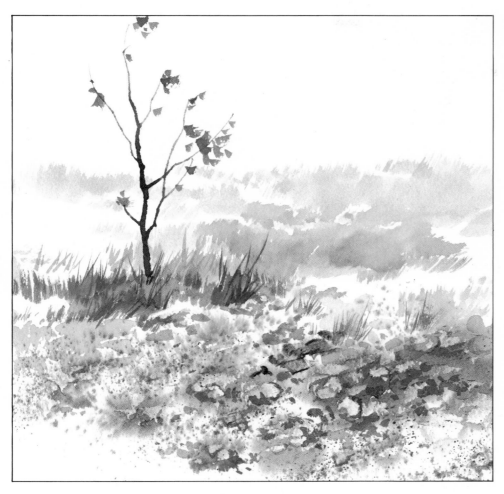

Pebbled Stones and Gravel. I used burnt sienna, French ultramarine, brown madder, and Antwerp blue for the light textured washes of the pebbled foreground. I started on wet paper and finished on dry. I used the knife to texture the stone shapes. I painted the grass with raw sienna and Antwerp blue. Finally, I knifed in the young tree and brushed on a few leaves.

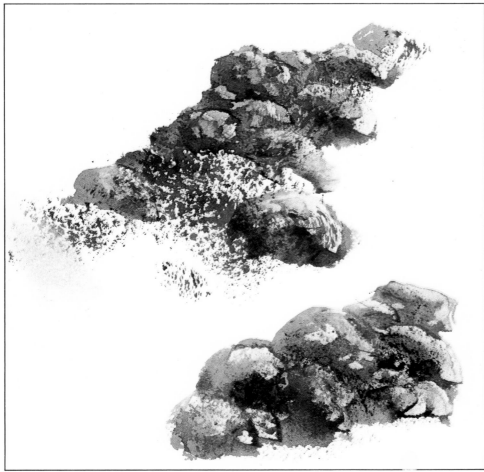

Modeling Glacial Rocks. I started by sponging on the mottled texture of the rock with sepia. After this dried, I glazed on a medium wash of sepia, burnt sienna, and raw sienna, and knifed off the top (lighter) planes of the rocks. The sponge texture shows through because the knife removed only the top layer of paint, and sepia is a staining color.

Rocks, Soil, and Mountains

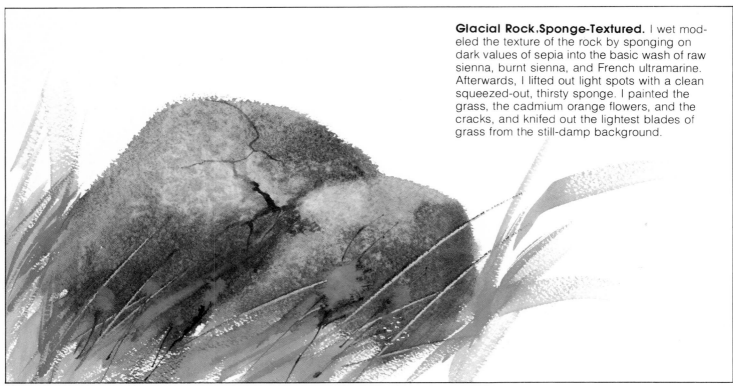

Glacial Rock, Sponge-Textured. I wet modeled the texture of the rock by sponging on dark values of sepia into the basic wash of raw sienna, burnt sienna, and French ultramarine. Afterwards, I lifted out light spots with a clean squeezed-out, thirsty sponge. I painted the grass, the cadmium orange flowers, and the cracks, and knifed out the lightest blades of grass from the still-damp background.

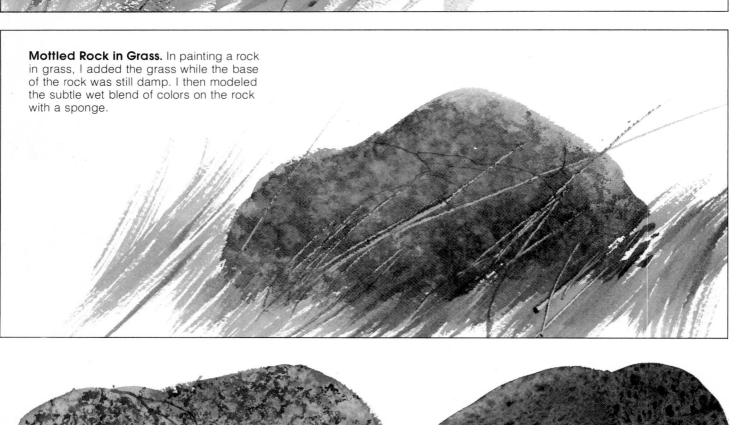

Mottled Rock in Grass. In painting a rock in grass, I added the grass while the base of the rock was still damp. I then modeled the subtle wet blend of colors on the rock with a sponge.

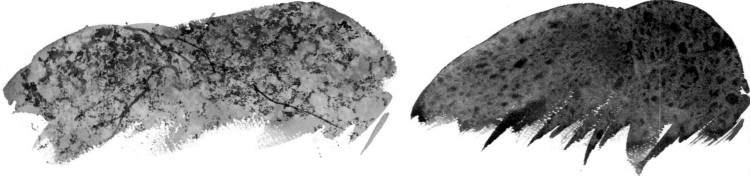

Glacial Rocks. The stony surface of the rock on the left shows dark color sponged on over a light background. The rock on the right shows dark color lifted off with a thirsty sponge.

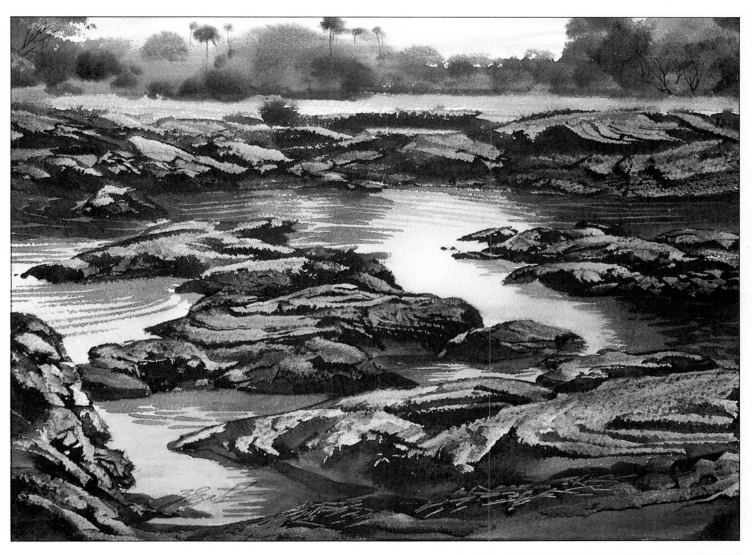

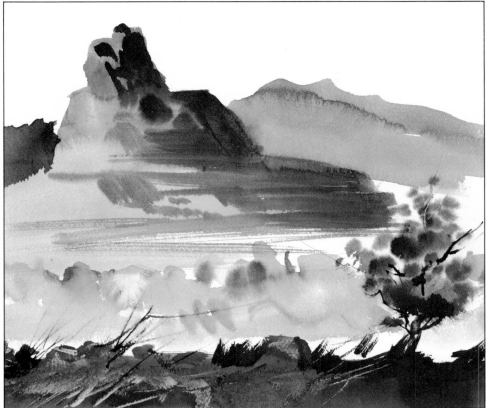

Lava. (Top) I painted the lava above the waterline with a varied mix of burnt sienna, French ultramarine, and sepia. I knifed out the sheen of its mudlike surface and added lush foliage for contrast.

Layered Buttes, Knifed Out. (Above) I began the layered rocks with a silhouette wash of brown madder and Antwerp blue. I knifed out the layered rocks while this wash was still damp. I glazed on the distant hill and drybrushed the grass.

Layered Buttes, Drybrushed. (Left) I used light red, burnt sienna, raw sienna, Antwerp blue, and some new gamboge in the foreground, applied in a graded wash to define the tall peaks. When this wash was almost dry, I drybrush glazed on the shaded sides of the layered rock formations with a bristle brush and Antwerp blue.

Rocks, Soil, and Mountains

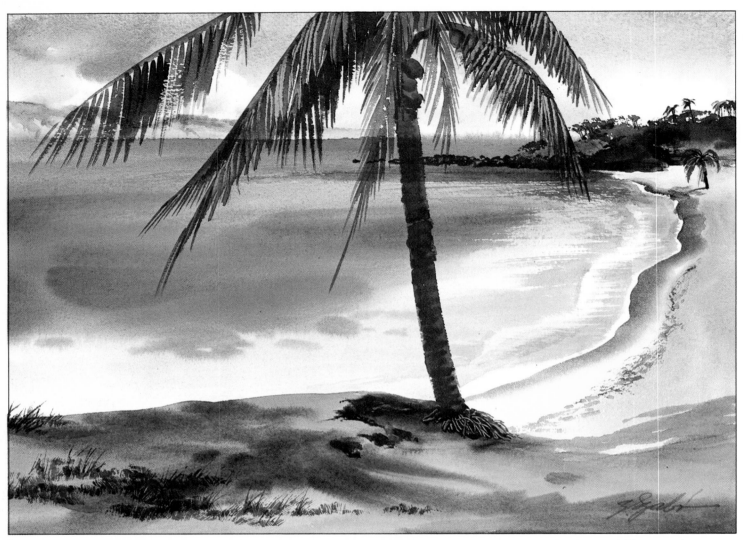

Sandy Beach. I applied French ultramarine, yellow ochre, and warm sepia in various combinations for the sand. The granular separation was slight because the washes weren't very wet. The neighboring cool blues and greens make the sand appear even more invitingly warm.

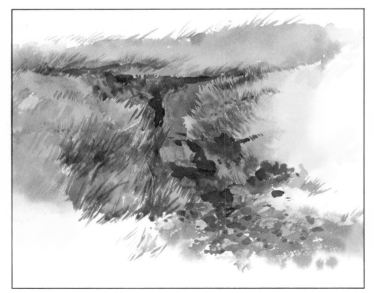

Eroding Soil. I painted the eroding red soil with glazes of burnt sienna, brown madder, Antwerp blue, and French ultramarine in varied combinations. Raw sienna, burnt sienna, and Antwerp blue were my colors for the grass. I applied touches of knifework for the lower crumbly chunks of soil.

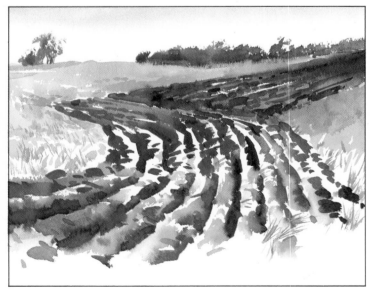

Plowed Field. I painted the contrasting dark soil to show perspective. The furrows are clearly defined in the foreground and in the highlighted middleground, but are simplified in the distance. I used burnt sienna, sepia, and French ultramarine, applying my brushstrokes on dry paper and allowing them to blend as they touched. For the grass, distant shrubs, and the sky, I used raw sienna, burnt sienna, and Antwerp blue.

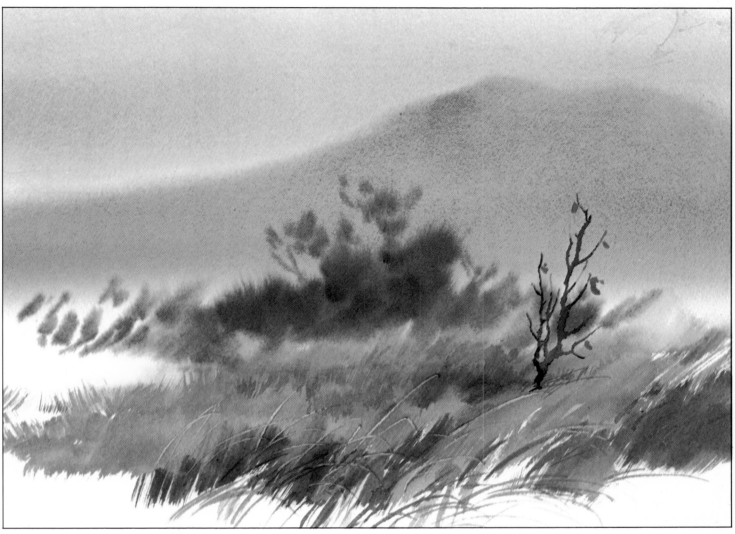

Distant Misty Mountains. I started with a wet-in-wet sky of French ultramarine and burnt sienna. I quickly brushed on the distant mountain into the wet wash with less water and more paint. I followed by adding the closer objects in the middleground with still more concentrated pigment. Finally, I painted the foreground, sharpened the definition of the lush grass, and knifed on the young tree.

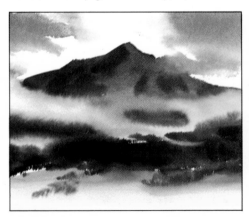

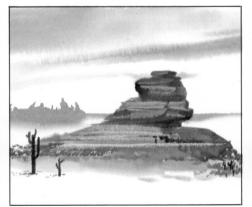

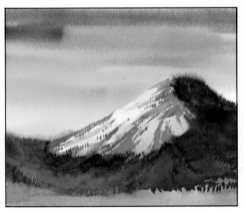

Mist at the Base of a Mountain. I glazed on the gray of the mountain with a 1″ (2.5 cm) flat, sable brush using burnt sienna and French ultramarine. I lost the edge and base of the mountain by lifting it off with a clean, damp bristle brush. (I also applied this technique where I wanted the clouds to appear soft.) The touch of sap green at the foot of the mountain suggests fresh pasture.

Desert Buttes. I painted the sky on wet paper with Antwerp blue and raw sienna. When the paper dried, I painted the distant buttes with Antwerp blue and brown madder, losing their bottom edges with wet blending. The dark silhouette of the nearest butte was painted with brown madder, burnt sienna, and Antwerp blue, its layered areas knifed out while this wash was damp wet. Finally, I added a tall cactus to indicate relative proportions.

Sunlight on a Snow-Covered Mountain. I painted the effects of the setting sun with new gamboge, brown madder, burnt sienna, and French ultramarine. In the shaded area, I used Winsor blue, French ultramarine, raw sienna, and burnt sienna. I allowed these glazes to blend in spots to de-emphasize details.

Still and Moving Water

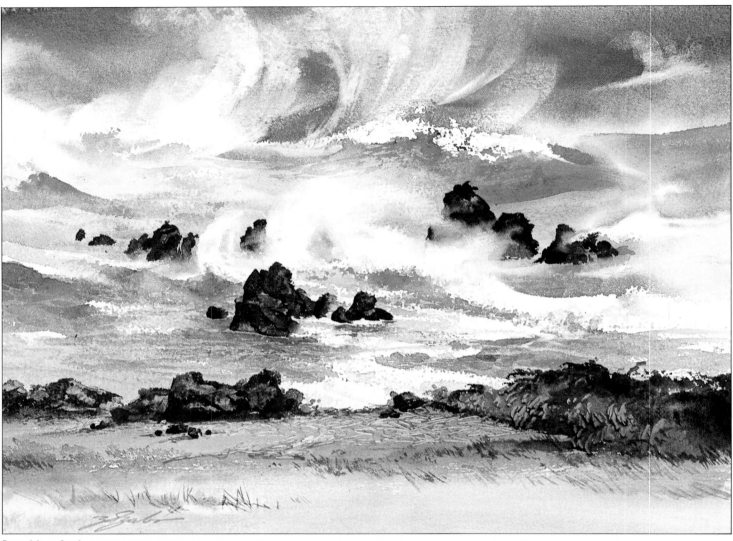

Breaking Surf. As the white surf broke into bubbles and the waves calmed down near the shore, I drybrush glazed on several layers of cerulean blue and Antwerp blue, with a touch of sepia, in light washes. I dragged the brush back and forth on its side on the dry paper. I did *not* use the tip here.

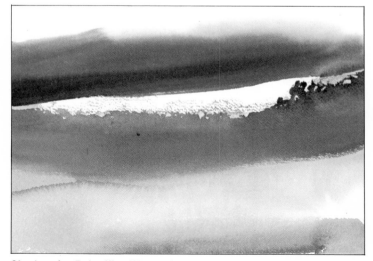

Study of a Tubelike Wave. I added a quick touch of dark color to the underside of the rolling surf and another one along the top edge of the white area. My colors were French ultramarine, Antwerp blue, raw sienna, and sepia.

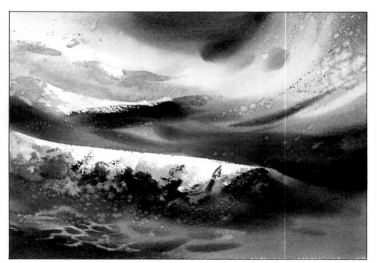

Choppy Surf. My palette for the waves in turmoil was Antwerp blue, sap green, and warm sepia. First I established the water's values with wet-blending washes. I sprinkled droplets of water into the drying washes for texture. Afterwards, I wiped out the diamond-shaped reflections at the lower left with a soft, damp brush, blotting off the loose paint. I made sure that these shapes connected with each other in perspective like a honeycomb.

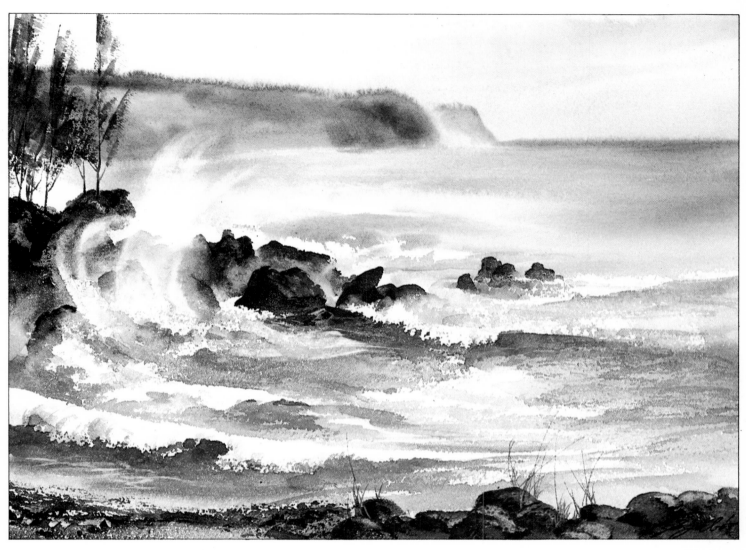

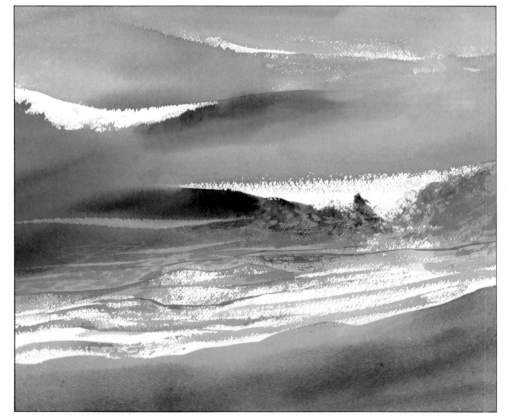

Waves Against Rocks. (Above) I painted the rocks behind the spray with a medium-strength mix of sepia and charcoal gray. After it dried, I wet and scrubbed the spray with a bristle brush and blotted up the loose paint several times. I drybrushed on the dark definition on the other rocks but avoided the spray area, thereby exaggerating the contrast.

Waves Against the Shore. For the water, I painted Winsor blue, cerulean blue, and new gamboge on the dry paper. I left the surf heads white. I used the knife to lift a few foreground waves into a lighter value. For the breaking, foamy waves, I used a light color in my brush and pushed the drybrush strokes against the ferrule of the flatly held brush in a zigzag pattern, imitating the churning waves. For the sand, I painted raw sienna, burnt sienna, and French ultramarine in a single blend and let the colors separate in granules.

Still and Moving Water

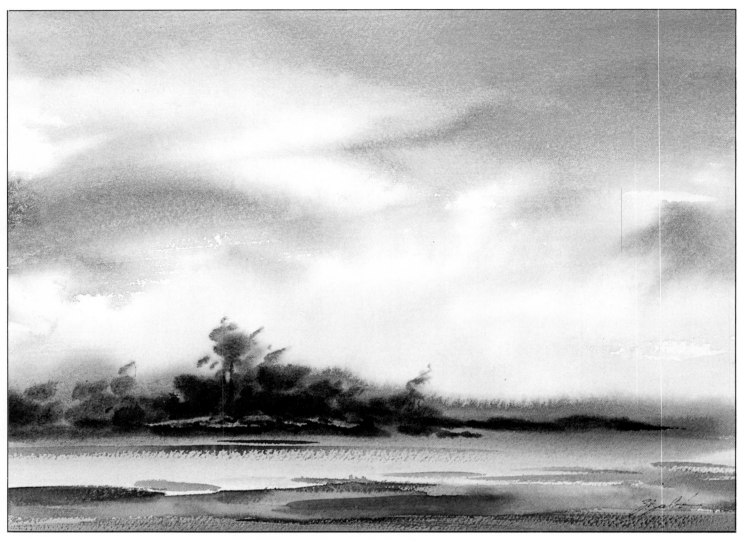

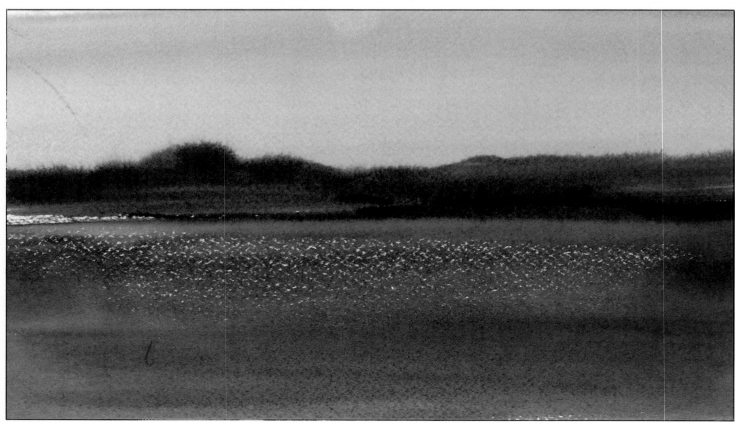

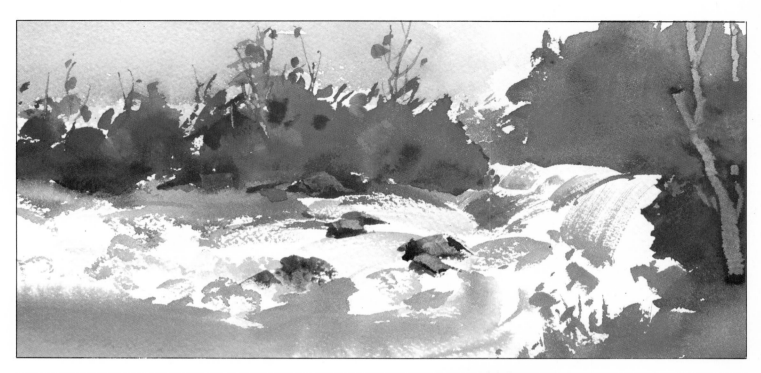

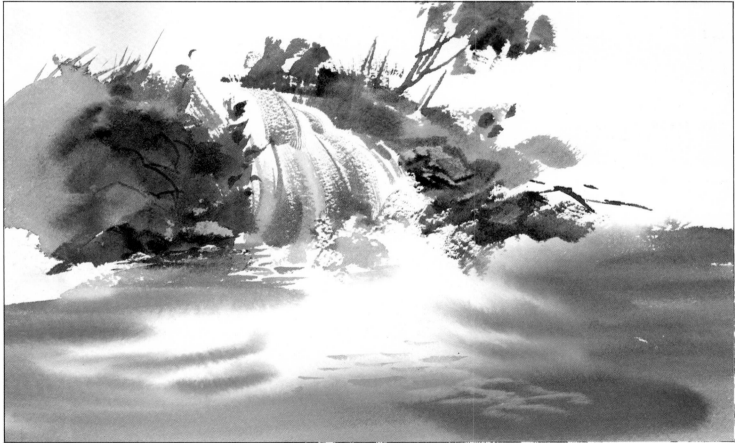

Breeze Patterns on a Lake. (Opposite page, top) I painted the sky, island, and water on wet paper and knifed out the rocks. After this dried, I drybrushed on the darker two reflection patterns. I immediately added a dark touch of color to the thin washes below the tall trees, and let it bleed on both sides.

Shimmering Lights on Water. (Left) I used the straight, sharp side of a piece of paraffin wax on dry paper to wax out the shimmer. I pressed hard at the top edge of the wax and released the bottom. Then I painted on the rich, dark, contrasting paint.

Direction and Flow of Rapids. (Top) Where the churning water gushes around the rocks, I darkened my drybrush strokes slightly to make the water appear more transparent. These contrasting strokes follow the direction of the water.

White Highlights of a Waterfall. (Above) Where the falling water forms plateaus, I drybrushed on a light wash by flicking my ½" (1.3 cm) bristle brush upward so the white sparkle appears to be falling downward. The base of the falls was painted around the wet, white shape. The effect is of foam breaking up.

Still and Moving Water

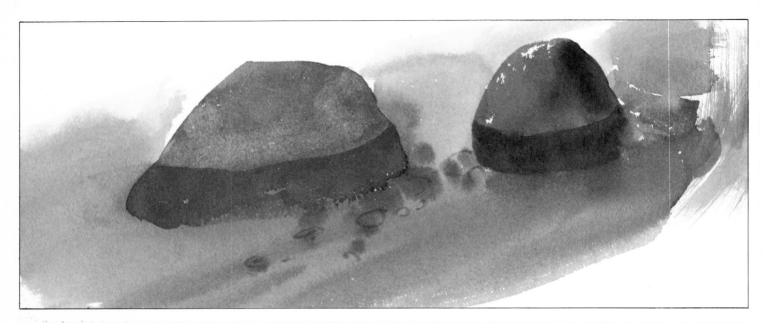

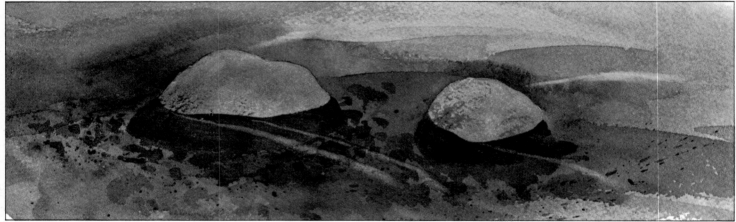

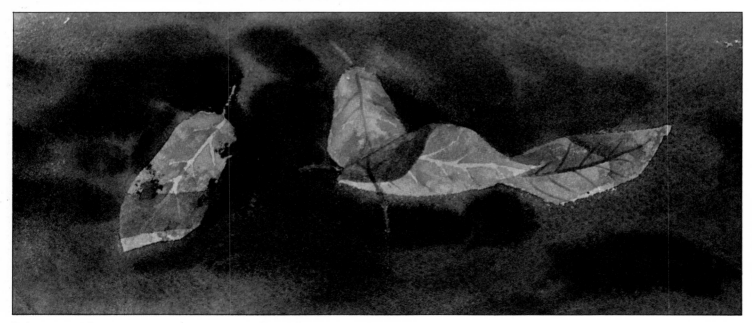

Submerged Rocks. (Top) I painted the rocks on dry paper with burnt sienna and French ultramarine. I covered the rock on the left and the lower half of the one on the right with a wash of raw sienna and Antwerp blue. When it dried, I wetted and blot-lifted off the greenish glaze from the top of the rock at the left.

Flowing Water and Obstructions. (Center) I glazed on the sepia, burnt sienna, and Winsor blue washes around the exposed light tops of the rocks. When dry, I wetted and blot-lifted off the soft lines indicating the direction of flow *over* the submerged forms. The Winsor blue and burnt sienna color remains.

Floating Leaves. (Above) I masked out the leaves and finished the water with a dark wash of Winsor blue and sepia. After it dried, I removed the latex and painted the leaves with burnt sienna and new gamboge. Finally, I glazed Antwerp blue and sepia over the submerged parts of the leaves.

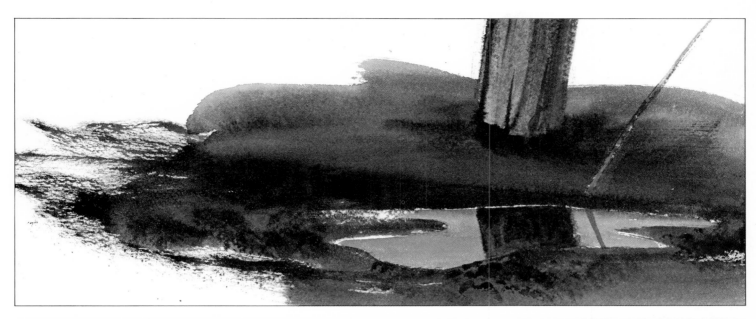

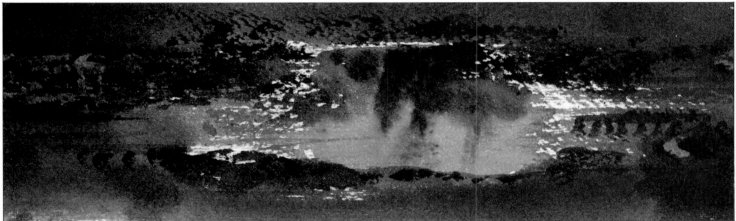

Puddle Reflecting a Post. (Top) I painted the water separately here, but on a smoother surface. The post and the grass are reflected sharply in the light blue water. The reflection starts and stops abruptly at the edges of the puddle.

Puddle Reflecting the Low Sky and Shore. (Center) In this sketch, the dry areas of mud are darker than the sky's reflections. The low sky was reflected here, which is always lighter than the zenith of the sky.

Puddle Reflecting the High Sky. (Above) All three puddles on this page were painted on dry paper, and their edges left white. But here, the earth is a lighter gray and the water a darker blue because the angle from which I viewed the puddle reflected the darker, deeper sky directly overhead.

Still and Moving Water

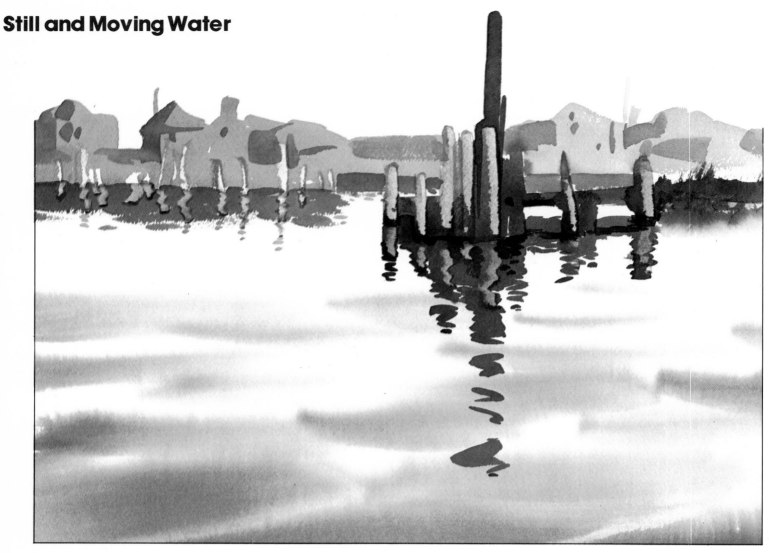

Reflections of the Dark Underside of a Tree. (Right) I painted the tree with burnt sienna, cerulean blue, and French ultramarine, with raw sienna added to the foliage. For the pale color of the water, I used raw sienna, sepia, and cerulean blue. When this had dried, I painted the dark, wiggly reflections of the shaded undersides of the tree and the weeds along the shore, adding Antwerp blue to a burnt sienna wash.

Reflections in Water. (Above) I first painted the ripples wet-in-wet with French ultramarine and burnt sienna. After the wash dried, I glazed on the buildings, the pillars, and the grassy walkway, and knifed out the lighter values from these warm colors. I then painted the darker gray distant reflection, and knifed out the lighter reflections from it. Using a ¾" (19 mm) flat brush, I painted in the blue-gray reflections with Antwerp blue and sepia, and knifed out the light values. A few dark wiggles were glazed on last.

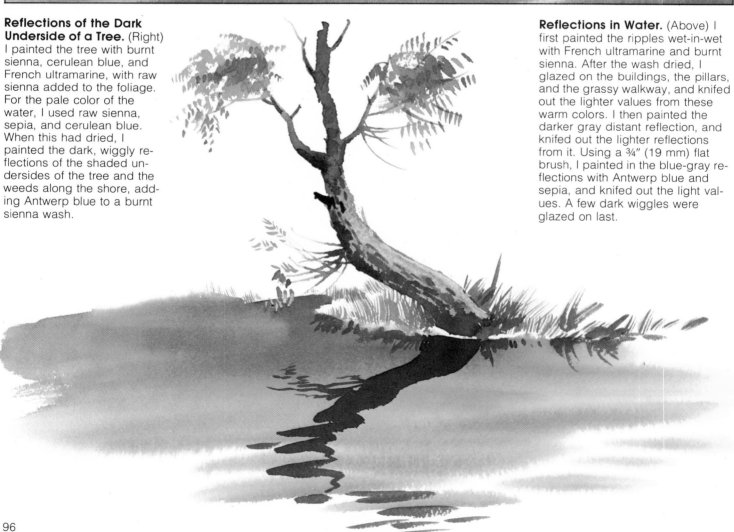

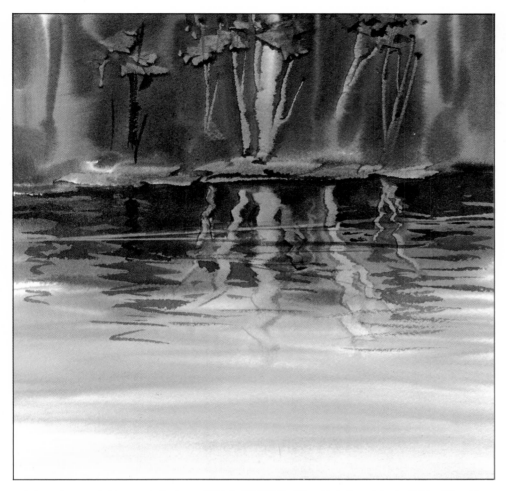

Reflections of Trees by the Shore. With sap green, sepia, and burnt sienna, I painted the medium-dark water, losing its bottom edge on the wet paper. After it dried, with a darker mixture of the same colors, I painted the dark reflection with a 1″ (2.5 cm) flat, sable brush. My brush-strokes blended where their edges touched. I knifed out the wiggly reflections with my palette knife. The sap green shows through the knifestrokes, as it does on the tree trunk above the water.

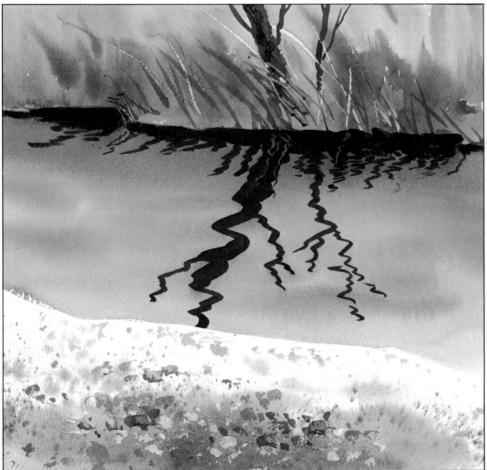

Reflections of Branches and Grass. I started with the wet-in-wet background colors of raw sienna, new gamboge, burnt sienna, and brown madder and I knifed in the trees. I painted the light areas of the water with burnt sienna and French ultramarine, adding to it the dark reflections of brown madder, Antwerp blue, and burnt sienna. For the pebbles on the foreground shore, I used French ultramarine, burnt sienna, and Antwerp blue, painting and splattering them on loosely, and occasionally knifing them out.

Snow, Ice, and Frost

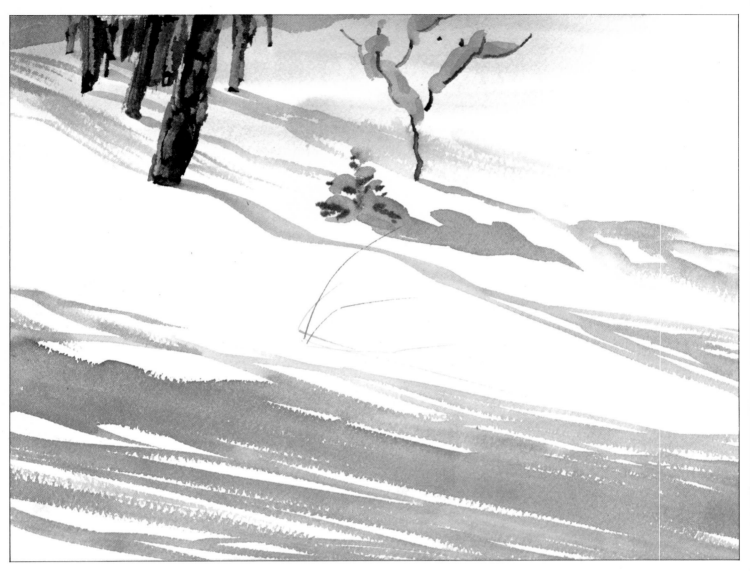

Bright, Sunlit Snow. (Top) Here the day is bright and sunny, so the shadows are sharper and follow the curving surface of the snow. The color of the shadows—I added Antwerp blue to them—is bluer.

Grass in Snow. (Above) For the small clumps of grass, I used burnt sienna and sepia, painting them on dry paper with a bristle brush and a No. 4 rigger brush. When they dried, I glazed a wash of manganese blue and French ultramarine over them and lost the top edges of the wash.

Shadows on Snow. (Right) The trees are blurred here, indicating a hazy sun. The cast shadows are a gray blue mixed from burnt sienna and French ultramarine.

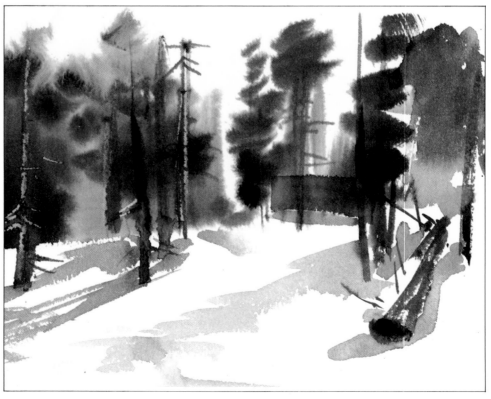

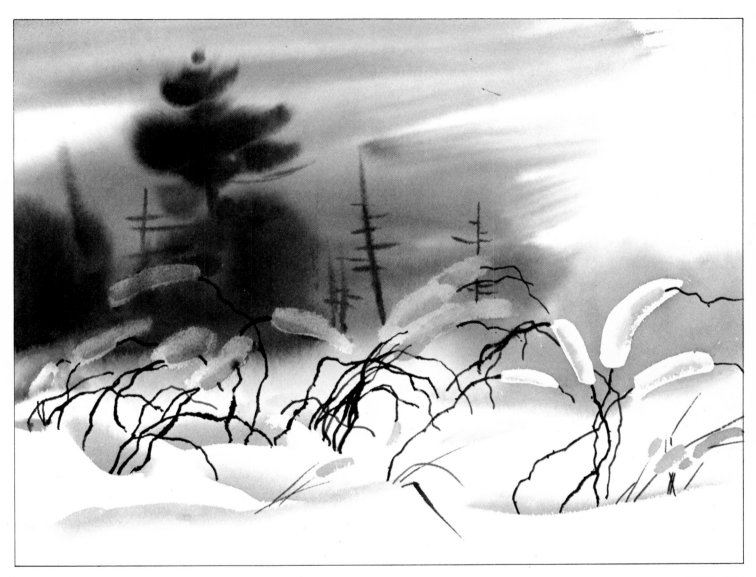

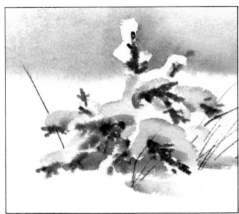

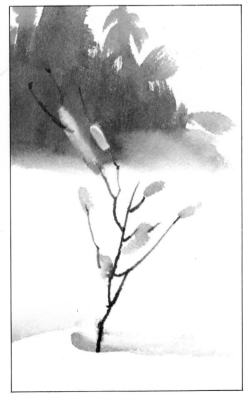

Snow Clumps. (Top) I painted the clumps of snow on the twigs in two ways: by lifting them out of the background wash and by masking them out with latex and later painting in their shadowed sides. I knifed on the dark twigs and brushed in the lighter ones in the foreground with French ultramarine and burnt sienna.

Snow-Covered Spruce. (Above) Because of the overcast sky, I used burnt sienna and French ultramarine to model the fresh snow and its shadows. Each brushstroke represented a lost-and-found technique.

Tree and Snow Clumps Against a Light and a Dark Background. (Right) I wiped out the snow on the branches of the twigs silhouetted against the dark, shaded evergreens, and painted them a darker value against the white background. My colors were French ultramarine and burnt sienna.

Snowcaps Against a Light and a Dark Background. (Above) Snowcaps on the posts are painted on dry paper with French ultramarine and burnt sienna. On the example at left, I lost the lower edges of the snow where it's only slightly darker than the white background. On the post at the right, I painted the sky color around the white cap of snow and shaded the bottom part of the form with a soft, lost edge.

Snow, Ice, and Frost

Objects in Snow. I painted the snow-covered hollows with French ultramarine and burnt sienna mixed as a cool gray. I left the bottom edge of each brushstroke sharp and lost the top one with soft blending. I knifed out the birches and painted on the dark tree with rich paint while the background was still wet.

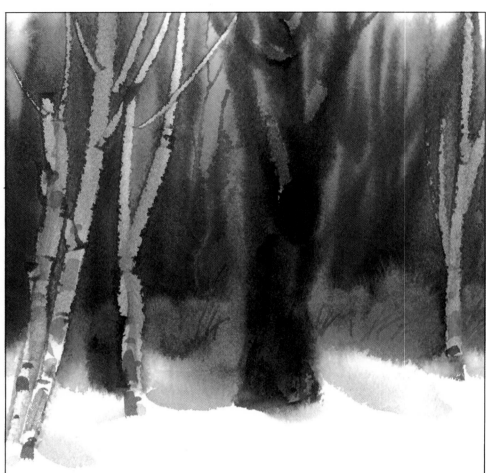

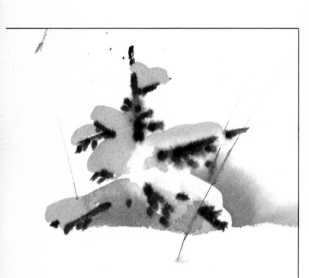

Spruces in Snow. (Above) I painted the young spruce trees on damp paper with rich pigment and little water in my brush and let the edges soften as the brush touched the paper. I painted the snow with lost-and-found edges again, using Antwerp blue, burnt sienna, and French ultramarine.

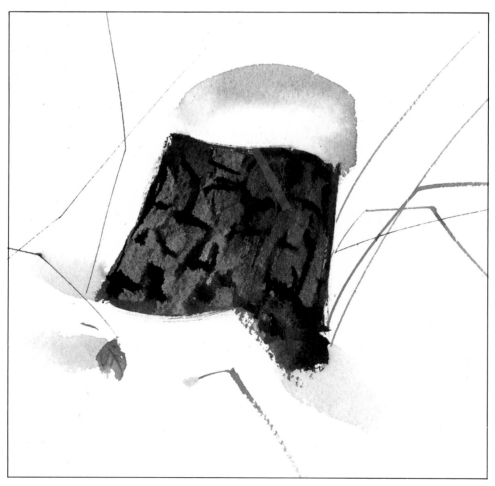

Tree Stump in Snow. I knifed out the bark on the stump and painted the snow with lost-and-found edges.

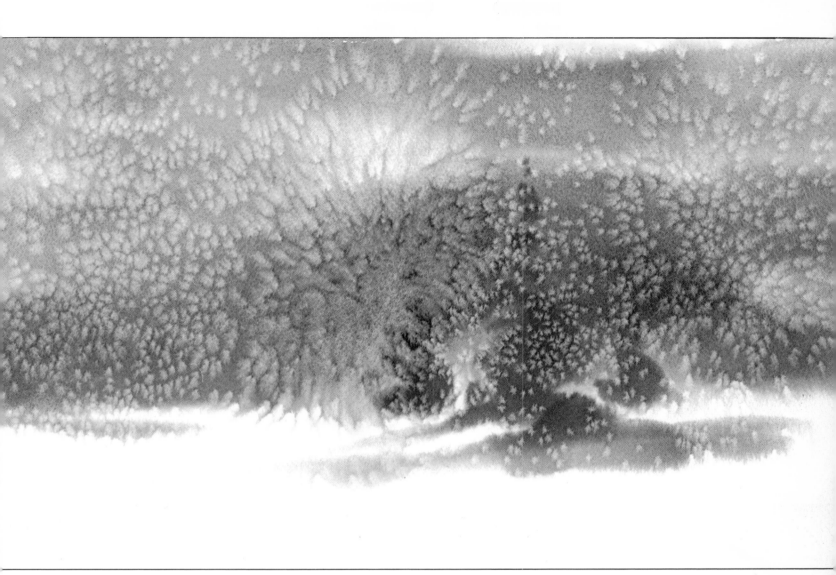

Blizzard. I painted the background wet-in-wet with Antwerp blue, burnt sienna, and French ultramarine. I sprinkled the salt into the wash while it was still wet and shiny.

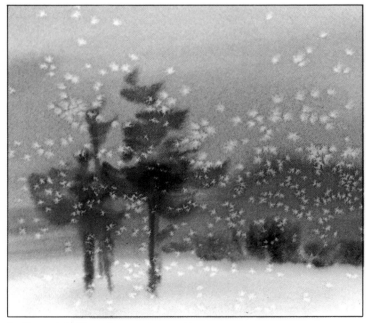

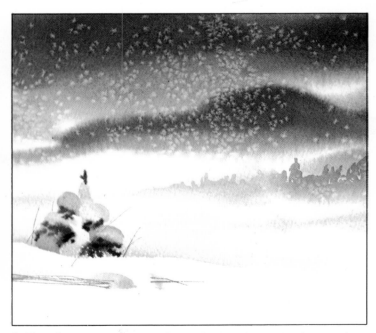

Salt and Falling Snow. I used French ultramarine and burnt sienna for the hill and added a little Antwerp blue to the misty pines with a wet-in-wet technique. I sprinkled salt into the wash a little before the wash had lost its shine.

Falling Snow and Spruce Tree. The wet-in-wet background was drier than the painting on the left, and the snowflakes are smaller because the salt didn't dissolve as long. I painted the spruce and weed when the paper dried.

Snow, Ice, and Frost

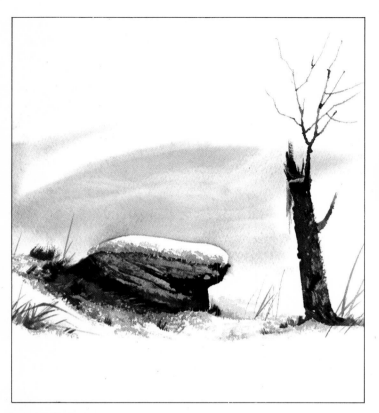

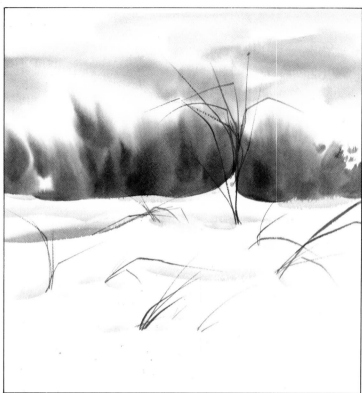

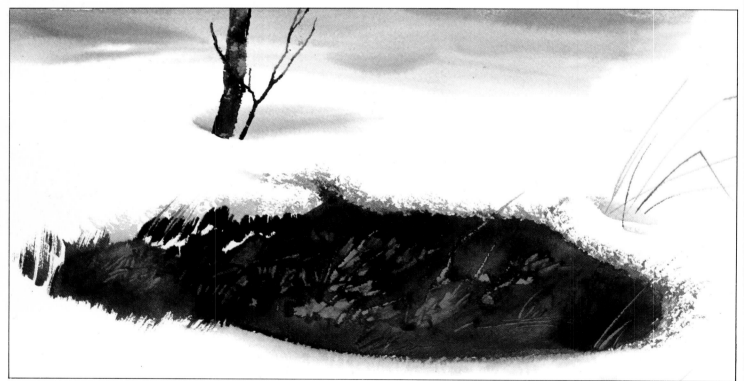

Melting Snow and a Dripping Icicle.
(Top left) For the loose, soft, wet-in-wet background I used French ultramarine and burnt sienna. Next, I painted the rock and tree trunk with brown madder and sepia, and knifed out their texture. Then, with burnt sienna and sap green, I painted the grass. I finished with several drybrush glazes of Antwerp blue and a touch of raw sienna at the edges of the melting snow on the ground and on the rock, as well as on the icicle hanging from the tree stump.

Snow Drift as the Center of Interest.
(Top right) I wetted the top half of the painting and loosely painted on the shrubs using a combination wash of burnt sienna, raw sienna, and French ultramarine. I defined the white, closer drifts with the sharp bottom edge of this wet background. I continued with light lost-and-found brushstrokes of burnt sienna and French ultramarine, defining the drift shapes. I finished by painting the windblown weeds into drifts with a thin rigger brush and burnt sienna, raw sienna, and Antwerp blue.

Melting Edge of Snow Patches. (Above)
I started with a wet-in-wet technique for the more distant snow surface, using Antwerp blue and burnt sienna. I knifed on the young trees with brown madder, burnt sienna, and Antwerp blue. I used a thin rigger brush to paint the raw sienna-colored weeds. I painted the dark, wet grass where the snow had already melted with burnt sienna, raw sienna, Winsor blue, and sap green, and knifed out some grass. I glazed on several layers of Antwerp blue to indicate the melting snow.

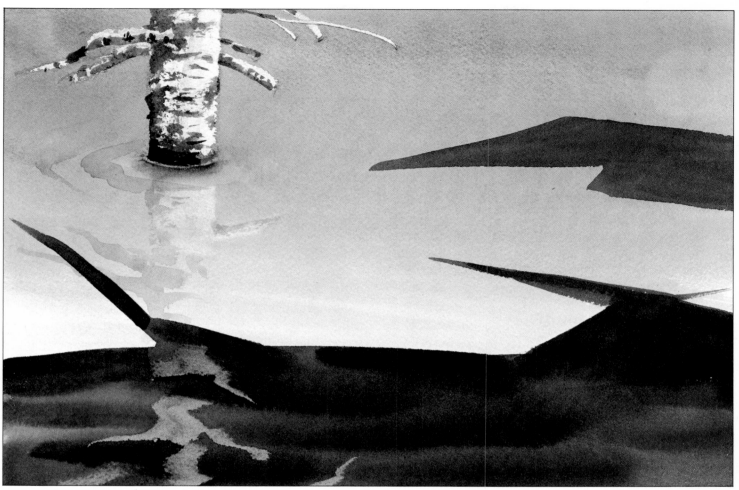

Reflections on a Sheet of Ice. I started the painting with a medium-value wash of French ultramarine, burnt sienna, and cerulean blue, which remained the color of the ice. I knifed out the shape of the light tree before this wash had dried. Next, I painted in the dark water with Antwerp blue and sepia. Then, I textured the bark on the large tree. I completed the sketch with the addition of the light reflection of the tree over the ice.

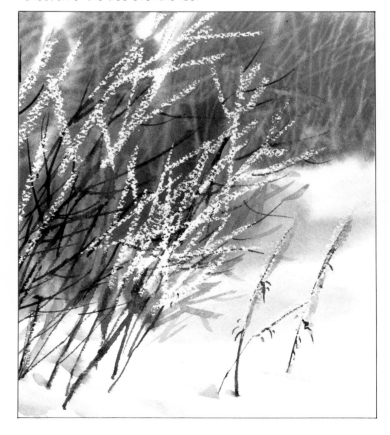

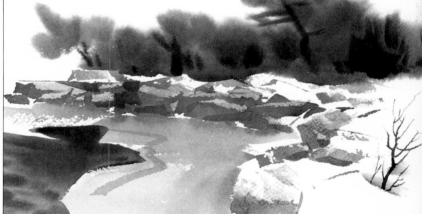

Ice Slabs on Shore. (Above) First, I glazed on the squarish shapes of the piled-up ice slabs and modeled some of them with my knife while the paint was dry. Then, I wet the top part of the painting and painted the softly blurred forest, defining the top edge of the ice with the bottom edge of the background wash. I knifed in the little tree to add a feeling of depth and perspective.

Freezing Rain on a Sunlit Branch. (Left) I masked out the sharp, ice-covered twigs with paraffin wax and painted the background wet-in-wet with cobalt blue, Antwerp blue, sepia, and burnt sienna. When the wash was damp, I used plain water and a rigger brush to paint the distant icy branches. I then removed the wax with a hot iron and a tissue and painted the twigs.

Snow, Ice, and Frost

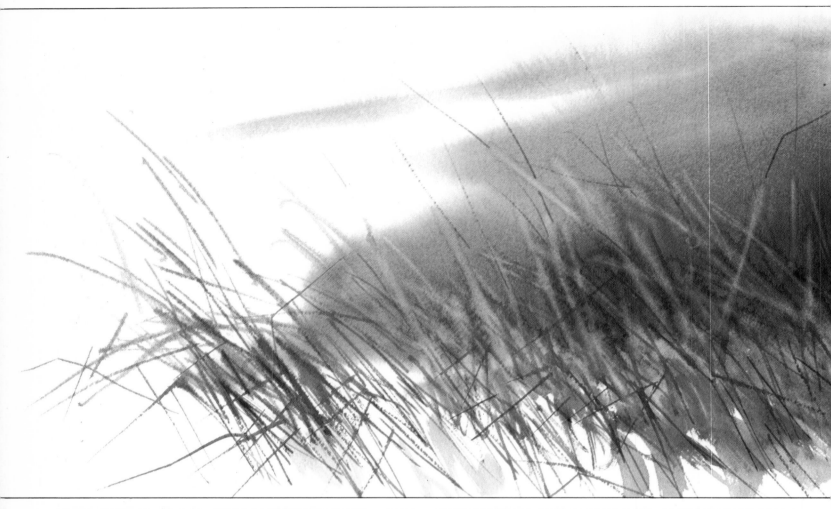

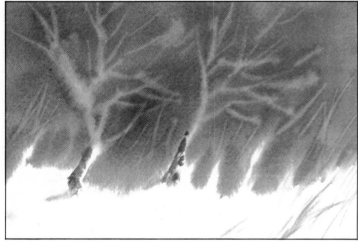

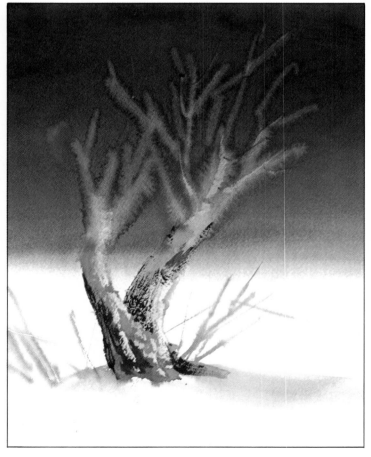

Frost on Weeds. (Top) I painted on a burnt sienna and French ultramarine wash on wet paper for the sky. As this wash lost its shine, I painted the frost-covered weeds into it with cerulean blue and raw sienna with a rigger brush. I had little water in the brush to reduce the soft blur of the thin brushstrokes. I used more raw sienna on lower parts of the weeds where the frost didn't go.

Hoarfrost Effects with Oozing Wet Strokes. (Above) I brushed clear water onto the background while it was still wet, before it lost its shine. My fast brushstrokes oozed softly. The brushwork alone gives the effect of hoarfrost.

Frost Under an Overcast Sky. (Right) While the dark background was still damp but the wash had lost its shine, I brushed in clean water and allowed the accidental backruns to happen, and to dry that way.

Frost on Leaves and Branches. I wet the paper first and wiped off the excess water with a tissue. I brushed the twigs onto this damp surface with French ultramarine and burnt sienna. Afterwards, I rewetted the paper and painted the frosty fluff over the branches with Antwerp blue and cerulean blue, and added the leaves with cerulean blue, raw sienna, burnt sienna, and Antwerp blue. The soft values and drybrushed touches make them look frosty. The heavier brown details on the branch add contrast to the frosty areas.

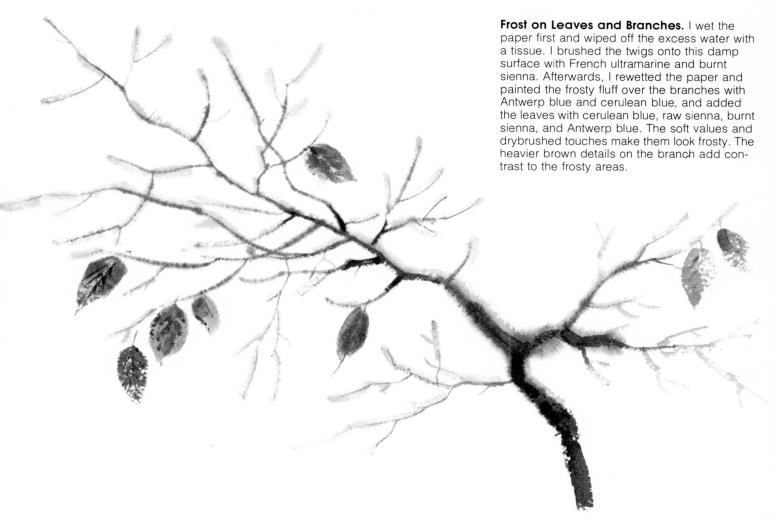

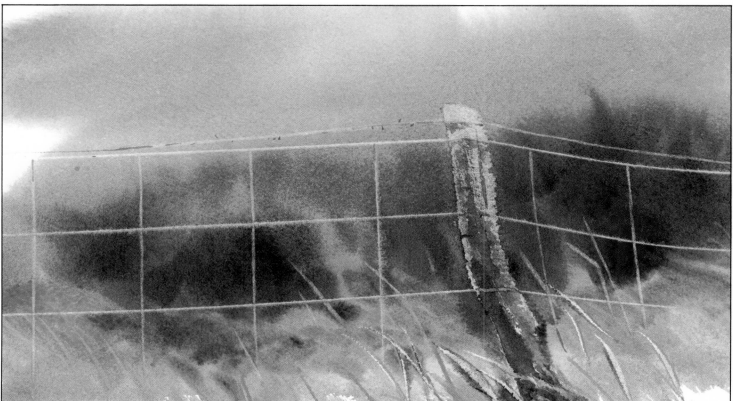

Frost on Thin, Delicate Shapes. I painted the background on wet paper with cool colors of Antwerp blue, cerulean blue, French ultramarine, and burnt sienna—plus raw sienna for the foreground grass. I knifed out the fence post and wiped out the thin wire from the damp pigment with the damp point of a sable brush and a wet-and-blot approach.

Skies and Weather

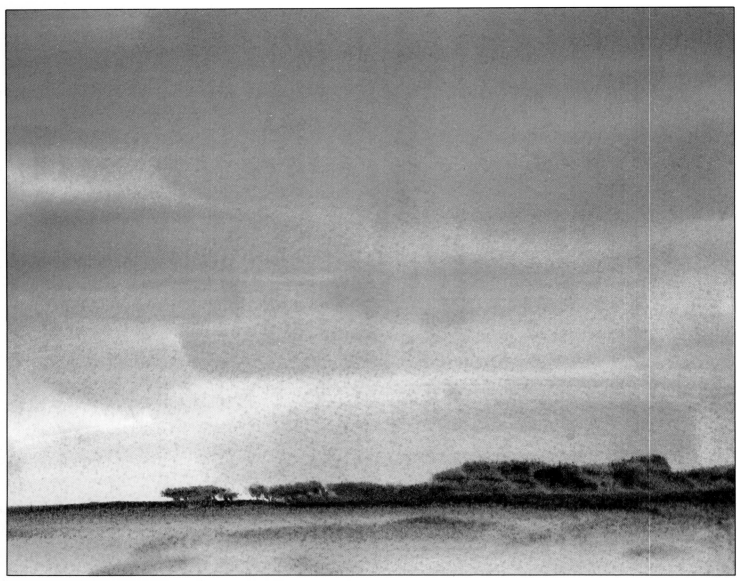

Harmonizing Sky and Ground. I used four blues: cerulean blue, Antwerp blue, French ultramarine, and Winsor blue, which I applied in heavy brushstrokes onto the wet paper, keeping the colors darker at the top and lighter near the horizon. The brushstrokes remained visible, creating a variety of softly blending textures. For the colors on the ground, I used raw sienna, French ultramarine, and Antwerp blue.

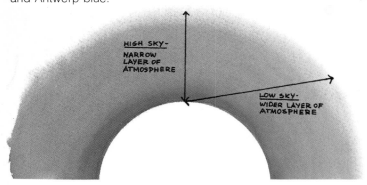

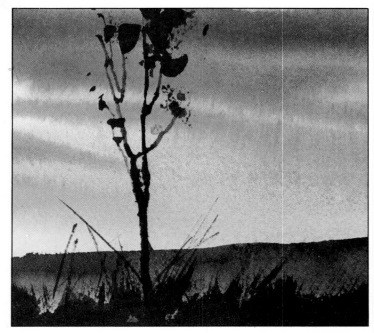

Thickness of the Atmosphere. (Above) This diagram shows the different thicknesses of the atmosphere as a result of the curvature of the earth's surface. The thickness of the vapor varies with the angle of our vision.

Sunset on a Clear Day. (Right) I wet blended alizarin crimson, cadmium yellow deep, French ultramarine, and brown madder into the sunset sky. After it dried, I added the distant hill with a medium-strong mix of brown madder and Winsor blue. I finished the painting by knifing in the tree and drybrushing in the grass with a darker value.

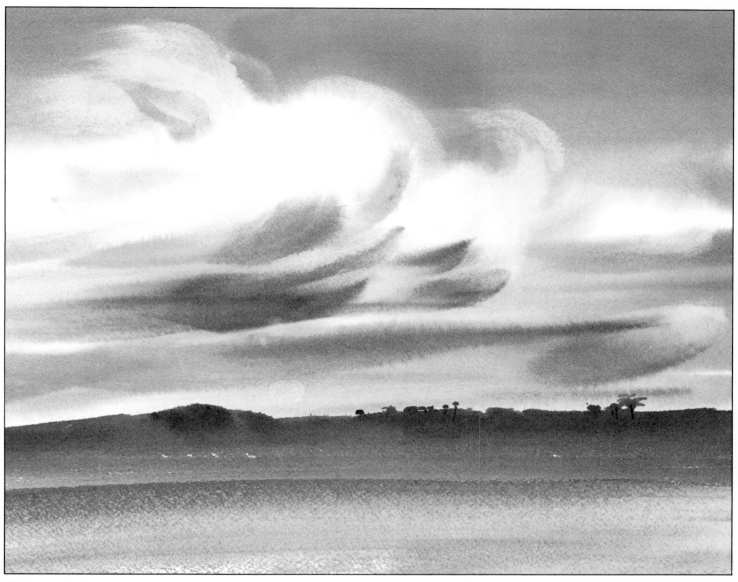

Windswept Cumulus Clouds. I painted a mixture of French ultramarine and Antwerp blue around the top of the clouds on wet paper. In the lower part of the sky, I also added cerulean blue and raw sienna. I lifted out the windswept cloud tails with a damp, thirsty brush. I mixed a gray wash of burnt sienna and French ultramarine for the shaded bottoms of the clouds.

Lifting Out Cumulus Clouds. (Above) I wetted the paper, then brushed on Antwerp blue and burnt sienna around the white cloud shapes. I rinsed my 1″ (2.5 cm) flat brush, wiped it, and with this thirsty brush, I dampened and softened the inner edges of the larger cloud and lifted out the other cloud from the background. I quickly added a little gray brown to the cloud bases.

Painting Around Cumulus Clouds. (Left) I painted the blue wash around the white space on wet paper *without* lifting the edges of my brush. After the wash dried, I glazed on the grayer blue for the lower cloud and lost the upper edges.

Skies and Weather

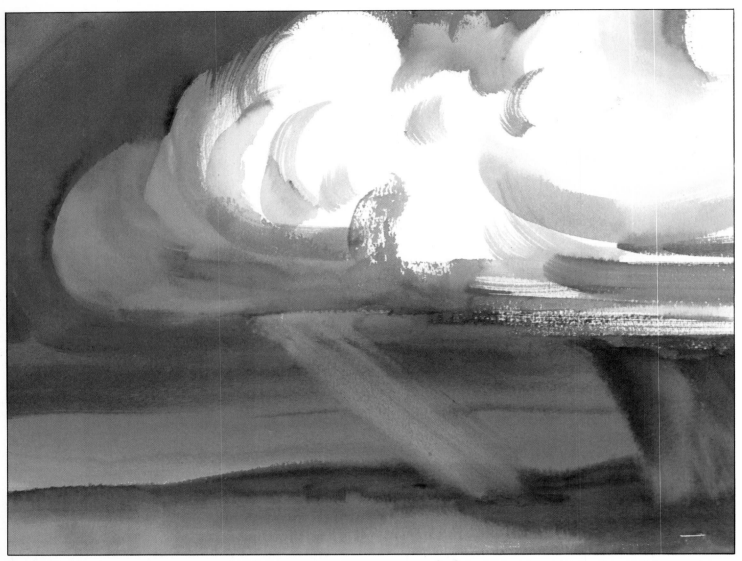

Thunderheads. This demonstration shows how I handled the first appearance of a thunderhead. First, I painted around the towering white clouds in the forefront. Then I lifted the blue clouds out of the background after the Winsor blue had stained it. I used a few strokes of sepia for the brown-gray shaded cloud edges. Below, I wiped off the rays of light and the rain from the dry paint with a crushed, damp tissue and painted on the soft gray of the rain afterwards.

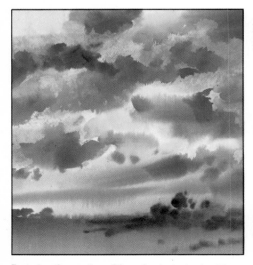

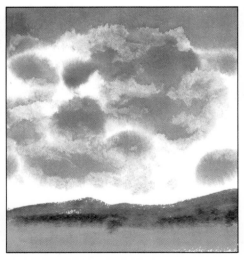

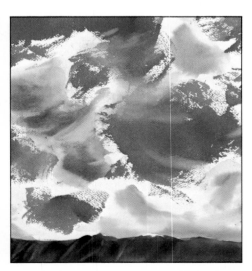

Fracto-Cumulus Clouds. I started with a wet-in-wet application of Winsor blue, French ultramarine, and Antwerp blue and left out some white clouds. I let the color dry a little and blot-lifted the broken clouds with a bunched-up paper tissue.

Fracto-Cumulus Clouds. Using a simpler approach to the same condition, I painted in the clouds wih French ultramarine, Antwerp blue, and raw sienna.

Backlit Clouds. I painted the sky with a large, soft, flat brush. I wiped off the soft wisps of clouds with a thirsty bristle brush and a tissue. Then I painted the centers of the white clouds with a warm gray wash and softly wet blended the outer edges.

Cirrus Clouds. I painted these layered cirrus clouds with raw sienna, burnt sienna, and Antwerp blue in two applications. The white cloud exposes the lighter layers, which were painted smaller to show perspective. The hill was painted next with burnt sienna and French ultramarine; then the tall poplars. I finished with the foreground of raw sienna and Antwerp blue.

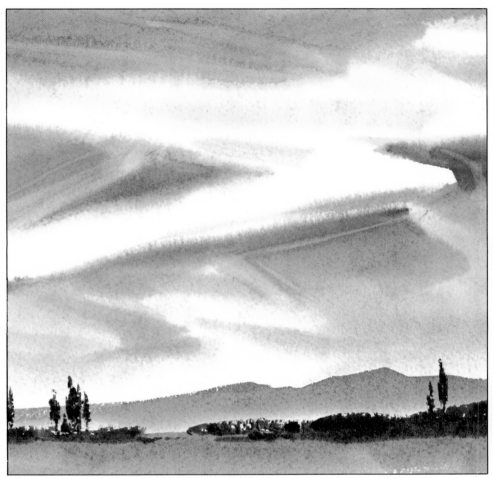

Strato-Cumulus Clouds. (Above) To paint these clouds, I quickly brushed on varied brushstrokes of Antwerp blue, French ultramarine, raw sienna, and brown madder onto a wet background. I used a 1″ (2.5 cm) flat brush, making sure that the brushstrokes were far enough apart that they wouldn't blend completely.

Windswept Clouds. I started with French ultramarine, burnt sienna, and raw sienna on wet paper, leaving out some clear white shapes. At the lower side, I added a little cerulean blue. When this wash was damp, I rolled and lifted out the color with a wide, thirsty brush. I followed by painting the dark hills, using burnt sienna, Antwerp blue, and raw sienna.

Skies and Weather

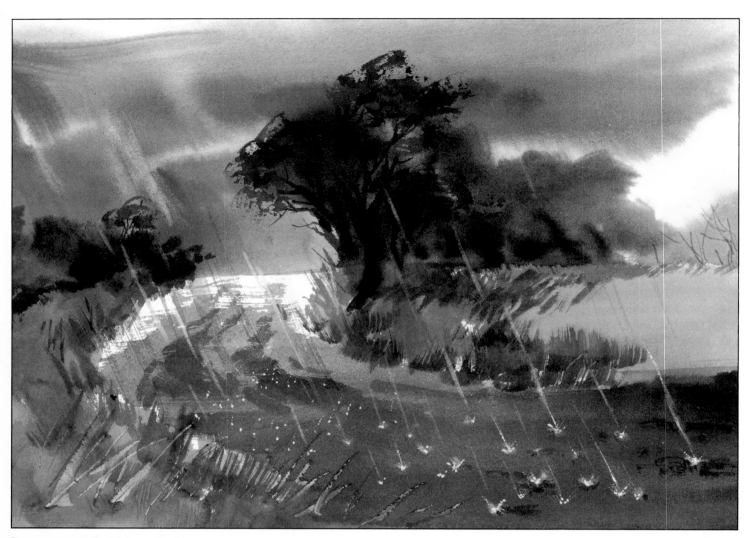

Downpour. (Above) I roughed in my sketch first, without the raindrops. Then I wetted and blot-lifted out the soft splashes and streaks of the falling raindrops from the dry paper. Later I scraped out two or three long, light streaks and gouged out the round highlights where the splashes hit the ground, with the sharp corner of a razor blade.

Rain on Leaves and Weeds. (Right) First I painted the light silhouette washes of the leaves. This color is still visible within the raindrops. After it dried, I masked out the beads of water with latex and modeled the texture of the leaves. Next, I removed the latex and shaded each raindrop.

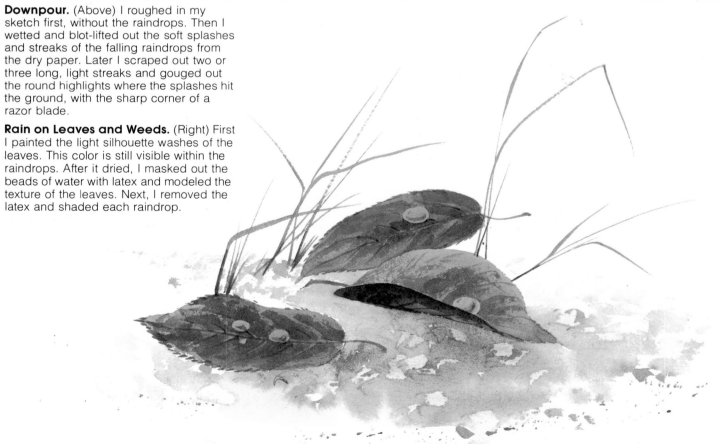

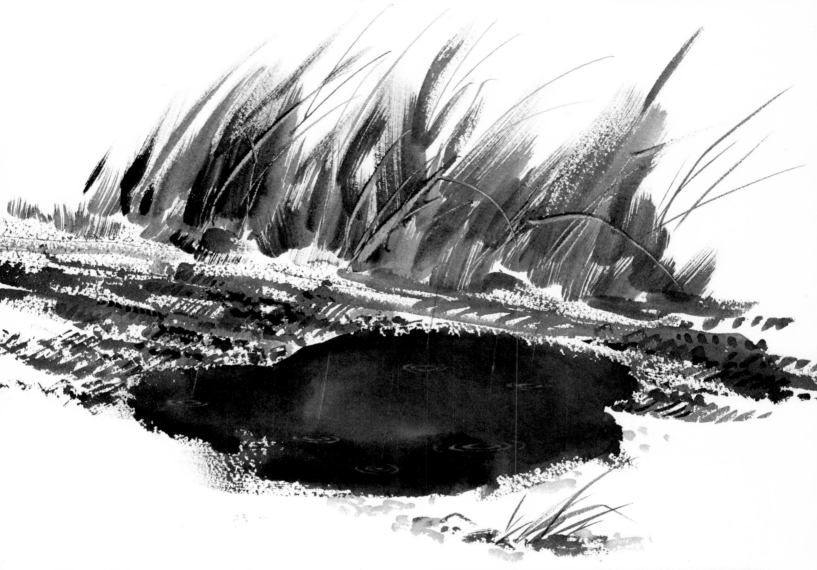

Raindrops in a Puddle. (Top) After I painted the puddle, I let the edges remain as drybrushed spots that appeared shiny on the dry paper. Next I drybrushed the mud texture around the puddle and wetted and blot-lifted out the ripples in the water and the long lines of the falling raindrops.

Raindrops on Dirty Windowpanes. (Above) On the dirty windows, I painted a textured wash of sepia and French ultramarine. At the lower right-hand corner, where the glass is missing, I painted a touch of nature outside.

Raindrops on Clean Windowpanes. (Left) I painted the outdoor colors to suggest clean glass. In both this picture and the one at the right, I dropped clean water onto the dry surface and blew it downward. I then wiped out the path of the droplet of water and added the shadow to the raindrop.

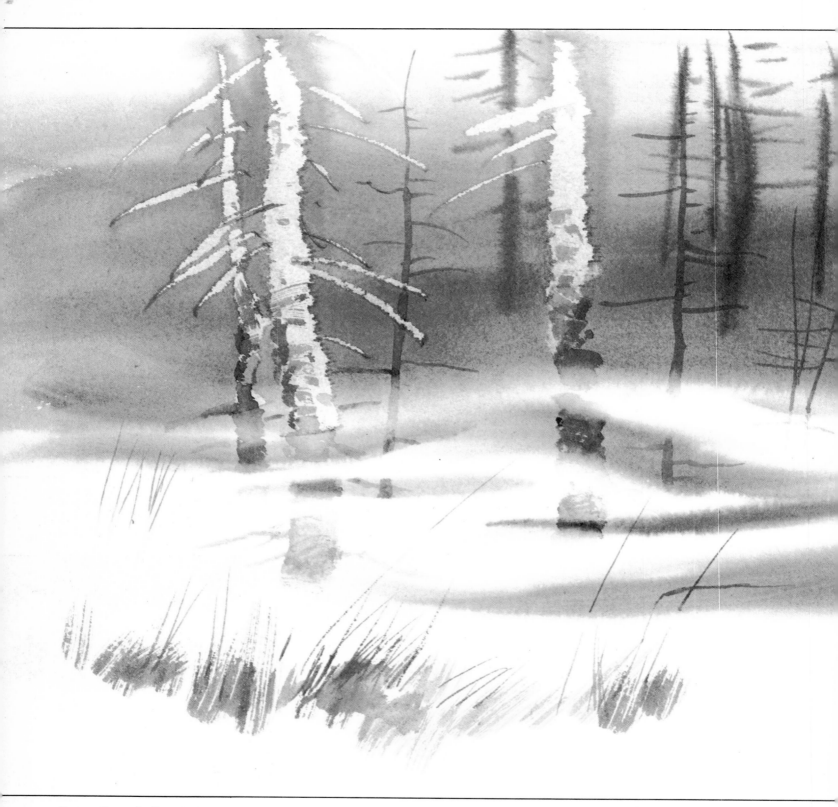

Barren Trees in Fog. In fog, the surface of the ground has varied transparency. I used cerulean blue, raw sienna, and sepia in light values on wet paper. I knifed out the light trees from this background. I also added the blurred tree skeletons. Where the trees are exposed between the layers of fog, I lost their edges accordingly. In the foreground grass, I used the same colors as above, with proportionately more raw sienna.

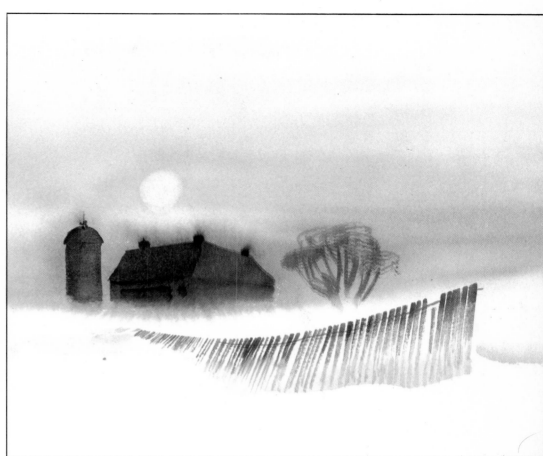

Barnyard Scene in Fog. The misty fog in the background is burnt sienna and French ultramarine. I painted the barn and tree on the dry paper, but lost the lower edges with a wet blending technique where they're hidden by the fog. I added the fence in the snow in a light value to confine the fog to the distance and to add to the feeling that the scene is surrounded by fog.

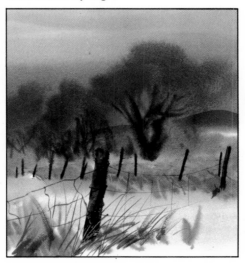

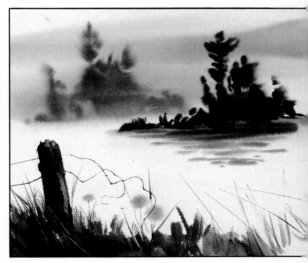

Foreground Center of Interest in Fog. I indicated the light mist with a wet-in-wet technique, but painted the foreground post and grass sharper and stronger in color. As objects recede into the distance, they lose definition. My palette was French ultramarine, burnt sienna, cerulean blue, and raw sienna.

Layers of Fog. I wetted the paper and painted in the distant island and the misty sky with a light value of burnt sienna, Antwerp blue, and French ultramarine, with a soft brush. I painted the closer island using a bristle brush, very little water, and a rich mixture of burnt sienna and French ultramarine. I added the foreground last, drybrushing and knifing in the sharper forms with richer color.

Manmade Structures

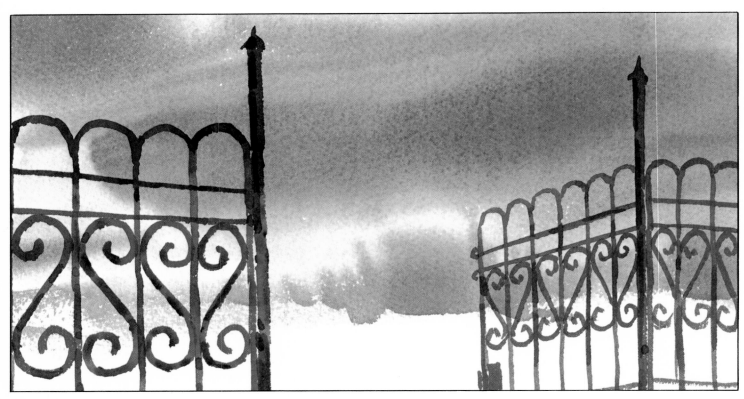

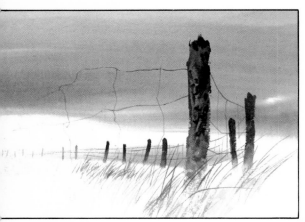

Wrought Iron Fence. (Top) I started with a light, natural background of French ultramarine, burnt sienna, and raw sienna. For the gate, my palette was sepia, brown madder, and burnt sienna. I roughly brushed on the ironwork, glazing one color on top of another and building the texture slowly.

Wire Fences in Fog. (Above) The closer fence posts fade more gradually into the fog than the more distant ones. For the sky, I used burnt sienna and French ultramarine, and for the post, burnt sienna, French ultramarine, and raw sienna. I knifed on the wire with the edge of my palette knife.

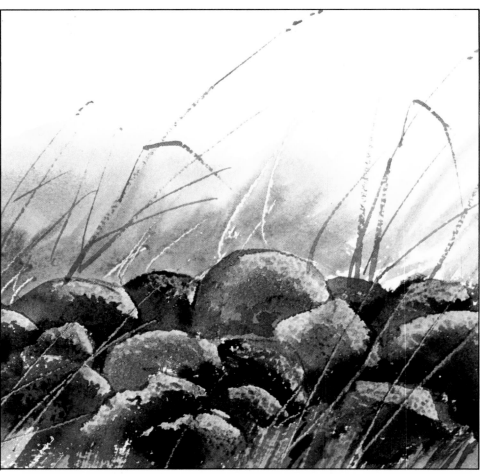

Old Stone Fence. For this stone fence in disrepair, I varied my colors of burnt sienna, brown madder, and French ultramarine, blending them on the paper. These colors show through where I knifed off the light shades. For the weeds, I used raw sienna and Antwerp blue on wet paper and later textured them with knifestrokes and fine brush lines.

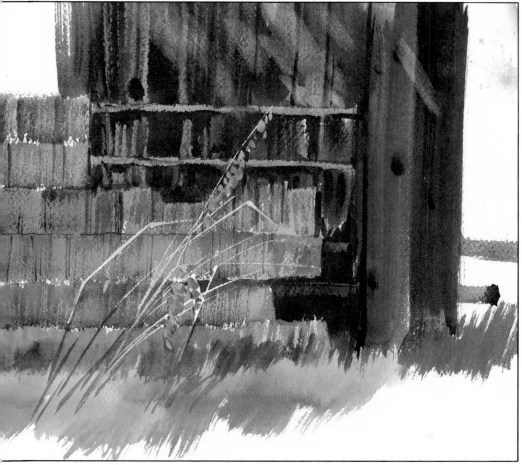

Wooden Boards. (Top) On the barn wall and fence I painted the woodgrain on dry, white paper with split drybrush strokes of sepia, using a bristle brush. After it dried, I painted a combination of burnt sienna and sepia over the grain texture as the main value. After this dried, I wetted and blot-lifted off the sunshine.

Cobweb on a Wooden Fence. (Above) I painted the fence with burnt sienna and sepia. When it was dry, I wetted and blot-lifted off the cobweb. However, cobwebs can also be scraped out of the back-ground with the corner of a razor blade when the background wash is dry, for a dewy or highlighted effect.

Shingles. I used a horizontally dragged, 1″ (2.5 cm) flat brush double-loaded with burnt sienna on one side, French ultramarine on the other, plus a little sepia, to get the double color of the rows of shingles. I masked out and later colored in the flowers, and wiped off the light patches of sun with a wet-and-blot technique.

Manmade Structures

Mortar Knifed Out of a Stone Building.
(Right) I painted the stone wall as a single wash, blending burnt sienna, raw sienna, and French ultramarine. I knifed out the light mortar from this wash before it lost its shine. I repeated this on the chimney. My colors for the roof and wooden wall were burnt sienna, French ultramarine, and sepia. I hinted at some grassy texture in the foreground.

Brick Wall. (Below) I started with loosely blended brushstrokes of brown madder, burnt sienna, French ultramarine, and sepia. I knifed out the light brick color, and later glazed on a few brushstrokes to add textural variety. Raw sienna and Antwerp blue supplied the colors for the grass.

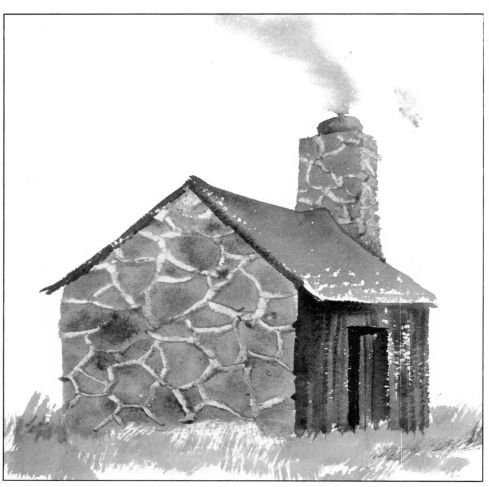

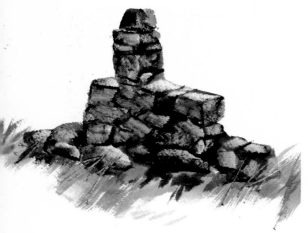

Stone Building in Ruins. (Above) I used raw sienna, burnt sienna, French ultramarine, and sepia washes to define the large stone shapes of the ruin. I knifed out the lighter values, leaving the texture as it appears here. I added the grass with raw sienna and Antwerp blue.

Shadows Glazed on a Stone Building.
(Right) I painted the stones with French ultramarine, burnt sienna, brown madder, and Antwerp blue, freely blending them. I left the space between them (representing the mortar) white. On the sunny side of the building, I glazed on burnt sienna and French ultramarine to color the mortar in the shade. I added the wooden walls above the stone with sepia, burnt sienna, and French ultramarine. My colors for the shrubs and grass were French ultramarine, raw sienna, and Antwerp blue.

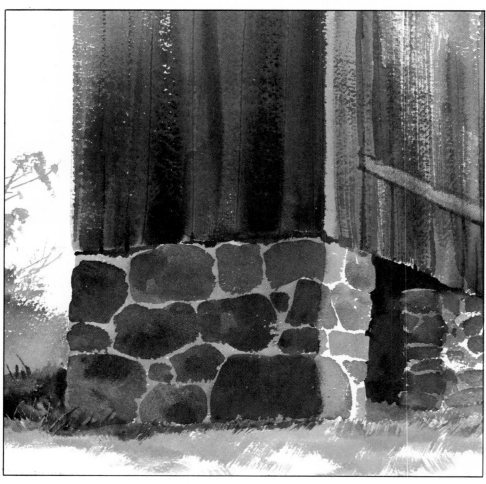

Transparent Glass. (Left) Dark washes of sepia, burnt sienna, and French ultramarine show dim contrast against the new gamboge, cerulean blue, and sap green background. I wiped out the light, chipped glass at the top and glazed on the transparent piece of glass in the lower right-hand corner.

Cracked, Reflective Glass. (Below) Dusty gray mixtures of burnt sienna, raw sienna, and French ultramarine were applied in light glazes to each windowpane and reveal the jagged edges of the cracked glass. Where the cracks are light, I wiped and blotted them off with the point of a soft brush after the paint was dry. In contrast, I scratched in the dark lines with my palette knife while the wash was wet.

Cracked, Transparent Glass. (Above) First I painted the outdoor scene through the transparent glass. Into the wet wash, I cut the design of the cracked glass with the edge of my pocketknife. I painted the dark windowframes last.

Overlapping Layers of Glass. (Center left) As the initial dark wash dried, I blotted off the medium-light windowpanes with a double-folded tissue. Next, I wetted and blotted off the color where the glass overlaps. I drybrushed the wooden frame last.

Reflections on Glass. (Left) I wet washed the fresh colors of the reflected outdoor scene onto each pane of glass separately. I painted the dark space behind the cracked pane after the first wash had dried.

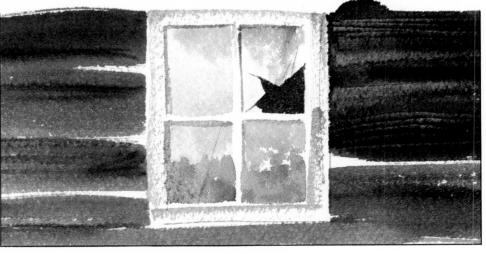

Manmade Structures

Dusty Glass. The dusty glass on the old structure was washed on and modeled, a pane at a time. I used sepia, French ultramarine, burnt sienna, and Antwerp blue. I scraped the cracks into the wet wash and painted the inner space through the broken window over a dry surface with a dark combination of sepia and French ultramarine. The color of the new fence makes the wall of the old house look more aged in contrast.

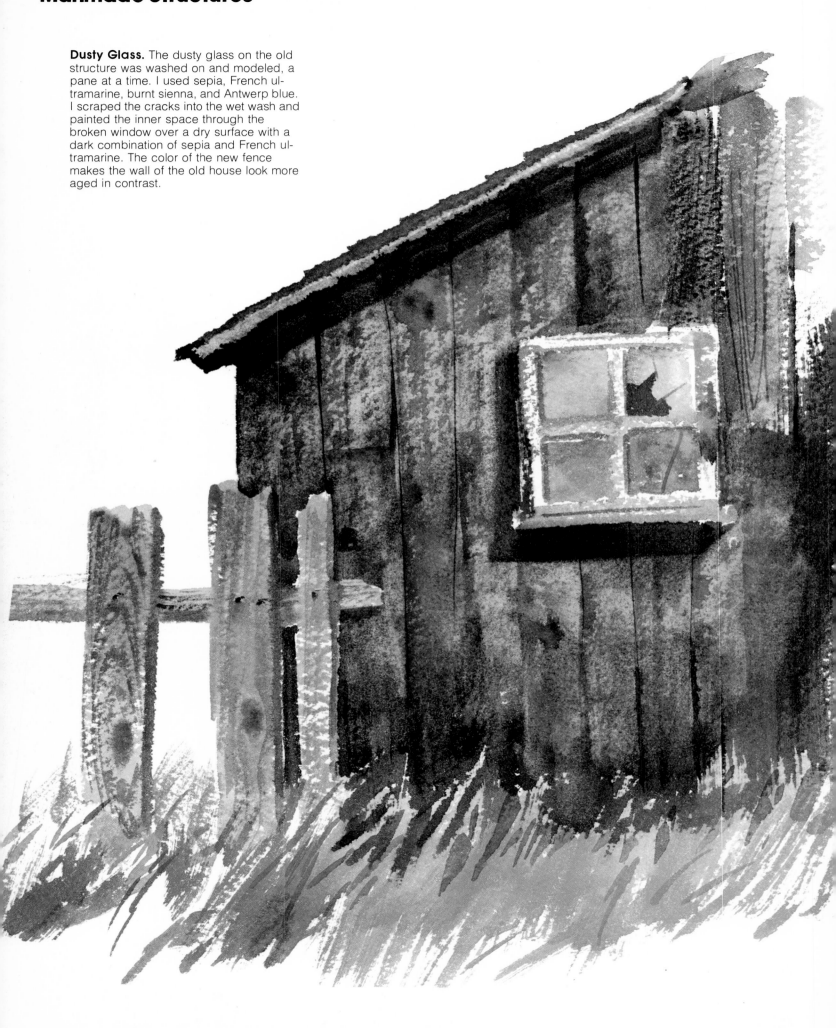

FINISHED PAINTINGS IN COLOR

Details of Misty Bouquet

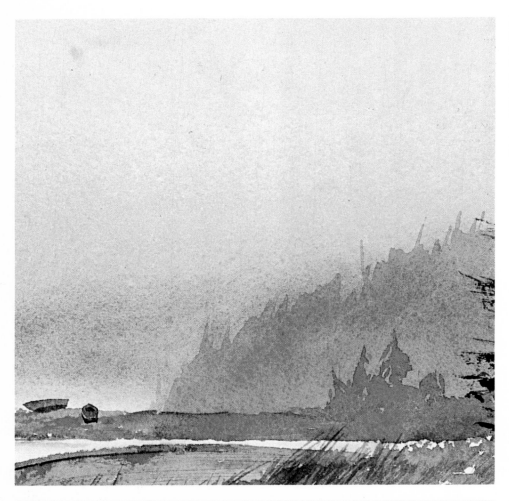

Distant Hills. (Top of painting) To give the feeling of distance, I used descending values and started painting the lightest and coolest colors first, with a wet-in-wet technique. I glazed on the darker shapes after the previous wash dried. My washes gained in detail and darkened in value as they came closer to the foreground. The balance is delicate, and aerial or color perspective and color unity had to be considered too.

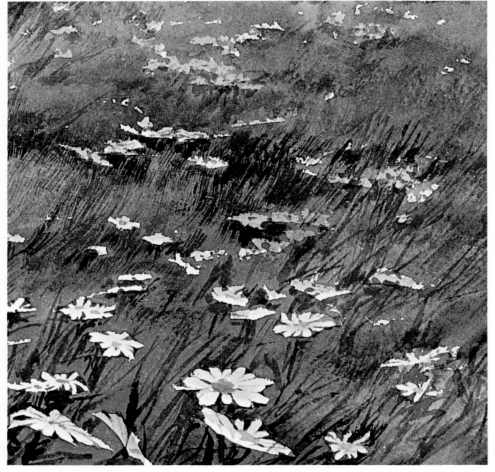

Field with Daisies. (Bottom of painting) The medium-value wash of Winsor blue and burnt sienna shows color variety under the grassy texture. Each brushload of paint modifies the field. I had to mix and paint fast to prevent the washes from drying, because the whole field had to blend. The shapes and clusters of the daisies were also painted in this speedy application, but the closer flowers had to be redefined later, when the basic wash was dry.

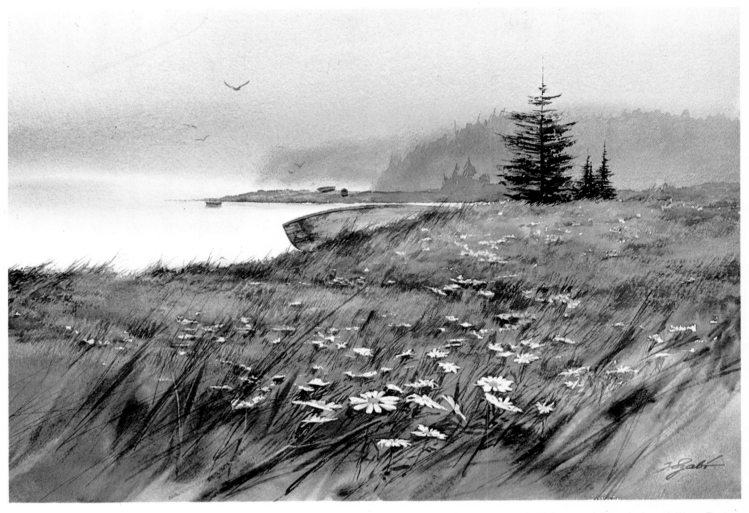

Palette

Burnt Sienna
Cerulean Blue
French Ultramarine
Winsor Blue
Cadmium Yellow Deep

Misty Bouquet. June 1970, 15" x 22" (38 x 56 cm). This nostalgic painting of River Port, Boquet, Nova Scotia, is the result of a combination of charming subject matter and soft misty conditions. First I painted the most distant point on wet paper at the same time as the sky. After the paper dried, I silhouetted the next layer of trees a little darker and followed with the narrow point of the little boats, again using darker values and giving the edges little more definition. For the misty sky, I used French ultramarine, burnt sienna, and Winsor blue. For the reflection on the left-hand side of the water, I omitted the Winsor blue, and for the layers of distant points of land I added cerulean blue as well. I painted the large field with a wet-on-dry technique. I started from the top, quickly brushing on the paint. When the brush skipped white spots, I left them there. I carried the pools of paint downward with additional brushloads of pigment fast enough to prevent their edges from drying. The closer I got to the foreground, the more carefully I handled the shapes. I painted around the closest daisies, leaving their shapes white. After this value wash was dry, I drybrushed in the delicate dark spruces, added the details to the daisies, and textured the grass with more burnt sienna, Winsor blue, and cadmium yellow deep. Finally, I dropped in the hull of the grounded old boat and painted in a few gulls.

Details of Day's End

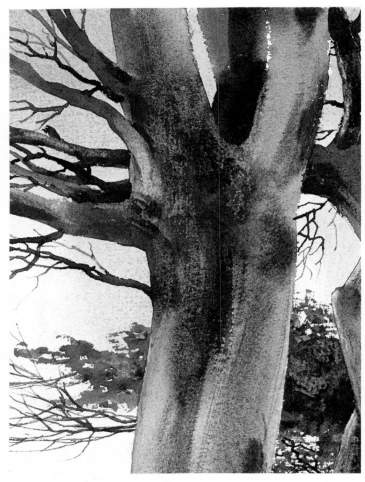

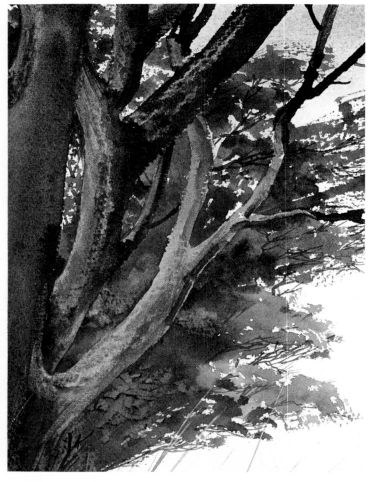

Branch Structure. (Top left of painting) Subtle maneuvering of medium and dark values added to the effect of three-dimensionality between branches. These branches were painted over a pale blue sky which was too light to distract from the warm, dark color of the branches. I used burnt sienna for the warm, lighter sides of the heavier branches. Then I wiped or knifed out the modeling in the light and textured it with some drybrush strokes.

Middleground Tree Trunk Against Background Tree. (Right center of painting) The quiet play of light on form defines the different planes in this detail. I lifted off the light-textured modeling from the large branches with a knife, exposing a transparent hue of burnt sienna, raw sienna, and warm sepia. Later I shaded the darker side with an occasional touch of Antwerp blue and warm sepia. For the contrasting background, I painted on a rich dark wash of sap green, Antwerp blue, burnt sienna, and raw sienna. I then scumbled the delicate drybrushed edges of the branches onto the dry surface by holding a flat bristle brush on its side with hardly any pressure. Finally I painted the fine branches that link the foliage into the sections of sky beyond.

Palette
Raw Sienna
Burnt Sienna
Antwerp Blue
Warm Sepia
Sap Green
Cerulean Blue

Day's End. July 1974, 15″ x 22″ (38 x 56 cm). This watercolor, painted on the island of Maui in Hawaii, is a study of tree structure under subdued lighting in which the painting knife is used in every conceivable way. First I glazed on most of the background with a thin wash of Antwerp blue, cerulean blue, and raw sienna. Then I painted the trunks of the old, dead trees. They've lost most of their bark, and their smooth trunks are influenced by both warm and cool lighting. I brushed on the warm (burnt sienna and raw sienna) and cool (Antwerp blue and warm sepia) washes simultaneously. On the large branches, I knifed out the light values from the dark wash for a rougher texture. At the bottom of the trees, I wet blended the value washes of the grass into the base of the tree trunks. I knifed out and painted on individual blades of grass later when the washes were dry. I painted the network of crisscrossing dark branches with a palette knife; the liquid paint flowed off the tip of the knife. With raw sienna, sap green, Antwerp blue, and warm sepia, I drybrushed on the lacy shapes of the dark background trees in the background and connected the units of foliage with fine branches, using a thin rigger brush. I completed the painting by adding a few final touches: the bark texture and cracks in the wood, the knifed-out foliage detail, and the brush-lifted thin blades of grass, applying a wet-and-blot technique.

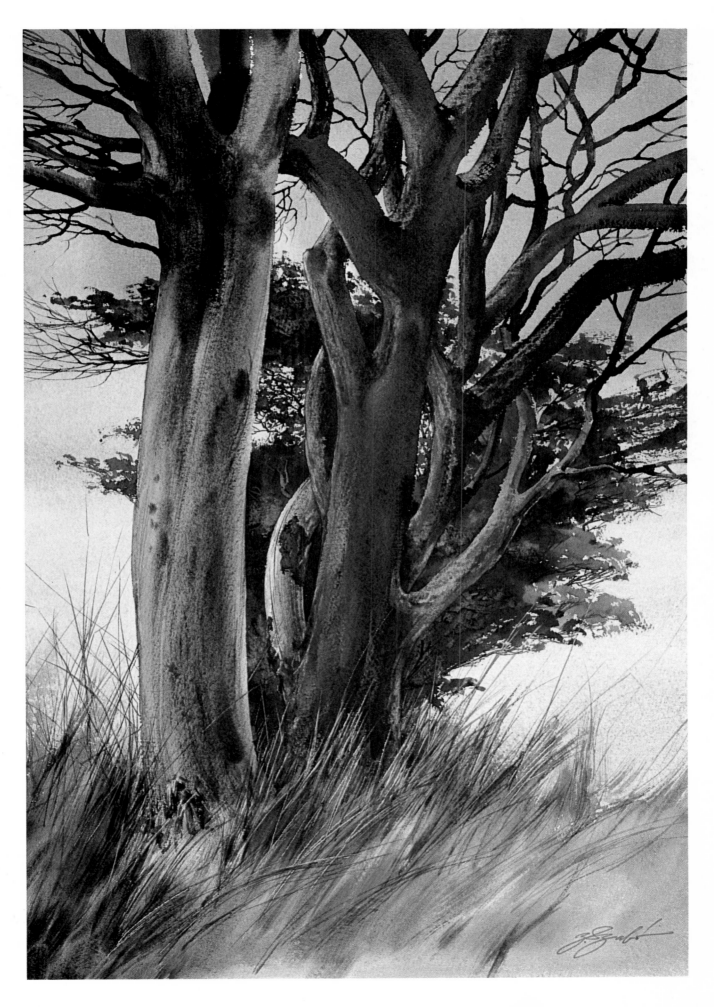

Details of The King and His Castle

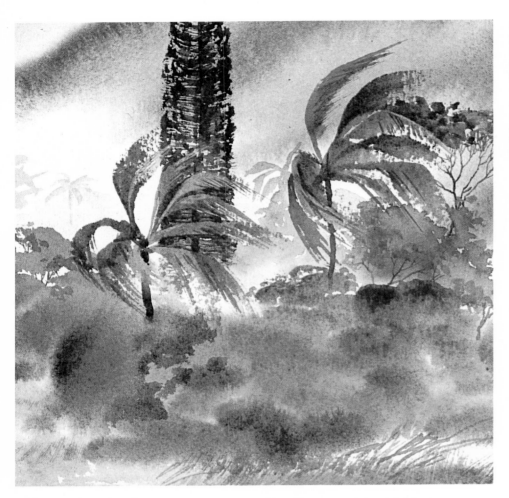

Cluster of Palm Trees. (Left bottom of painting) In this area, the forms were built up gradually by brushstrokes applied throughout the entire drying period. At first, the shapes were very blurred on the wet paper, but as the paper dried, the brushstrokes became sharper and sharper. I placed the final details on form that was clearly visible in the mist, when the paper was completely dry. Sap green is the dominant hue here.

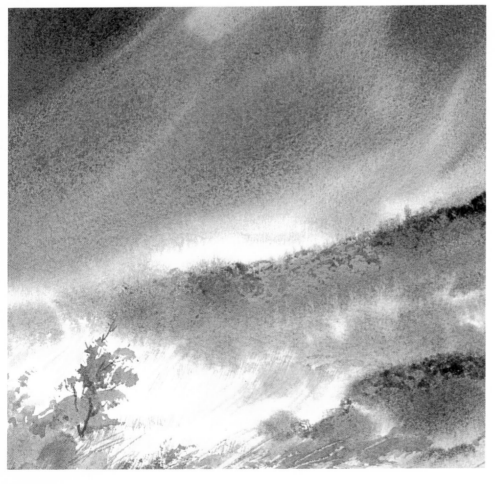

Descending Middleground. (Right center of painting). The effects of color perspective (warm foreground, growing cooler with distance) and gradually simplified values and texture lead your eye toward the rainy slopes. I used all four colors of my palette here, carefully controlling their values. The soft white glow of mist is a negative shape. It zigzags into the distance and serves as a good background for the tree and clusters of grass that connect the middleground on the right with the center of interest at the left foreground.

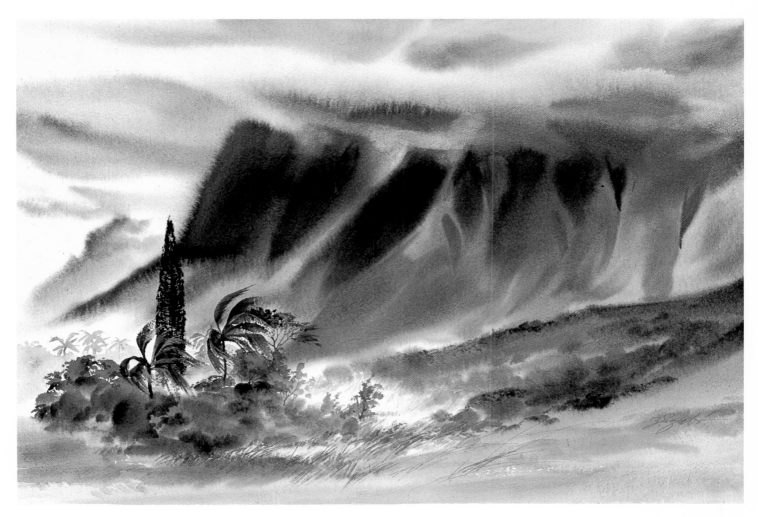

Palette

Raw Sienna
Sap Green
French Ultramarine
Warm Sepia

The King and His Castle. July 1974, 15″ x 22″ (38 x 56 cm). This painting, with its contrast between the rich, tropical colors and the soft cloud-covered cliffs, typifies the mystery of the Hawaiian landscape. To paint it, I first wet my paper thoroughly. With a 1″ (2.5 cm) soft, flat, well-loaded brush of French ultramarine and warm sepia, I painted in the wet clouds. I used the same colors, but with much less water, for the jagged cliffs, adding a touch of sap green and raw sienna to the lower, less-shaded slopes. When I applied these firmer shapes, my brush was thirsty enough to actually remove some water from the wet paper while simultaneously adding thick color. I added a little more definition to the lower middleground with firm, flat-bristle brushfuls of raw sienna, sap green, French ultramarine, and warm sepia. I started the rich green mass of foliage on the left-hand side with a similar technique on the still-damp paper. The forms of the shrubs and windblown palm trees followed after the paper dried. I knifed out a few touches of leaves from the palm branches, then added the tall, dark Norfolk Island pine with a dry-brush technique. The lighter, more distant plane of palms behind these rich colors was painted with a light wash of French ultramarine and sap green. I finished the composition by adding minor details such as blades of grass and the lighter branches with a small rigger brush.

Details of The Good Scout

Leaf and Pine Needles. (Left side of painting) The leaf and pine needles and the protruding part of the branch were masked out from all three glazes and were finished later. The leaf at bottom left—masked out before the second wash—shows the color of the first glaze. Other leaves and needles were masked out after the second glaze dried. They show the soft, dark reflections. The submerged part of the branch came next and the light line at the water's edge was done last.

Leaves and Trunk. (Right side of painting) The dark glazes, contrasting with the bright, floating leaves, indicate deeper water and create more drama. The blue-gray modeled, charred wood gives a cool color contrast to the bright leaves. I painted the burned texture with drybrush. Note the leaf texture: I shaded the maple and poplar (pink and yellow) leaves with the brush, but I scraped the oak leaf veins into the wet wash with the sharp point of my brush handle. Where the water touches the dry wood, I lifted the thin highlights with the tip of a thirsty brush.

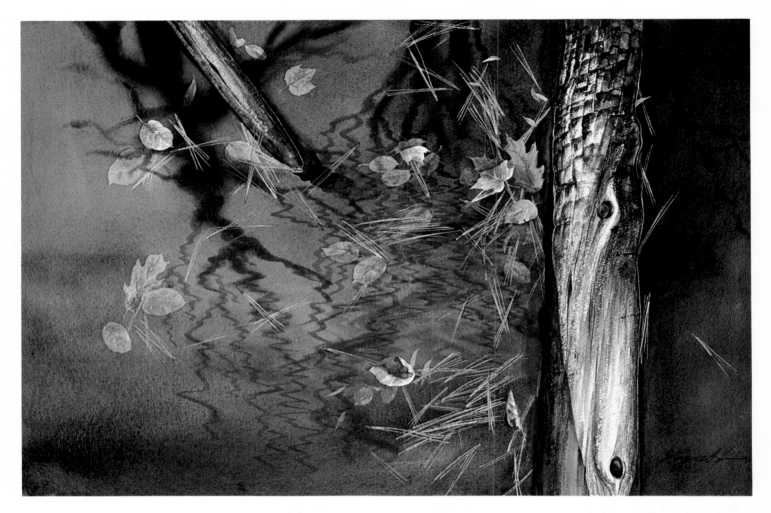

Palette

Burnt Sienna
Raw Sienna
Antwerp Blue
French Ultramarine
Brown Madder

The Good Scout. November 1975, 15″ x 22″ (38 x 56 cm). This painting is based on careful control of glazing, plus the use of masking. My palette consisted only of very transparent colors. The water area has three layers of well-diluted French ultramarine, Antwerp blue, and burnt sienna. The brightest colored leaves, needles, and the dry-brushed wood were masked out first on white paper. Then I glazed on my first wash of the mixture described above. On this dried color, I masked out more leaves and pine needles, then painted my second glaze for the water. Into this wash, I added the softer branch reflections and the deeper tones at the right of the log and in the left bottom area. After drying, I masked out more leaves and applied the third glaze. When this dried, I painted the sharper branch reflections. I removed all the masking latex and finished the details on the freshly exposed surfaces of the leaves. Then I drybrushed the charred log without the overlapping water. I painted the underwater part of the log with a rich glaze over the wood texture and the submerged parts of the leaves. At the end, I brush-lifted the thin highlights where the water touches the wood.

Details of Valentine Card

Woodgrain and Washes. (Lower left corner of painting) The abstract pattern is the result of the application of salt and the wet splatter of color while the salt was drying. The cerulean blue and burnt sienna separated in the wash as I had intended, proving their blending incompatibility with each other. The carefully painted, almost formal, woodgrain creates a striking contrast with the frosted pane, though both treatments are actually very realistic.

Heart Shape. (Right center of painting) Within this completely abstract design area, I painted the heart shape with cerulean blue, burnt sienna, and Antwerp blue and sprinkled salt into it while it was still wet, including the shape of the running droplet of water. When the salt dried, it made this shape resemble a re-frozen surface. For this technique, I chose a light background area that also helped strengthen the center of interest.

Palette
Burnt Sienna
Raw Sienna
Brown Madder
Antwerp Blue
Cerulean Blue

Valentine Card. February 14, 1976 (Valentine's Day), 15″ x 22″ (38 x 56 cm). I masked out the windowframe with masking tape. I then wet the whole area of the windowpane and painted in the distant blurred forest with brown madder, burnt sienna, and Antwerp blue, leaving the area near the bottom and two sides a little lighter. As this wash was settling, I sprinkled on concentrated amounts of salt the way Indians paint with sand. After the salting, I added more color splatters of cerulean blue, burnt sienna, and Antwerp blue into the active salt texture. While this wash was drying, I removed the masking tape and finished the woodgrain design with a combination of drybrush and wet-and-blot techniques, using brown madder, raw sienna, and Antwerp blue. When the paper was thoroughly dry, I painted the heart shape, imitating the movement of a finger on frosted glass, and sprinkled salt into this new wet shape. The next day, I scrubbed off the dry salt and exposed the finished texture. I concluded by adding a few bent, rusty nails and some rusty stains below them.

Details of Emerald Bath

Breaking Waves. (Left center of painting) I drybrushed on the greens and blues of the deeper water, but as the water neared the sandy shore, I grayed my washes. I used manganese blue in the mixture because it granulates and separates from the other colors, adding a pattern of its own to complement the lacy drybrush effect. A strong separating wash is good for the foreground, but would be wrong in a more distant location.

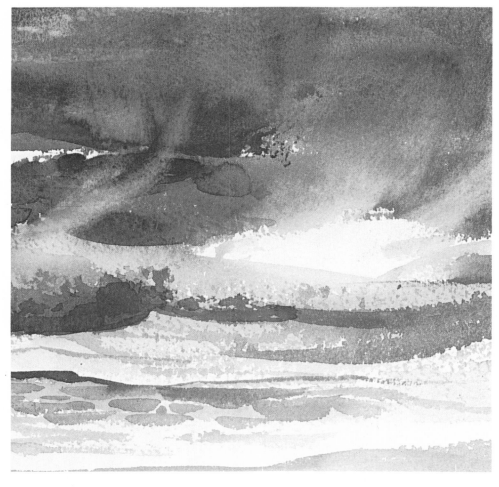

Crashing Surf Spray. (Top right of painting) Warmer green colors again appear closer than the cooler blue ones. To exaggerate the soft misty ocean spray, I painted drybrush touches of beading droplets next to it. To create the spray, I scrubbed the dry paint hard with a bristle brush. After I loosened the pigment, I lifted it off with vigorous pressure into a bunched-up tissue. I repeated this two or three times until the blotted value was just right.

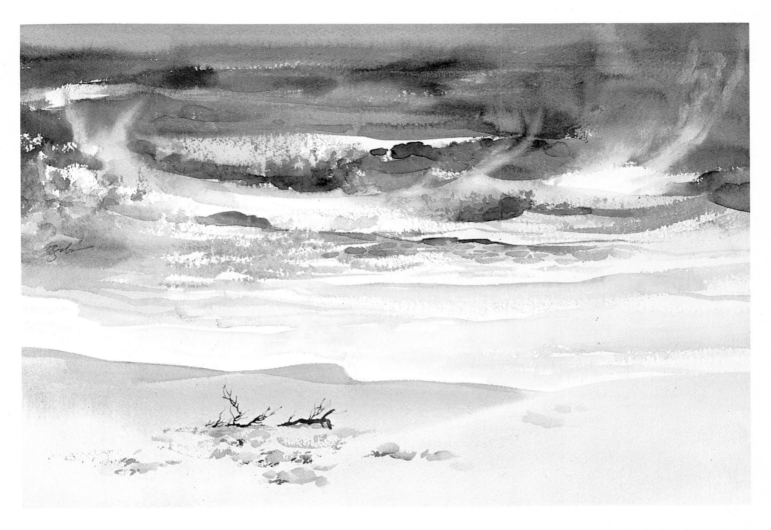

Palette

Antwerp Blue
French Ultramarine
Manganese Blue
Burnt Sienna
Aureolin Yellow

Emerald Bath. March 1976, 15″ x 22″ (38 x 56 cm). This watercolor is the outgrowth of designing into accidental forms. I painted the scene in glaring bright sunlight on the white sand beaches of the Gulf of Mexico in Pensacola, Florida. The accidental wet-in-wet effects occurred when I painted several large, rich brushfuls of varied blues onto the dry paper so fast that they flowed into each other. As accidental white shapes were formed, I kept them intact, and they later became white surf. I even intensified their contrast with the blue waves by painting a darker brushful of color next to them. I advanced the wash from the top downward using lighter color and more and more white space between drybrush strokes. The behavior of the breaking waves showed the extremely white foam as pure sparkle where it touched the sand. To exaggerate the purity of the blue waves, I contrasted it with the soft wash of burnt sienna and French ultramarine for the sandy beach. The scattered twigs and footprints supplied foreground interest. I painted the branches with a palette knife and modeled the sand with lost-and-found edges. I added a touch of the warm sandy color into the thin layer of foamy water to give a hint of refraction for better color unity. With a touch of aureolin yellow added to the waves, I introduced a color accent of luminous green. I blotted out the soft spray of the crashing surf with a paper tissue immediately after wetting the dry surface with clean water. After adding a few touches of clarifying shapes in the waves, I was finished.

Details of Frozen Ruby

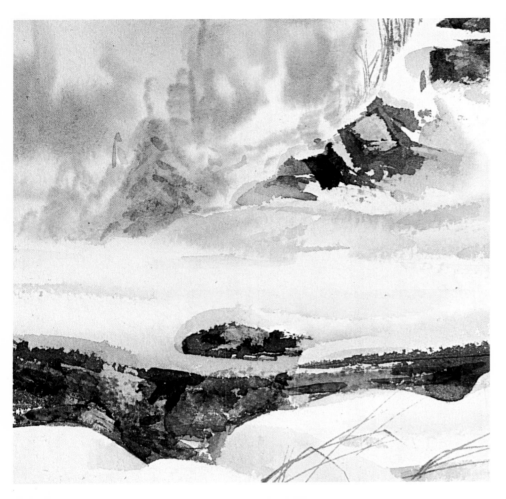

Middleground. (Left center of painting) I want to draw your attention to the lost-and-found edge modeling of the snow. The soft shaded edges mean gradual blending and the sharp gray edge defines the shape of the snow hump in front of it. The soft, cool-blue evergreens recede into the distance, while the warmer color of granite and the dry weeds make them appear closer. Note the extreme contrast in texture between the rock and snow.

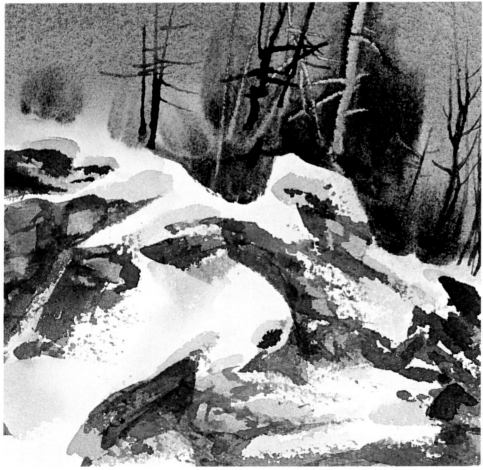

Large Rock and Trees. (Top right center of painting) I painted the dark rock colors quickly on dry paper and modeled them by knifing. The variety in the trees comes from their asymmetrical shapes. The light trees were knifed out first, then the dark trees painted later with the tip of my palette knife. Note the rich, light hue of the knifed-out spots on the rocks where the burnt sienna and brown madder has already stained the paper.

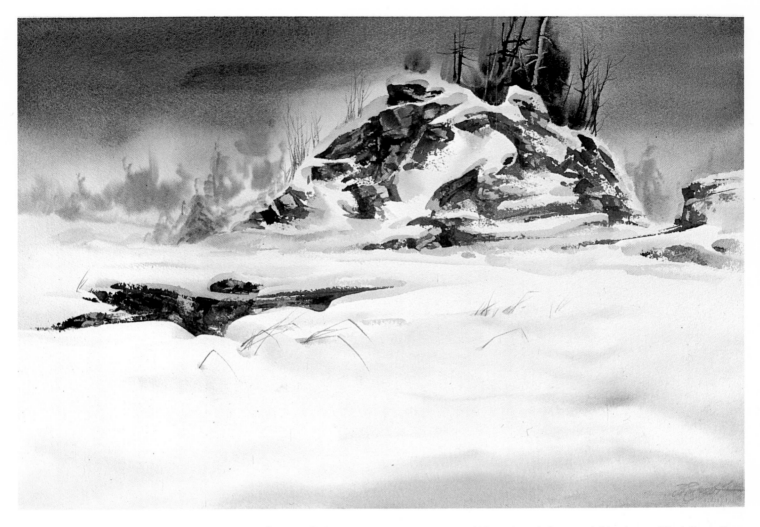

Palette

Raw Sienna
Burnt Sienna
Brown Madder
Antwerp Blue
French Ultramarine

Frozen Ruby. March 1976, 15″ x 22″ (38 x 56 cm). I started this drama-filled Canadian winter scene by wetting the upper part of the painting. I painted the threatening sky into the wet paper with a rich mixture of French ultramarine, raw sienna, burnt sienna, and brown madder, encouraging the burnt sienna to dominate the lighter lower sky with its warm glow. Into this wet wash I painted the light bluish-green evergreens with Antwerp blue and raw sienna, using only a little water in my brush. At the top of the snow-covered rock I introduced the dark, warm, soft shape of the evergreens with burnt sienna, raw sienna, and Antwerp blue. Where the trees touch the snow, I kept the edges sharp by painting the wash on a dry surface, and I knifed out the lighter trunks and branches. I brushed on the dark rock shapes and textured them with a palette knife, designing them to look like exposed sections of a single rock, partly hidden by snow. I treated the rocky dip in the middleground the same way, with brown madder, burnt sienna, and French ultramarine as my colors, paying special attention to the negative white shapes. I softly modeled the deep snow with lost-and-found edges using burnt sienna, French ultramarine, and very light brown madder and Antwerp blue. The softly shaded French ultramarine and burnt sienna in the low foreground make the white snow in the center appear cleaner by contrast. For the finishing touches, I sprinkled a few drift-covered weeds in the middleground with their usual snowy nests, knifed in the bare dark trees, and brushed on a few twigs in the background.

Details of Sand Pipe

Green Shrubs and Dead Branches. (Top center of painting) I wetted and blot-lifted the light cloud from the sky with a thirsty brush to increase its contrast with the dead branches. The isolated note of green foliage adds an eerie quality to the painting. The loosely hinted foliage was a result of accidental washes, which I left. I designed the dry branches into these shapes after they dried. I modeled the large, dead branch out of a darker color with the heavy pressure of a palette knife.

Light-Colored Weeds. (Left front of painting) I modeled the subtle sand dunes with a lost-and-found shading. I painted the weeds with a thin rigger brush, applying a single, slow brushstroke for each stem and leaf to emphasize their fragility. I knifed in the nearby half-buried twigs in a light value that would contrast subtly with the more fragile weeds, without distracting attention from them.

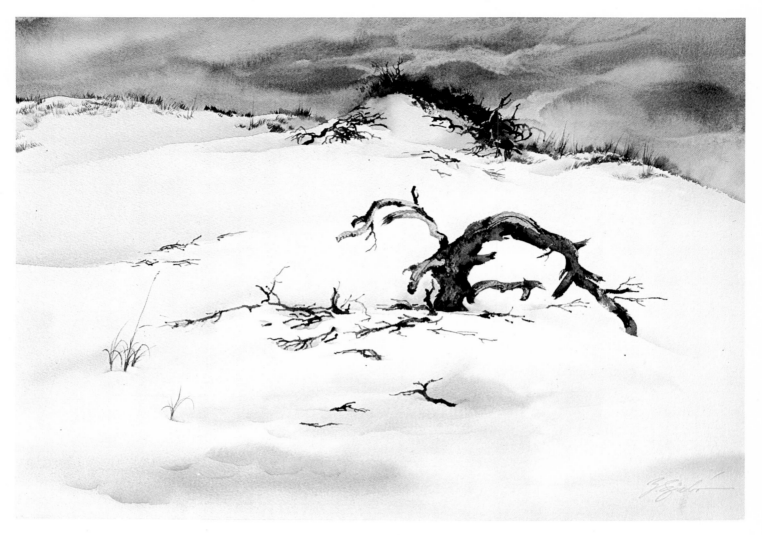

Palette

Burnt Sienna
French Ultramarine
New Gamboge
Antwerp Blue
Brown Madder

Sand Pipe. March 1976, 15″ x 22″ (38 x 56 cm). The white sands near Pensacola, Florida, resemble snow. The telltale green on the shrubs subtly hint life. I used a large expanse of white paper for the sand, with very soft shading of French ultramarine and burnt sienna for the lost-and-found modeling. A dynamic rhythm flows through their curved shapes. I painted the half-buried tree skeleton with quick brushstrokes and textured it with the painting knife. Using brown madder, French ultramarine, burnt sienna, and Antwerp blue, I knifed in the finer branches scattered about the foreground as well as those around the distant green hump. To paint the narrow sky area, I wet the paper only to the edge of the sand dunes, defining their shape carefully. I painted the cloud-covered area with a wet-in-wet technique and French ultramarine, Antwerp blue, and brown madder. I washed in the green shrubs and the soft grass clumps on the right horizon with new gamboge, Antwerp blue, and burnt sienna. I completed my painting by adding the grass on the top left with a split drybrush technique, and by better defining the weeds in the left foreground.

Details of Sunlit Harbor

Tire Area. (Left bottom of painting) There's a clear contrast between the light, warm, sunlit colors of the middleground gravel and the dark, blue-gray, shaded foreground that defines the two planes. I first painted the shape of the tire in a single dark wash, using very little water in my brush. I modeled the light values with an uneven palette-knife stroke for the flat side and quick, small, but firm scoops for the light tire tread. Several staining washes of Winsor blue, burnt sienna, and brown madder insured that the blue-gray foreground was dark enough to look shaded.

Boat Reflections. (Right center of painting) Glazed-on layers of transparent colors, warmer in the foreground and cooler in the distance, form this contrasting passage. First I painted the larger shapes with a soft 1″ (2.5 cm) flat brush, letting lots of white paper show. Then I added the pilings and the darker linear details. As a final step, I wet a broad area of dry paint with a single pass of a soft, flat brush and clean water and I knifed out the light ropes from this remoistened pigment with the tip of my pocketknife.

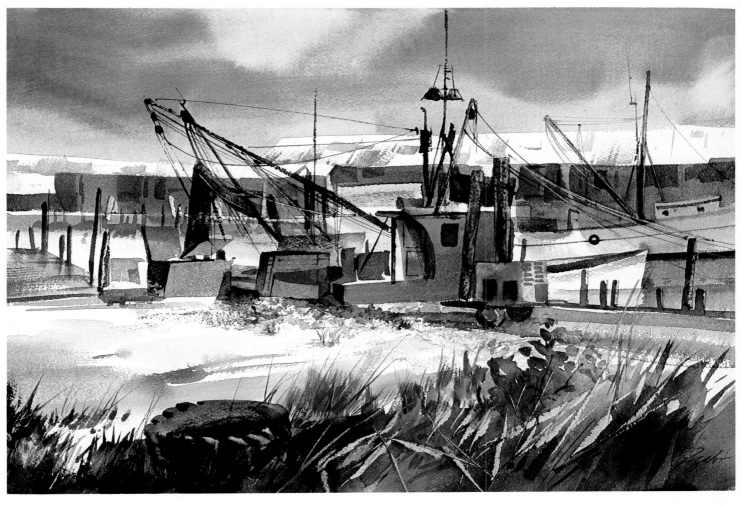

Palette
Burnt Sienna
Brown Madder
New Gamboge
French Ultramarine
Winsor Blue

Sunlit Harbor. April 1976, 15″ x 22″ (38 x 56 cm). In this composition, transparent glazes complemented by white shapes and accented with a textured line offer a lively variety of brushstrokes. The clutter of the busy fishing harbor is suggested rather than represented in photographic detail. I painted the gray glazes on the docked shrimp boats and the shaded background buildings with a 1″ (2.5 cm) soft, flat brush and Winsor blue, brown madder, burnt sienna, and French ultramarine glazes. I varied the color mixes in each brushstroke in the structures as well as in the bright sky. My two blues dominate the sky, influenced by a little new gamboge where this wet-in-wet wash defines the hard edges of the white roofs. I drybrushed in and knifed out some of the larger forms such as the net and posts to suggest three-dimensional details. For my foreground I used Winsor blue, French ultramarine, and new gamboge with a little burnt sienna in dark, shaded colors. Where the new gamboge and Winsor blue dominated the mix, I knifed out the weeds and the light side of the old tire, letting the lighter stained colors indicate shadow detail. For the drybrushed middleground area I worked with the well-diluted, light washes of burnt sienna, French ultramarine, and Winsor blue. For the final touches, I knifed in the masts and ropes as unifying lines, along with rust spots on the white roofs, added the grass in the middleground, the shadows, and the delicate weeds around the tire in the foreground.

Details of Strange Antlers

Wood Shed. (Left center of painting) The neutral-gray value of the old wood is lightly textured and its detail simplified because of the distance. Burnt sienna, French ultramarine, and Antwerp blue with touches of sepia served as the ingredients for the aging wood of the shed. I paid more attention to the unit as a whole than to fine detail. There are even fewer details in the soft, clean, green washes of the foliage behind the building, increasing the effect of their distance. I preferred a palette knife to a brush when I painted the tree branches. The knife-painted branches look gnarled and natural.

Stone Barn and Shed. (Top right of painting) With a medium-light wash, I defined the shape of the front wall of the barn. As this wash became a little drier (damp wet), I knifed out the irregular shapes of the stones. The darker spaces between the light stone forms look like mortar. At this point I purposely left out the stairway and door at the top—I painted them on later when the surface was dry. A hint of drybrush on the light door suggests textural variety.

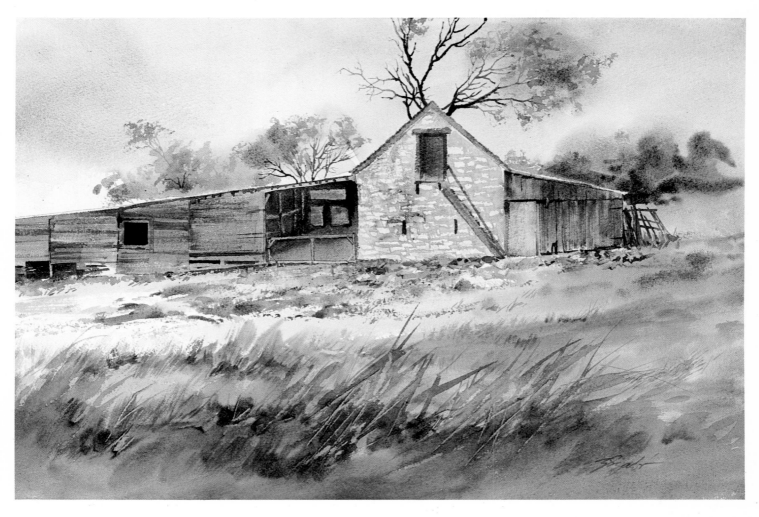

Palette

Raw Sienna
Burnt Sienna
French Ultramarine
Antwerp Blue
Sepia

Strange Antlers. April 1976, 15″ x 22″ (38 x 56 cm). The subject of this painting is aging textures amusingly juxtaposed to each other, with the weatherbeaten trees behind the house reflecting bygone days of Texas. I began with a medium-light wash of raw sienna, burnt sienna, and sepia for the stone barn, and knifed out irregular stone shapes while this wash was damp. Next, I glazed on the gray value of the patched-up wooden buildings with sepia, French ultramarine, and a little burnt sienna. I knifed out some light details from this wash, particularly in the dark stable directly left of the stone wall. I wetted and drybrushed the gravel in front of the buildings with a high-contrast mixture of raw sienna, burnt sienna, Antwerp blue, and a little sepia, allowing some white paper to survive. As I move closer to the foreground, I painted on wet-in-wet brushstrokes with a flat bristle brush. I glazed and knifed out light and dark clusters of scruffy grass. This area was kept darker to lead the eye toward the lighter stone wall. I washed a very pale combination of French ultramarine and burnt sienna into the light, overcast sky. While this color was wet, with raw sienna, Antwerp blue, and French ultramarine I painted the basic colors of the trees behind the structures as well as the distant bush in a bluer color at the upper right. When the washes dried, I drybrushed on more foliage to further define the trees and structured the branches with the tip of my palette knife using a dark wash of Antwerp blue, burnt sienna, and sepia. I completed the painting by adding final details such as the door and steps of the stone building, cracks on the board walls, splatter in the middleground, and the dilapidated structure on the right extremity of the building.

Details of Rapids Serenade

Flowing Water and Distant Forest. (Top right of painting) The combination of textures is important in this area. I started painting the misty forest with a series of wet-in-wet blended washes. I knifed out the light rocks and, with less pressure, the textured light tree. After the paint dried, I glazed on the closer, darker trees. The fine clutter of twigs and weeds supply additional interest above the rocks. For the horizontal drybrush glazes that represent the dark reflections in the rapids, I mixed warmer colors to bring it closer in color perspective than the cool blue-gray forest beyond.

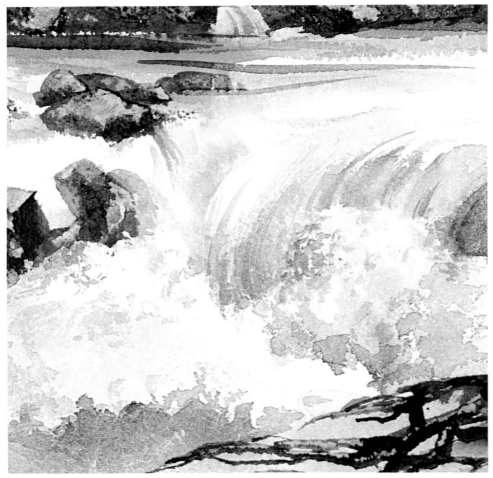

Foaming Waterfall. (Bottom center of painting) Drybrush glazing cannot be rushed. To capture the luminous, transparent quality of water, I painted very light, well-diluted washes of color in several layers, waiting for each coat to dry before applying the next. The dark, solid shapes of the protruding rocks, painted with sepia and Prussian blue, contrast with the rushing water both in value and texture. The staining quality of sepia and Prussian blue are clearly evident where I have knifed out the light planes of the rocks. The underlying color looks light against the shaded edges, but dark and solid beside the white foaming water.

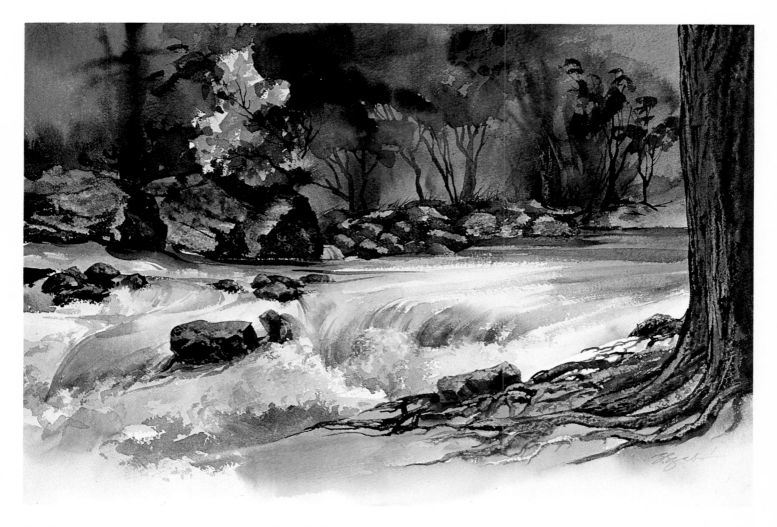

Palette
Aureolin Yellow
Burnt Sienna
Prussian Blue
Sepia

Rapids Serenade. April 1976, 15″ x 22″ (38 x 56 cm). I started my composition of a rapids in Gruen, Texas, with a bright, yellow-green tree. To accentuate the freshness of the spring foliage against the deeply shaded, somber forest, I chose aureolin yellow because it is subtle in hue, very transparent, and could be mixed lightly into the water, further diluting the color without dominating the wash. I painted in and knifed out the boulders, simplifying their shapes. Sepia and Prussian blue were too cold for the large rocks, so I glazed a light wash of burnt sienna over the knifed-out light shapes. I combined sepia and Prussian blue for the dark forest, washing them on to dry paper, later modeling the wash with darker glazes. Next, I painted the rushing water and its active bubbles with several light drybrush glazes of aureolin yellow, Prussian blue, sepia, and burnt sienna in varying combinations. Into these forms I sprinkled smaller boulders with aureolin yellow, Prussian blue, and sepia, and knifed out their light sides. I used sepia and Prussian blue for the old cypress trunk and its exposed roots. I knifed out the bark texture from the wet paint and structured the roots with the knife, as well. I added final details on the branches and directional washes in the water to complete the painting.

Details of St. John's Gift

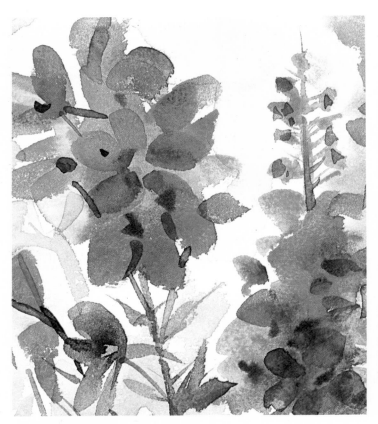

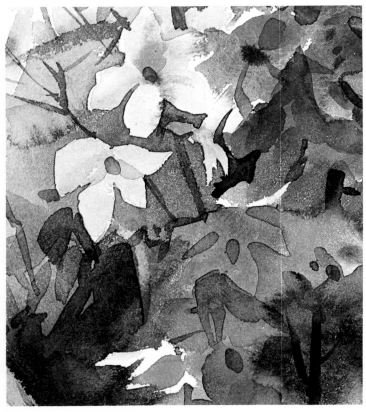

Dark Flowers with Light Background. (Top center of painting) The bright contrast between the backlit flowers and the background is emphasized in this detail. Notice the white sparkles next to some of the petals. They imply bright light from the rear and offer the purest complement to the clean, colorful glazes beside them. I used all three blues from the palette above plus well-diluted alizarin crimson to assure the transparency typical of backlit petals. The stems, leaves, and seed pods are a medium-dark green and firm in texture, in contrast to the limp, delicate flowers. The warm glow of the background wash gives the illusion that the cool blues and blue greens are shaded from a flood of sunlight.

Light Blue Flowers. (Center of painting) Blue is the unifying color influence in this detail as well as throughout the rest of the painting. The shadow details are darker in the leaf and stem area, and contrast with the delicate blue flowers. The two blooms are the areas best defined in the painting. Whenever I paint a cluster of flowers of the same species, I like to emphasize a few blossoms and play down the rest with looser handling. Note the thin, white, accidental edges between the petals and the background that appear consistently throughout the painting and are loose in detail. I allowed a touch of green to seep into the pure blue flower. I used well-diluted cobalt blue and Winsor blue in the petals, and the green is a combination of new gamboge and Winsor blue.

Palette

Winsor Blue
French Ultramarine
New Gamboge
Alizarin Crimson
Cobalt Blue

St. John's Gift. June 1976, 15″ x 22″ (38 x 56 cm). This painting is essentially a study of a backlit subject—delphiniums at St. John's University in St. Cloud, Minnesota—using a glazing technique. I started with the lighter, clear blue colors to establish the character of delphiniums, slightly past their prime. I varied the blues from one brushful to the next and applied them to the dry paper. I then introduced some alizarin crimson to warm the deeper forms, giving them a backlit glow. Wherever these brushstrokes touched, I encouraged a wet-in-wet effect, particularly in the lower half of the painting where I painted a shaded variety of greens mostly wet-in-wet. Free blending of these colors suggested shapes that I further defined by knifing them out of the damp wash. I paid particular attention to the transparent quality of the glazes when I modeled the flowers. I painted the misty background around and between the blooms using a light combination of new gamboge, a touch of alizarin crimson, and Winsor blue; and wet-brushed the blurry flowers into it with a mix dominated by Winsor and cobalt blues.

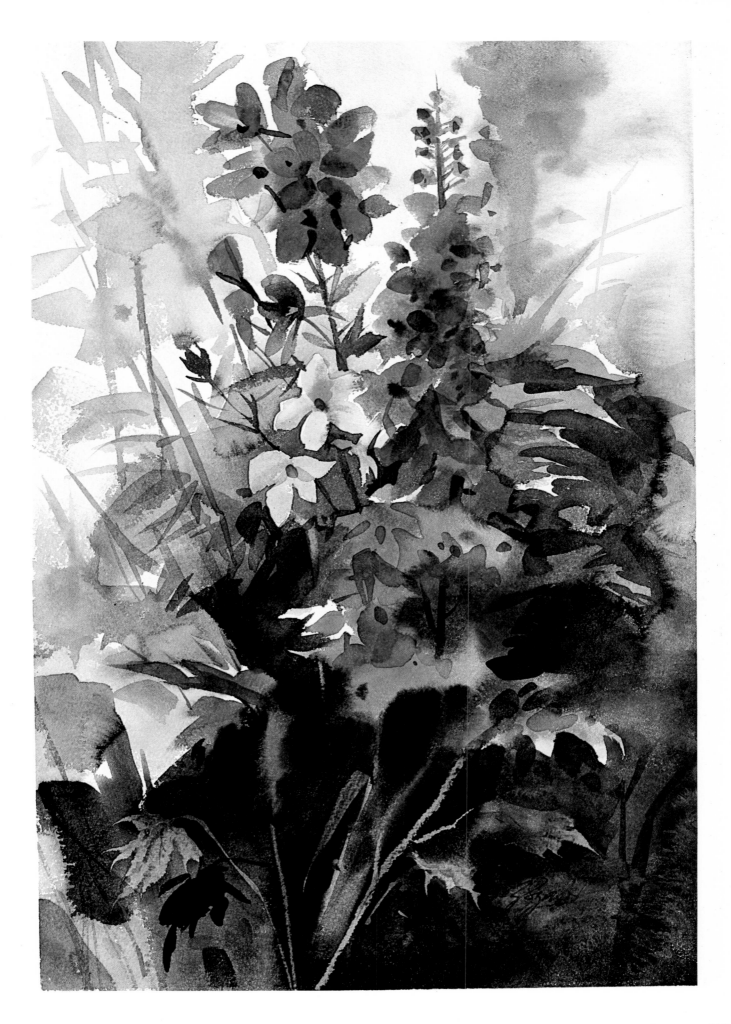

Details of Wishing Pool

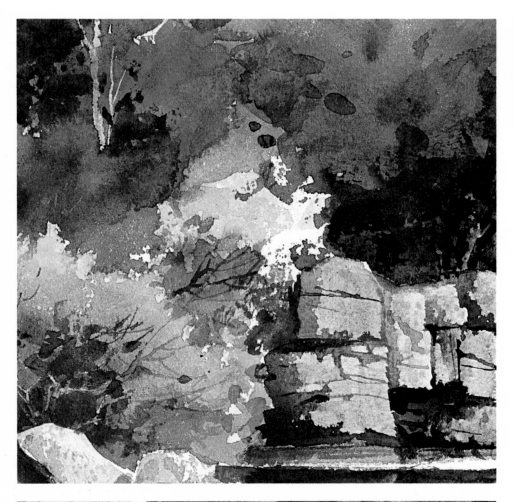

Light Green Shrub and Rocks. (Top of painting) Before painting this plump bush, I left the top edge as a jagged, lacy-white shape against the darker wash of the background forest, thus establishing a distinct edge between the two planes. The distant rocks were simplified with bold knifestrokes, as were the line details on the cracks and the dark branches.

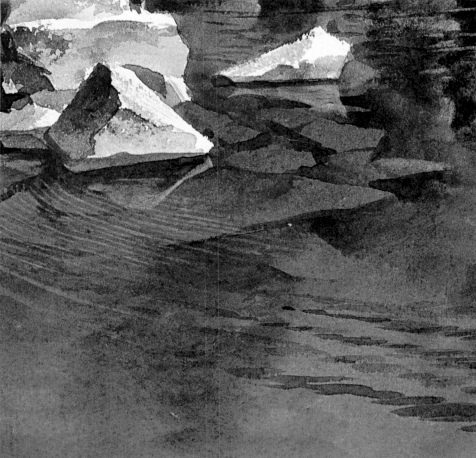

Submerged Rocks and Ripples. (Bottom of painting) The white sparkling sides of the rocks and their warm dry-brushed texture above the water level trap sunshine and contrast with the rich colors of the clear, smooth water: sap green, burnt sienna, and new gamboge. I glazed on the shaded edges of the submerged rocks with Winsor blue, burnt sienna, and brown madder. I wiped out the light-green reflections over the submerged rocks when the paper was dry.

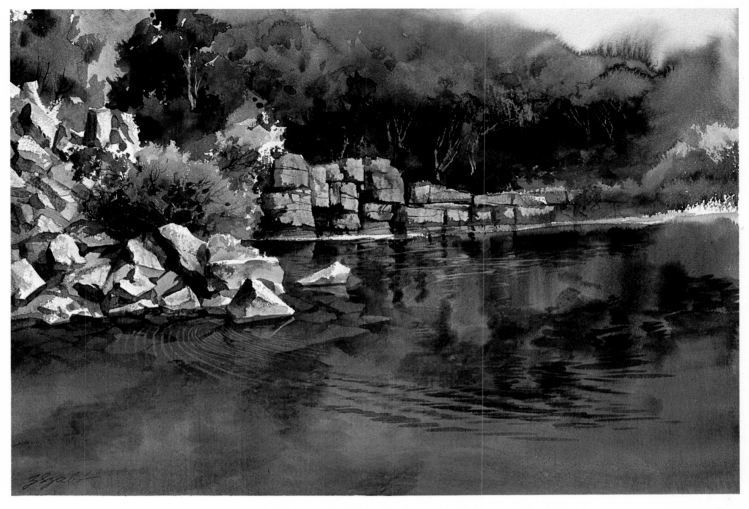

Palette

Brown Madder
Burnt Sienna
New Gamboge
Winsor Blue
Sap Green

Wishing Pool. June 1976, 15″ x 22″ (38 x 56 cm). This painting of a scenic area near St. Cloud, Minnesota, is a study of calm water, with its reflection and refraction. I started by glazing on the warm color of the rocks with burnt sienna and brown madder. I then knifed out the lighter textures while the paint was still damp, one rock at a time. My next step was to paint the forest. I wet brushed the foliage onto dry paper but allowed these large brushstrokes to blend as they touched. New gamboge, Winsor blue, and burnt sienna mingle freely with an occasional backrun that defines the forest planes. I knifed out the light branches, then painted in the shrub on the left. For the water area, I painted the dominant color—sap green—and the soft reflections with all five colors on my palette, primarily emphasizing the sap green and new gamboge. When this wash dried, I glazed on the submerged rocks and the sharper, dark reflections, then added the blue cast shadows on the rocks. Finally, I lifted out the light ripples and reflections with my brush. The sap green glow remained, as you can see.

Details of A Look at the Past

Shelf Next to Window. (Top center of painting) These shelf objects act as clutter. So that they don't distract, I paint them in subdued, close-valued colors. The cobweb was carefully designed to complement the scene. Backlighting is suggested by the dusty cobwebs that look dark against the light plastic curtain. The edge of the shelf is a stabilizing line offering visual rest between two busy shapes.

Dangling Rope. (Bottom center of painting) The soft modeling of the wood and the dangling rope offers a contrast in texture to the brittle, jagged, coarse, knifed-out metallic shapes below. The woodgrain and the design of the rope are painted more carefully than the rest of the painting because they're important in the composition. The rusty shapes only hint at being objects but lack greater definition because they're too close to the corner and the edge of the painting. Superfluous detail there would distract from the center of interest and ruin the composition.

Palette

New Gamboge
Cerulean Blue
French Ultramarine
Antwerp Blue
Burnt Sienna

A Look at the Past. June 1976, 15″ x 22″ (38 x 56 cm). Painting interior detail, including windows with a view of the outdoors, demanded simplification of this extremely complex subject. I began with clean, light, wet-in-wet modeling of the outside scene. I then sharply defined the edges of the torn plastic curtain and the area of the windowframes except for the center bars, which I painted at the same time as the dark wall. Next I painted the boards, the cluttered objects on the shelf, and the windowframe, moving from one dry area to another to prevent the shapes from blending into each other while they were wet. When I painted the dark values of the wooden wall, I left the shape of the dangling rope pure white, but I knifed out the metallic clutter on the lower left, and gave it a quick glaze of burnt sienna afterwards. I painted the loops of rope, one loop at a time, with a light and a dark wash, and scratched the twisted lines into this wet wash with the sharp tip of my brush handle. Next I glazed on the light color of the plastic curtain and painted a continuation of the window's center bars behind the plastic only, in a lighter value. I let the shape of the cobwebs unite separate forms. I chose a wet-and-blot technique to design their soft shapes, accenting them with razor-blade scratches when the paper dried. I rewetted and knife-textured some of the wooden surfaces, and added touches of woodgrain. I wetted and then blot-lifted the light seeping in next to the white crack near the rope and, last, applied finishing touches to the objects on the shelf.

Details of Arizona Buttes

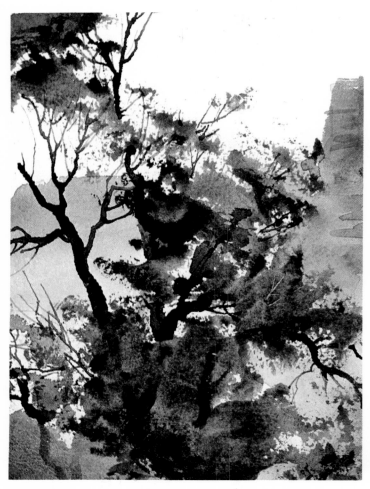

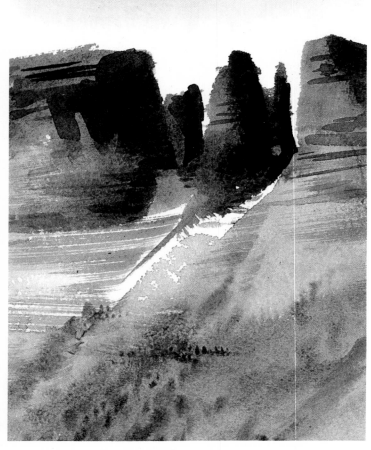

Foliage. (Upper left of painting) The foliage was painted over the lighter wash of the background mountains. To achieve its scrubby texture, I took advantage of the tendency of raw sienna to separate and included it in my wash, along with Winsor blue and burnt sienna. To further enhance the texture, I tapped on the foliage with a loose, drybrush technique. I indicated the skeleton of the tree with rich, dark, liquid brown knifestrokes.

Buttes. (Upper right of painting) Because they're in the distance, I chose a simple, bold glazing technique for the monumentlike buttes. The cooling influence of the Antwerp blue in the shadows also hints at the atmosphere, as do the pale sky and soft forest. I painted the layered modeling with split drybrush strokes.

Palette

Antwerp Blue
Raw Sienna
Burnt Sienna
Brown Madder
Winsor Blue

Arizona Buttes. June 1976, 15″ x 22″ (38 x 56 cm). I started with the two sky blues on wet paper and also added a touch of raw sienna to this wash. With a bristle brush, I painted the tall buttes, blending burnt sienna, raw sienna, and brown madder on the sunny sides, and adding Antwerp blue to the soft, shaded side. Horizontal split drybrush strokes created the layered character. The climbing trees add bluish vegetation to the mountain. I used brown madder and burnt sienna for the middleground rocks which I textured with a painting knife topped with raw sienna shrubs. Finally, I drybrushed the foliage of the large juniper and knifed in the dark branches to connect them to the twisted trunk. For the foliage, I used raw sienna, Winsor blue, and burnt sienna; for the branches, burnt sienna, Winsor blue, and brown madder. At the end, I knifed out a few light blades of grass in the foreground.

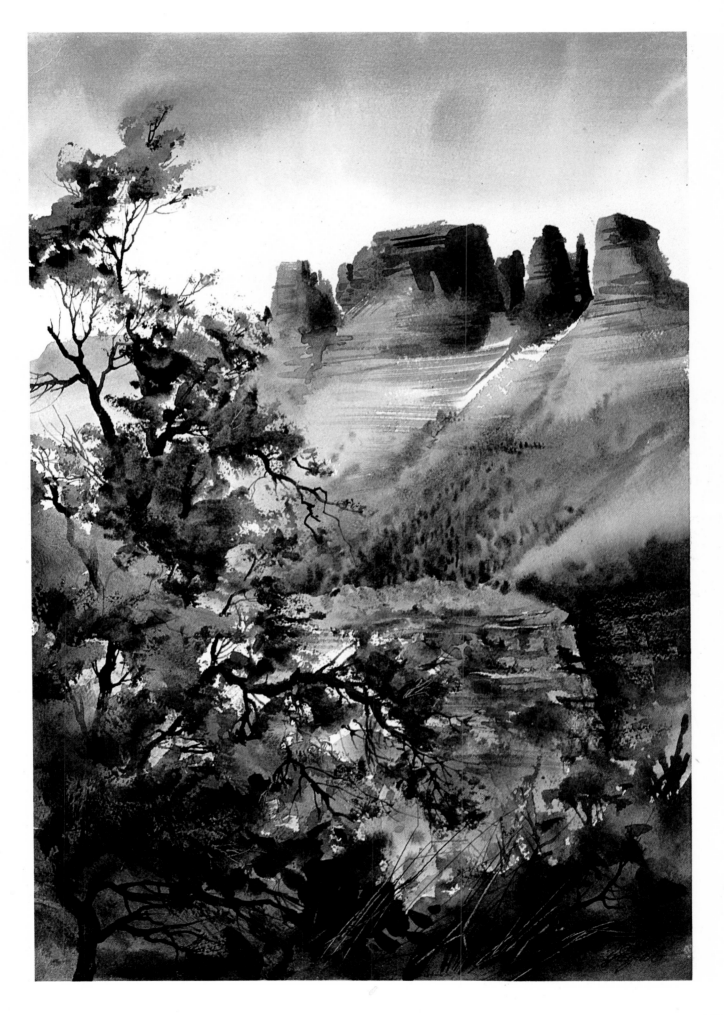

Details of Bubble Factory

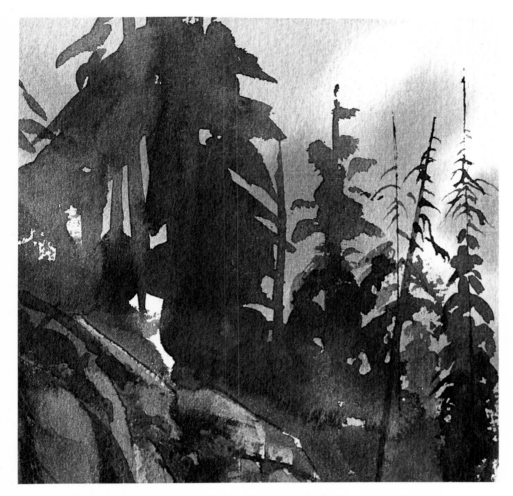

Trees. (Top left of painting) In contrast to the rocks and water, this area is painted boldly, without excess detail. The direction of the branches and the lighter top lines on the rocks point toward the center of interest: the waterfalls. I painted the trees on top of the dry wash of the blue sky with a round sable as one single silhouette with Winsor blue and raw sienna. I knifed out the rocks from a wash of brown madder and Winsor blue.

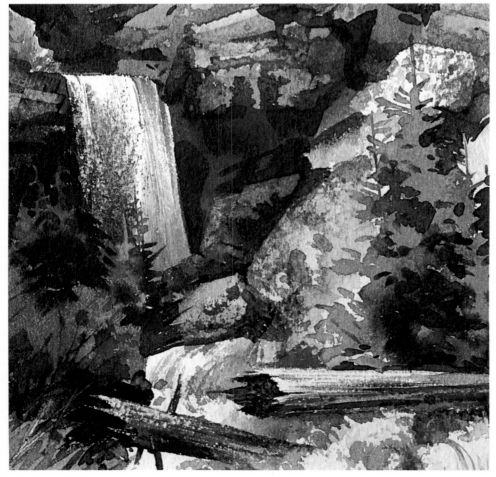

Rocks and Water. (Center of painting) Contrast in values is essential to separate the churning water from the solid forms. The wet, dry-glazed, and knifed-out textures complement each other, as well as define the physical nature of the forms. The bubbling water was drybrushed on in several loosely painted glazes on a dry, white background.

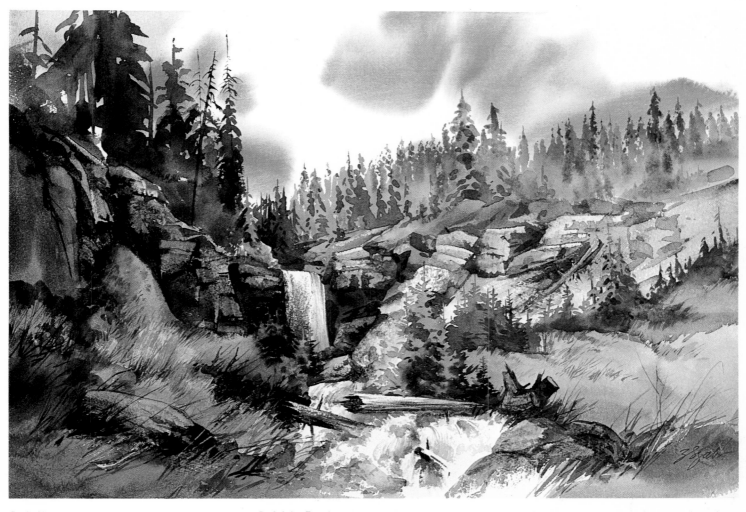

Palette

Winsor Blue
French Ultramarine
New Gamboge
Raw Sienna
Brown Madder

Bubble Factory. June 1976, 15″ x 22″ (38 x 56 cm). This scene was painted on location in Colorado. The bright sun and dry air at such a high elevation created fast drying conditions and I had to work on the painting in small sections. I painted the deep sky on wet paper with two blues together. Next came the sunlit rocks on the right side—brown madder, raw sienna, and Winsor blue, well-diluted. I knifed out the lighter shapes. On top of these, I followed with the shaded tall trees at top left, working with Winsor blue and raw sienna, and then I did the blue-gray rocks under them with brown madder, Winsor blue, and raw sienna. Blue dominates the shaded side. The churning water was drybrushed— painted after the middleground hills, trees, and rocks were finished. I completed the painting with fine-line touches, using my palette knife in the foreground and adding crisp drybrush definition on the shiny logs in the water.

Details of Colorado Drizzle

Sky. (Top center of painting) The soft blue sky blends into the angry clouds. To exaggerate the rough clouds, I used a separating wash of French ultramarine, burnt sienna, and brown madder. I lifted the wet edges with a thirsty brush, added sharp darks to some spots after the first wash dried, and lost one edge of this brushstroke, blending it into the cloud masses.

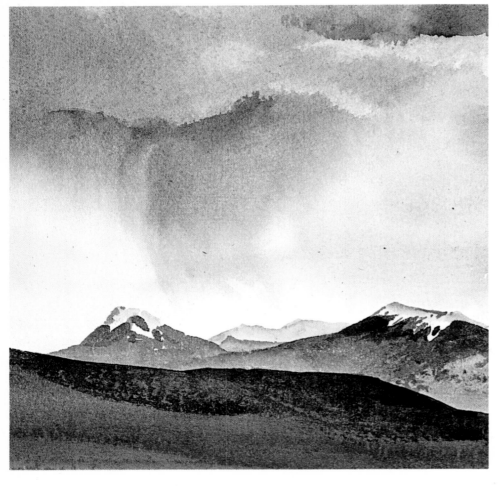

Peaks and Clouds. (Lower left of painting) The illusion of depth and distance is created by layered glazes that move from dark to light values and from cool to warm. The cool blue sky looks further away than the warm, gray clouds. The blue peaks seem further away than the strong, snow-covered, textured, and warmer green mountains. The strongly shaded closer slopes appear even nearer.

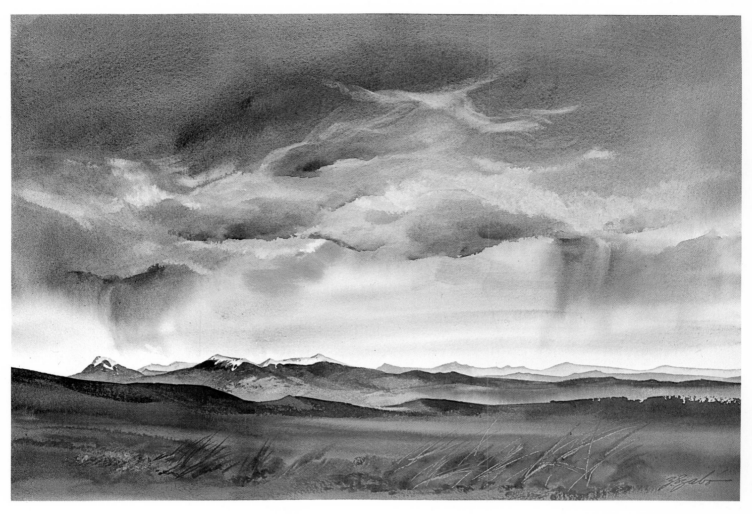

Palette
French Ultramarine
Antwerp Blue
Burnt Sienna
Raw Sienna
Brown Madder

Colorado Drizzle. June 1976, 15″ x 22″ (38 x 56 cm). I started by painting the sky on very wet paper: burnt sienna, French ultramarine, and brown madder in the clouds; Antwerp blue and raw sienna (in a light consistency) in the clear sky area. As this wash lost its shine, I lifted the light cloud edges with a clean, thirsty brush. For the rain, I rewetted the already dry lower sky and brushed in the rain with downward strokes. I glazed the ground definition on dry paper, starting with the blue, distant peaks, then adding more and more value, color, and definition as I approached the foreground. I painted the subdued foreground with quick, rich mingling washes of raw sienna, Antwerp blue, burnt sienna, and brown madder. I knifed out the light from this damp wash, brushed on the dark grass, and drybrushed a hint of coarse soil.

Details of Lone Perfomer

Birch Bark and Background. (Top right of painting) My wet, dark background wash started at the edge of the birch tree and was painted up to the edge and around the curling bark. I wet modeled the distant dark foliage and spruce trunks and, when it dried, I lifted the hanging moss with a wet-and-blot approach. As a final step, I shaded the peeling bark with luminous burnt sienna, contrasting the warm and light tree against a cool and dark background.

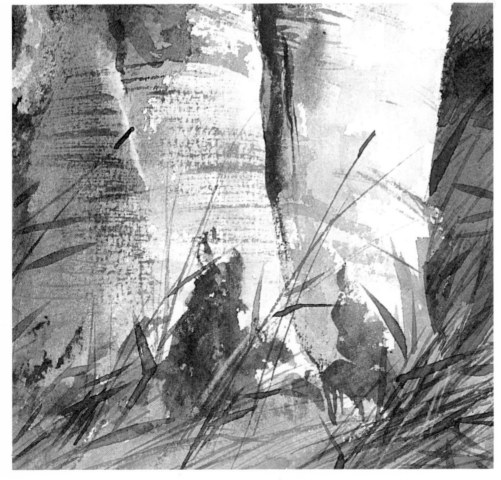

Tree Base. (Bottom center of painting) Luminous glazes complement rich dry-brush texture. Closeup details require accurate definition. The loosely painted grass forms a soft nest of texture at the base of the tree. This well-anchored feeling is important and roots the tree to its surroundings. Where I lifted up the other colors, the new gamboge has stained the paper and glows through the light grass. The occasional white sparkle of the paper helps the illusion of clean colors and fresh texture.

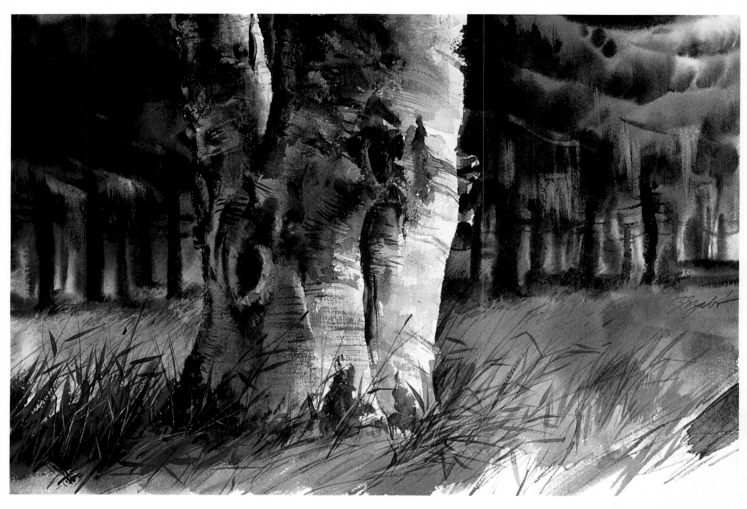

Palette
New Gamboge
Burnt Sienna
Winsor Blue
Sepia

Lone Performer. July 1976, 15″ x 22″ (38 x 56 cm). Soft lighting and playful texture form the technical basis for this watercolor. The shaded side of the large tree contains a variety of luminous colors resulting from reflected light. I applied all four colors in a rich blend with a large, soft, flat brush on dry paper. I lightened the wash considerably on the lit side of the birch at the right and let some white paper show. I began painting the ragged bark and scar textures with soft modeling on the damp paper, followed by drybrush strokes. Next, I painted the dark, old spruce trees in the background with a wet-in-wet technique using Winsor blue, burnt sienna, and sepia in varying combinations. I wiped out the hanging moss from the branches with a tissue. The brightly lit lush grass in the middle and foreground are mainly a combination of new gamboge, Winsor blue, and burnt sienna. At the foot of the tree I drybrushed some richly textured glass in darker shades of the same color and knifed out the light weeds while the washes were still damp.

Details of Daisy Nest

Window and Shrub. (Top right of painting) This detail shows a good example of knifework. The bold forceful pressure of the knife instantly established a light value in a dark wet wash. I gradually lost the value of the gray wall toward the right, preparing a light background for the darker green foliage. Some of the unbroken windowpanes reflect the green foliage, carrying warm accents into the cool gray area. I glazed on the dark inner space defining the chipped glass in the windows with brown madder and Winsor blue.

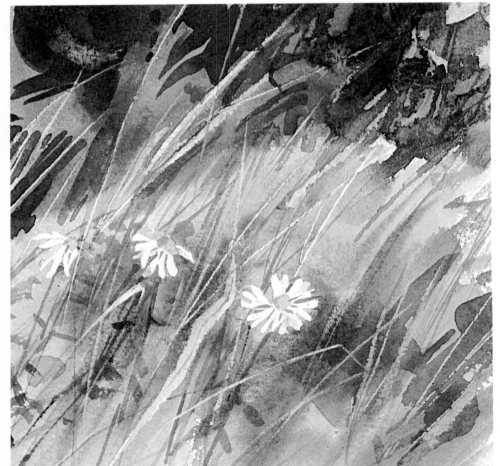

Daisies and Surrounding Weeds. (Bottom right of painting) To establish the shape of the flowers, I quickly but carefully painted around them with a well-loaded round sable brush. Before this wash dried I boldly established a color mass around them with a wide bristle brush, making sure that the two washes blended as they touched. Speed was my primary consideration—I had about 15 seconds to paint each flower. The details were knifed out where they're light and painted on with a soft sable or a thin rigger brush in the areas where they're dark.

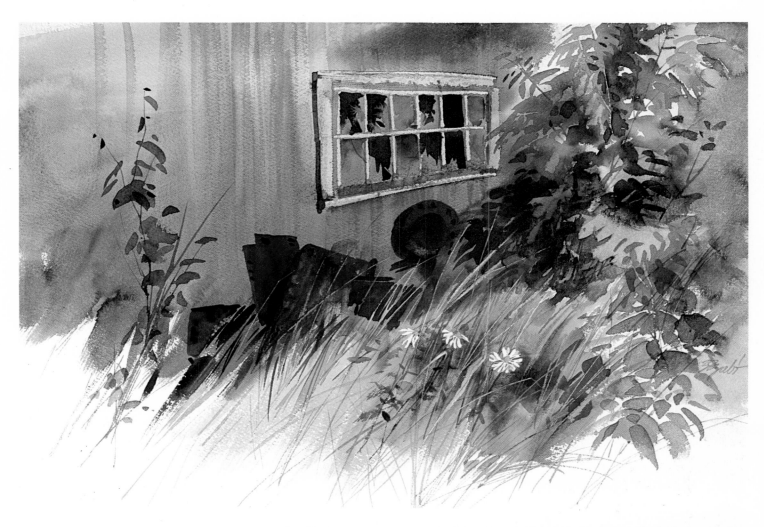

Palette
New Gamboge
Raw Sienna
Burnt Sienna
Brown Madder
Winsor Blue

Daisy Nest. July 1976, 15″ x 22″ (38 x 56 cm). This painting has a playful balance of warm sunlight and neutral shade. I used a wide, flat bristle brush to paint on dry paper the base washes of new gamboge, raw sienna, Winsor blue, and brown madder, with the yellows dominant. While this wash was wet, I painted around the daisies with a pointed sable brush, blending the two washes together as they touch. Again, with my wide bristle brush, I painted the cool gray color of the nearby building with Winsor blue and brown madder. From this damp paint, applying hard pressure, I knifed out the shape of the windowframe. Where the building touched the sunlit grass, I glazed on the warm, dark, rusty machinery parts with brown madder, burnt sienna, and Winsor blue. While this wash was still damp, I knifed out some thin grass blades, which I later colored yellow. I painted on the tall shrub on the right-hand side with a variety of green brushstrokes. I carried the wall of the gray building through to the right-hand side to act as a contrasting backdrop for the shrubs. I finished by adding the last details: the broken glass panes, the finer details in the grass, the shaded tall weed on the left side in front of the gray building, and, as a finishing touch, the yellow centers of the daisies.

Details of Nobility

Window Reflections and Building. (Left of painting) The clean, simple application of a light blue wash, followed by a second glaze of the blue-green silhouette of the reflecting foliage, presents a cool contrast to the neighboring warm brown madder and burnt sienna bricks. The texture differs, too. The glass windowpane is left smooth and undisturbed, while the bricks are coarsely textured and modeled with a brush and palette knife. Unlike the upper windows, which reflect the light sky, the lower windows show the dark silhouette of tree shapes. The dark reflection increases the window's transparency, permitting some interior detail to appear.

Street Lamp Area. (Right of painting) This is a space of complementary forms. I carefully painted around the white glass lampshades with darker, freely blending colors. The pale modeling on the glass is simple in shape and light in value. The wrought-iron fence presents a linear contrast to an area of subtle tonal modeling. The plywood construction fence provided a chance to repeat some of the warm reddish hues of the building in an unrelated area for better color unity.

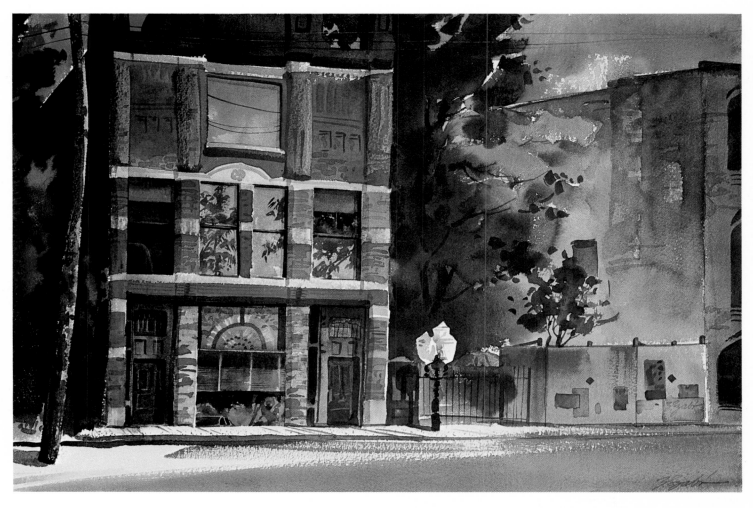

Palette

New Gamboge
Brown Madder
Burnt Sienna
Antwerp Blue

Nobility. July 1976, 15″ x 22″ (38 x 56 cm). To assure bright, clean, glistening colors in this Minneapolis street scene, I used only very transparent pigments. I started by painting the blue reflections in the windows, establishing their mechanical shapes by masking out their edges. I painted most of the details in the reflections before I lifted the tape to assure a feeling of continuity of the reflection's design. My colors were Antwerp blue, burnt sienna, and new gamboge. Then I removed the tape and started to paint the brick-work with a light wash of brown madder and burnt sienna. The darker details of the brickwork are glazed on with darker values of the same colors, with occasional knifing. On dry paper, I applied the washes for the green foliage and the gray building on the right-hand side with a large, soft brush. The colors—new gamboge, Antwerp blue, and burnt sienna for the foliage; brown madder, and Antwerp blue for the wall texture— flowed freely together as wet-in-wet washes. I worked on dry paper so I could paint around the triple lampshades and allow an occasional light sparkle to show between the branches. I painted the trees on the left-hand side in the same way and knifed out the shape of the telephone pole from the dark, wet background. I painted a quick drybrush texture on the sidewalk and road and in the foreground with Antwerp blue and brown madder. Finally, I finished the small details of the doors, iron fence, branch structure, and poster boards, and included such items as the lamp post and its shadow.

Details of Flower Basket

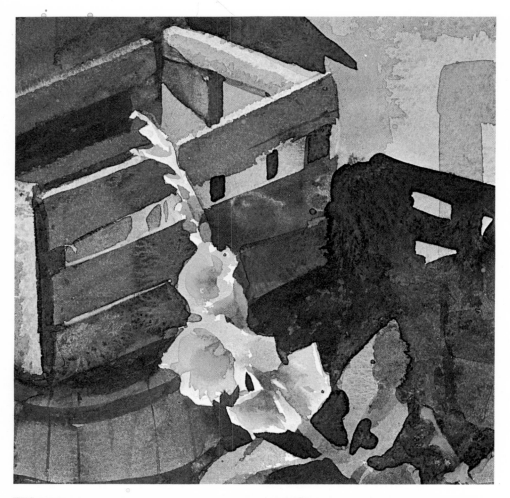

Flowers and Crate. (Top of painting) There's a sharp contrast between the clean, light colors of the flowers and the grayer, darker tones of the crate and the surrounding shadows. Firm, confident brushstrokes of rich paint are the secret of fresh-looking glazes. The judgment of your dark values must be correct the first time—hesitant strokes look overworked. My washes carefully followed the main form of the flowers, ignoring the small details. Accidental runs were left as accents.

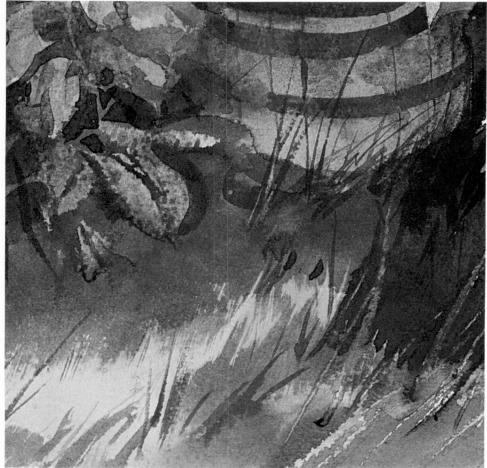

Shaded Area with Barrel. (Bottom of painting) Shadow details are subtle on the dark side. I knifed out some of the larger leaves with medium pressure, allowing the staining washes of Winsor blue and brown madder to remain dominant. My first medium-dark wash of burnt sienna and brown madder with Winsor blue survived on the barrel. I then related the darker details to this light shadow value. I dry-brushed the dark edges of the shaded grass over the sunny yellow glaze. Later I glazed more gamboge yellow over this area to unite the blue-gray shadows and the sunny yellow color of the flowers.

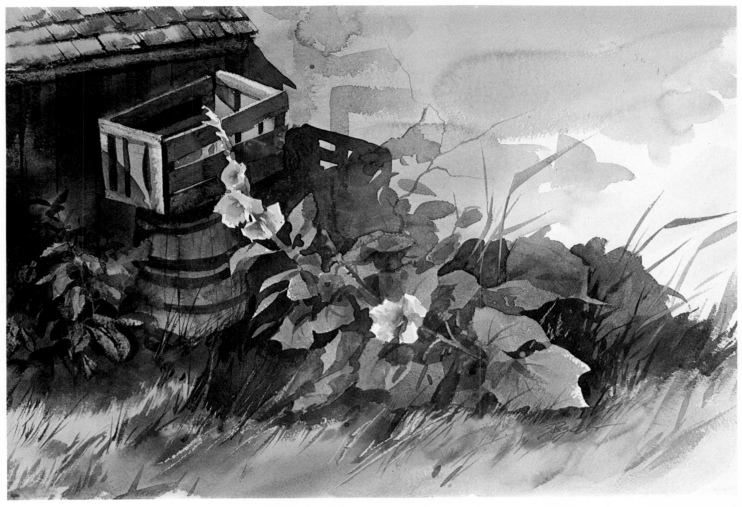

Palette
New Gamboge
Burnt Sienna
Brown Madder
Winsor Blue

Flower Basket. August 1976, 15″ x 22″ (38 x 56 cm). When you hunt for subject matter, look at your feet first! This painting is of one of those seemingly insignificant corners of sunshine and shadow. I used very clear colors in a light value for the hollyhocks: new gamboge, burnt sienna, and Winsor blue. In contrast, I mixed brown madder, Winsor blue, and burnt sienna for the shaded wooden surfaces and the wall. I glazed on the darker values over the lighter ones after they'd dried. I used a large, soft, flat brush for these loose washes. I painted the leaf and stem structures in the same way with new gamboge and Winsor blue, plus a touch of burnt sienna. I glazed on a sunny wash of new gamboge and burnt sienna under the foreground grass, texturing it quickly with wet and dry brushstrokes as well as with some knifestrokes. I painted the cast shadows around the flowers in a single wash of brown madder and Winsor blue. I added a few clarifying details such as the burnt sienna hoops on the barrel and the cracks on the wall, and the painting was finished.

Details of Jewel Case

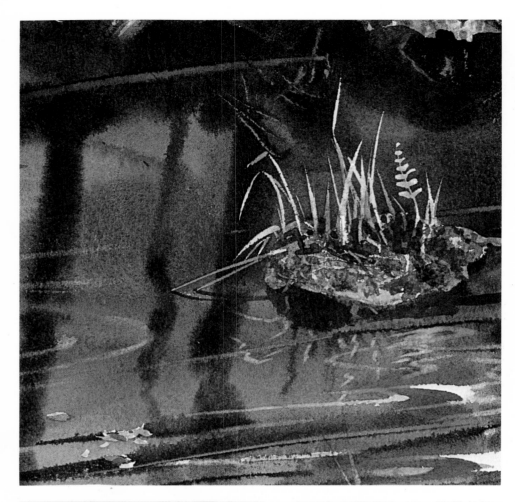

Islet. (Upper left of painting) I applied Miskit to the ferns and grass with a good sable brush that was first well-coated with soap for protection. I then proceeded to texture the isle of dry mud with a drybrush glaze of burnt sienna and French ultramarine, and modeled it with my painting knife while it was still damp. I wet and blotted off the reflecting soft ripples from the dark, dry color. The sap green stain remained while the other colors came off. When I removed the Miskit and painted the ferns and grass, their shapes were sharply detailed against the background.

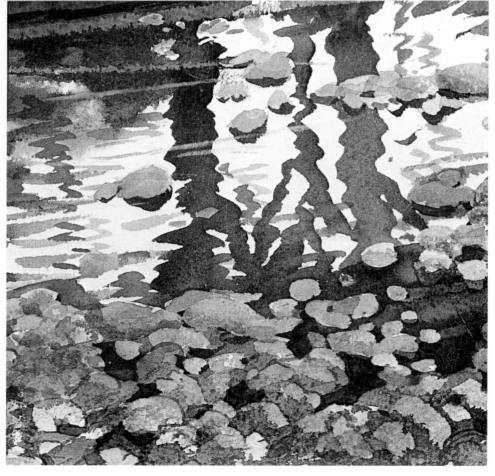

Reflecting Trees. (Center of painting) I held a soft, flat brush horizontally and painted the dark wiggly reflections of the trees and stones in the water over the masked-out rocks and leaves with Winsor blue and burnt sienna. I also painted some similarly reflected wiggles with sap green and burnt sienna. I paid careful attention to the strong contrast of values between the reflections of land and sky in the water.

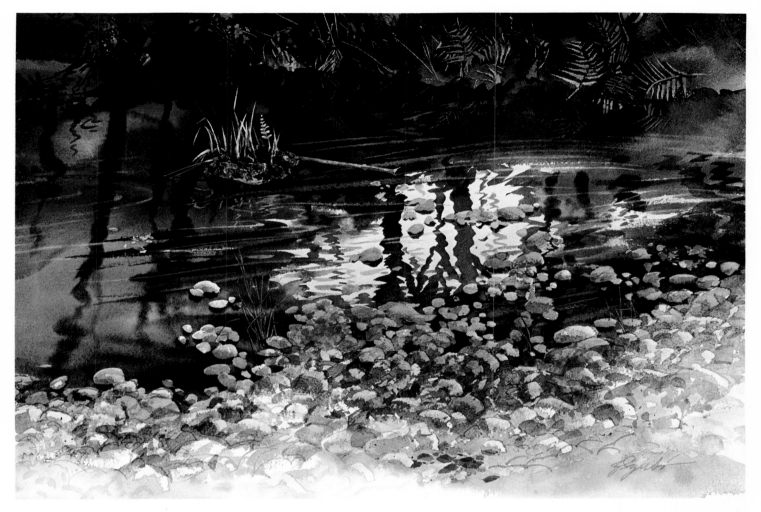

Palette

Sap Green
Burnt Sienna
New Gamboge
French Ultramarine
Winsor Blue

Jewel Case. August 1976, 15″ x 22″ (38 x 56 cm). This low-water riverbed in Saulte Ste. Marie, Ontario, was full of algae, which gave it a rich, green color. I started by masking out the little isle of weeds, floating leaves, and the edge of the stony shore and the protruding pebbles. I painted the deep color of the water on dry paper with sap green, Winsor blue, and burnt sienna fast enough to allow each brushstroke to blend with the other. I then painted the soft tree reflections into this wet wash with burnt sienna and Winsor blue, omitting the brightly lit reflection in the center. When this wash was tacky, I knifed out the ferns and weeds on the far shore, the tall grass in front of the dark water at the stony edge, and the horizontal highlights of the reflection. When the light gray wash of French ultramarine and burnt sienna had dried over the light center, I painted in the wiggly reflections of the trees and branches. After this wash was dry, I lifted off the Miskit and finished the stones by glazing on French ultramarine and burnt sienna. I used new gamboge and sap green for the grass on the brown isle. I lifted off the soft reflecting ripples and finished by painting the floating leaves and those scattered among the pebbles with burnt sienna and new gamboge.

Details of Sweet Home

Spider's Web. (Upper left of painting) Brown madder and Antwerp blue display their beautifully transparent glazing qualities here. First I textured the wood with French ultramarine and burnt sienna, then deepened their value later by glazing brown madder and Antwerp blue over the texture with a 1″ (2.5 cm) flat, soft brush. I wiped off the light wood surface and the softer part of the cobweb. After all was dry, I scratched out its white sparkle with the corner of a sharp razor blade.

Sunlight. (Bottom center of painting) This detail shows its originally dark value in the shadow areas. I lifted off the lighter sunlit values by first wetting the area with clean water and then wiping off the loosened pigment. A lot of the original texture survived, but I added more later to recover the woodgrain. I painted on the rusty streaks later with burnt sienna.

Palette

French Ultramarine
Burnt Sienna
Antwerp Blue
Brown Madder

Sweet Home. August 1976, 15″ x 22″ (38 x 56 cm). I masked out the edges of the vertical boards with masking tape, then proceeded to paint the horizontal logs with a flat bristle brush, and wet modeled the knots and the woodgrain. I did all this in dark values. I then lifted the masking tape and proceeded to paint the vertical boards similarly. After the surface had dried, I rewetted and wiped off the sunlit values, defining the edges of the shadows carefully and preserving as much texture as possible. I then drybrushed on more textural definition, such as cracks and edges. Next, I wiped off and knifed out the wire and painted on its shadow and added the rusty nails and their shadows as well as the rust stains. At last, I rewetted and wiped off the spider's "sweet home," its web, and highlighted its edges with a crisp scratch of a razor blade on the very dry surface.

Details of Old Friends

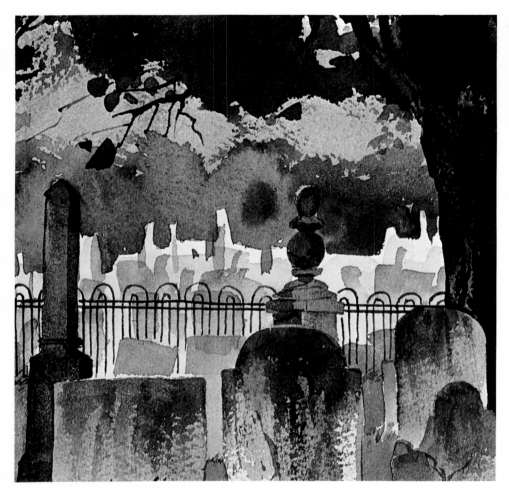

Maple. (Top right center of painting) I carefully controlled the light glazes: darker in the foreground, lighter farther away and pure white in the distance. The sharp contrast in color and value throws the forest into the distance. The values of the dark granite headstones, the dark shaded maple tree, and black iron fence create the illusion of white aging marble by their contrast. Note the knifed-out highlight on the tree bark.

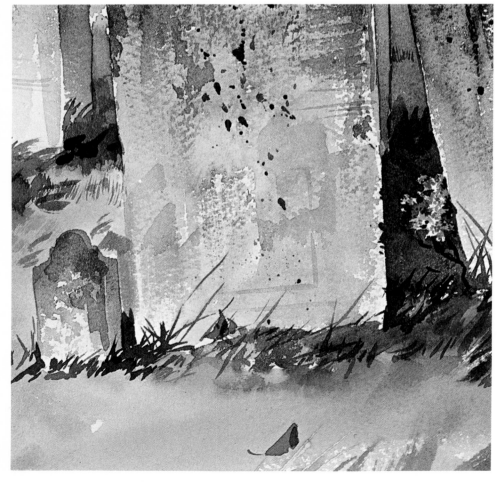

Small Tombstone. (Left bottom center of painting) The color and value differences between the grass and stones are obvious, but the texture really spells out the nature of their forms. I freely splashed on dry-brush glazes of brown madder, Winsor blue, and burnt sienna on the stone surface. I painted the dark contrasting grass around the blue flower without being too specific about tiny floral details.

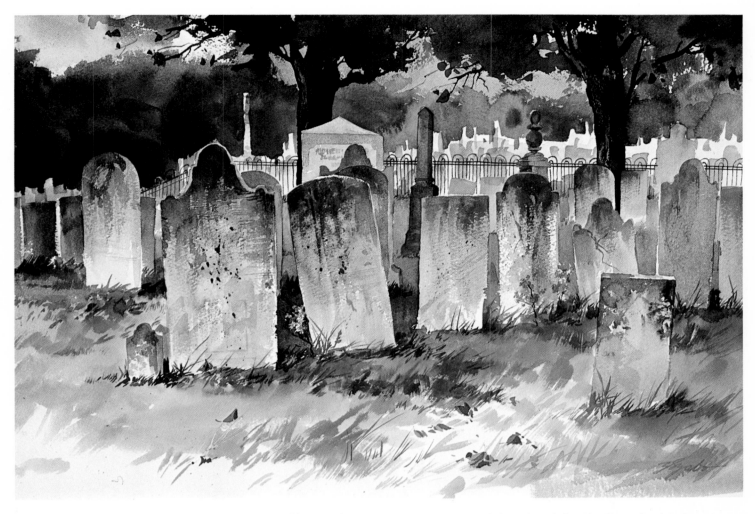

Palette
Brown Madder
Burnt Sienna
French Ultramarine
Winsor Blue
New Gamboge

Old Friends. September 1976, 15″ x 22″ (38 x 56 cm). I started to paint the closest stones in this Vermont cemetery with a wide soft 1″ (2.5 cm) brush using brown madder, Winsor blue, and burnt sienna. As I moved into the distance, I used lighter colors. I drybrush textured the aging surfaces, then added the splashy glazes of the textured grass with new gamboge, French ultramarine, burnt sienna, and Winsor blue. I painted the dainty blue flowers with Winsor blue and French ultramarine. Next I wet the upper part of the paper and painted the hill with French ultramarine and the lush, distant forest with burnt sienna, new gamboge, Winsor blue, and French ultramarine. I carefully defined the white silhouettes of the distant stones with the lower dry edges of this wash. After it dried, I painted on the two dark maples with Winsor blue, burnt sienna, and brown madder. I used very heavy paint with little water on the trunks and knifed out the reflected light on the bark. I finished the painting by adding the wrought-iron fence and the windblown, sprinkled leaves.

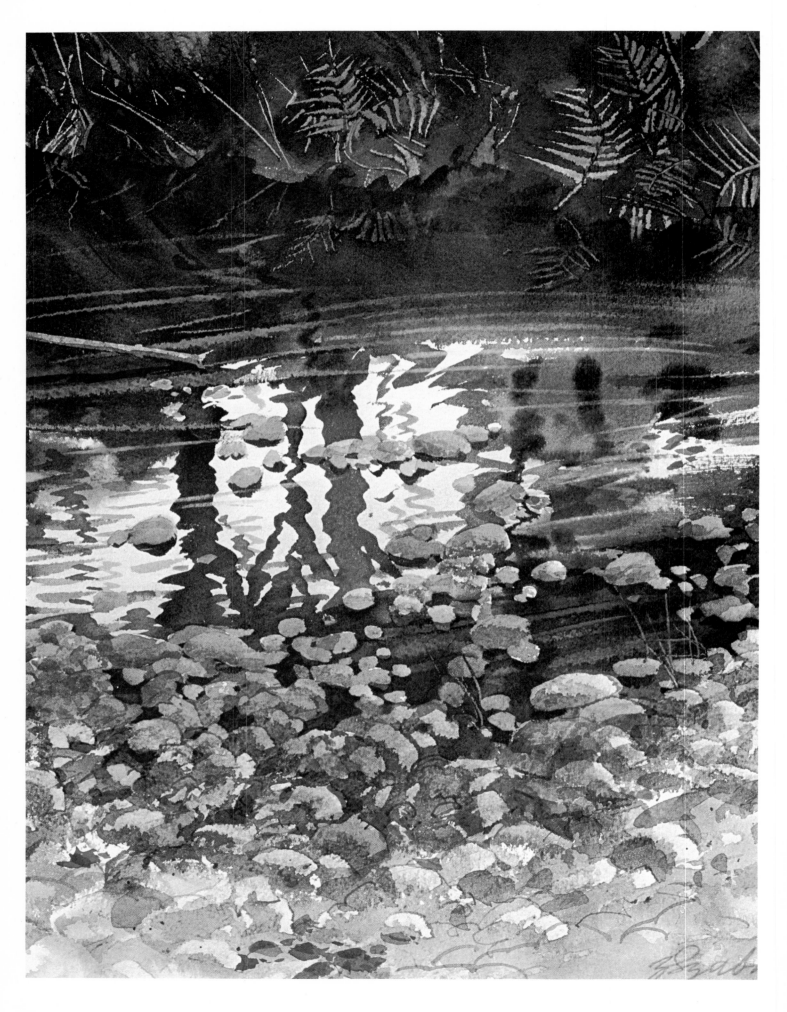

Detail of Jewel Case. The darks in the water were painted wet-in-wet and then the pale ripples were knifed out of the wet color. The foreground rocks are mostly patches of warm and cool strokes that suggest the rounded shapes, rather than delineate all of them—only a few rocks at the edge of the water are clearly defined.

Zoltan Szabo was born in Hungary in 1928, and studied at the National Academy of Industrial Art in Budapest. In 1949 he emigrated to Canada. Despite a busy schedule that includes giving workshops and seminars on watercolor painting as well as preparing demonstration films and slide/casette lecture packages, he still found time to write *Landscape Painting in Watercolor, Creative Watercolor Techniques,* and *Zoltan Szabo Paints Landscapes: Advanced Techniques in Watercolor,* all published by Watson-Guptill. His work has been featured on the Watercolor Page of *American Artist* magazine, and he is the designer of the original Zoltan Szabo watercolor easel made by Island Studios, Inc.

Zoltan Szabo's paintings are owned by public and private collectors all over the world, including the prime ministers of Canada and Jamaica. They are also reproduced annually as Christmas cards by Coutts-Hallmark of Canàda. His watercolors have been exhibited internationally: in London, England; in the United States (New York, Honolulu, Pensacola, and Detroit); and in Canada (Toronto, Hamilton, London, and Sault Ste. Marie).

He is a past president of the Society of Canadian Artists, a member of the Board of Directors of the Midwest Watercolor Society, and an Honorary Member of the Southwestern Watercolor Society.

SUGGESTED READING

Blake, Wendon. *Acrylic Watercolor Painting.* New York: Watson-Guptill, 1970.

———. *Complete Guide to Acrylic Painting.* New York: Watson-Guptill, 1971.

Brandt, Rex. *Watercolor Technique,* 6th ed., revised. New York: Reinhold, 1963.

———. *The Winning Ways of Watercolor.* New York: Reinhold, 1973.

Guptill, Arthur, edited by Susan E. Meyer. *Watercolor Painting Step-by-Step.* New York: Watson-Guptill, 1967.

Hilder, Rowland. *Starting with Watercolour,* New York: Watson-Guptill, and London: Studio Vista, 1967.

Kautzky, Ted. *Painting Trees and Landscape in Watercolor.* New York: Reinhold, 1952.

———. *Ways with Watercolor,* 2nd ed. New York: Reinhold, 1963.

Kent, Norman, edited by Susan E. Meyer. *100 Watercolor Techniques.* New York: Watson-Guptill, 1968.

O'Hara, Eliot. *Watercolor with O'Hara.* New York: Putnam, 1968.

Olsen, Herb. *Watercolor Made Easy.* New York: Reinhold, 1955.

Pellew, John C. *Painting in Watercolor.* New York: Watson-Guptill, 1970.

Pike, John. *Watercolor.* New York: Watson-Guptill, 1973.

Reid, Charles. *Figure Painting in Watercolor.* New York: Watson-Guptill, 1972.

———. *Portrait Painting in Watercolor.* New York: Watson-Guptill, 1973.

Schmalz, Carl. *Watercolor Lessons from Eliot O'Hara.* New York: Watson-Guptill, 1974.

Whitaker, Frederic. *Whitaker on Watercolor.* New York: Reinhold, 1963.

Whitney, Edgar A. *Complete Guide to Watercolor Painting.* New York: Watson-Guptill, 1965.

INDEX

(*Note*: Titles of paintings and page numbers on which illustrations appear in color are in *italics*.)

Edited by Bonnie Silverstein
Designed by Bob Fillie
Graphic production by Frank DeLuca
Composed in 10-point Helvetica Light by Gerard Associates/Phototypesetting Inc.
Printed and bound in Japan by Dai Nippon

cobalt bl.
Permanent magenta –
burnt Siena

 yel trol –

Greens – yel. lots of
Chears colors
 hint.

① Put a capful of glycerin in water when doing
Watercolor – it keeps the paint from soaking into
paper too soon.

n729 $11.00
Huntingbeach 946 27 watercolor books
morkes a good gray Tom. Linch
 Cal